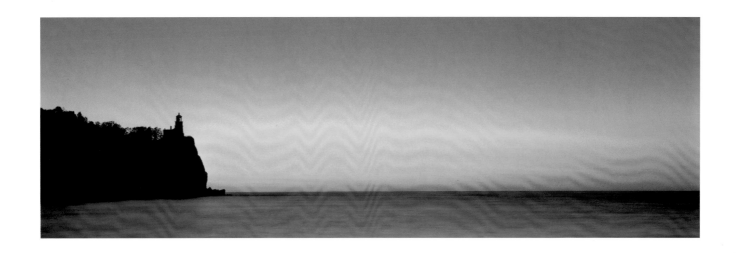

America Wide

This book is dedicated to the One in whom I trust — the Lord God Almighty, Creator of heaven and earth
and also to my treasures beyond measure, Pamela and Jessica Duncan.

P A N O G R A P H S ® B Y K E N D U N C A N

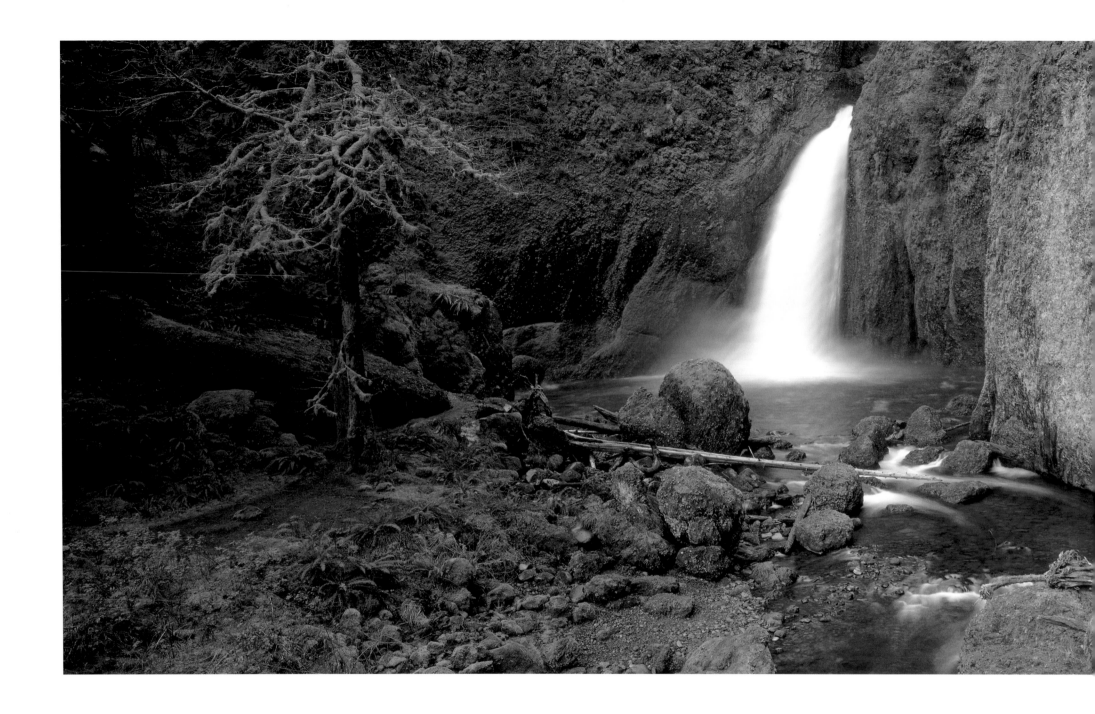

Wahclella Falls, Columbia Wilderness, Oregon

America Wide

AMERICA WIDE®
FIRST PUBLISHED IN 2001
REPRINTED 2001
BY KEN DUNCAN PANOGRAPHS® PTY LIMITED
ABN 21 050 235 606
PO BOX 3015, WAMBERAL NSW 2260, AUSTRALIA.
TELEPHONE: 61 2 4367 6777.

COPYRIGHT PHOTOGRAPHY AND TEXT:
© KEN DUNCAN 2001
PRINTED IN SINGAPORE
THE NATIONAL LIBRARY OF AUSTRALIA
CATALOGUING-IN-PUBLICATION ENTRY:
DUNCAN, KEN
AMERICA WIDE: IN GOD WE TRUST
INCLUDES INDEX
ISBN 0 9577861 2 3.
1. UNITED STATES - PICTORIAL WORKS. I TITLE
917.300222

VISIT THE KEN DUNCAN GALLERY ONLINE
www.kenduncan.com

AMERICA WIDE® AND PANOGRAPHS®
ARE REGISTERED TRADEMARKS OF
KEN DUNCAN AUSTRALIA WIDE HOLDINGS PTY LTD.

Front Cover
Sunrise, Monument Valley, Arizona
Previous Page
Split Rock Lighthouse, Minnesota

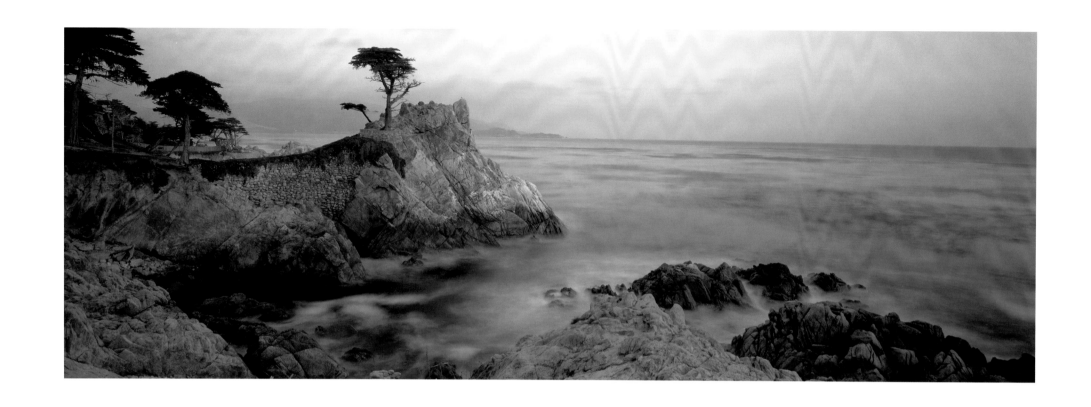

Acknowledgments

To the companies that have supported me in the production of this book, I would like to offer my sincere thanks. They believed in me and caught the vision to help bring this dream to reality. I have worked with these companies during the three years it has taken to shoot and produce this book and I know they are all strongly committed to one of the greatest nations on earth, The United States of America.

Special thanks also to my wife, Pamela, and daughter, Jessica, for all they sacrificed during the shooting of this project, and to my faithful assistant, John Shephard. Thanks also to Kevin Caldwell, Mel & Robyn Gibson, Susan Alcala, Steve Wilson, Dr Robert Schuller, Jillian Richards-Morey, Karla Oliveiro, Peter Morley, Peter Friend, all my fantastic staff and the many others who have helped along the way. God bless you all.

Bank of America

American Airlines

 QANTAS
THE SPIRIT OF AUSTRALIA

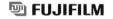 **FUJIFILM**

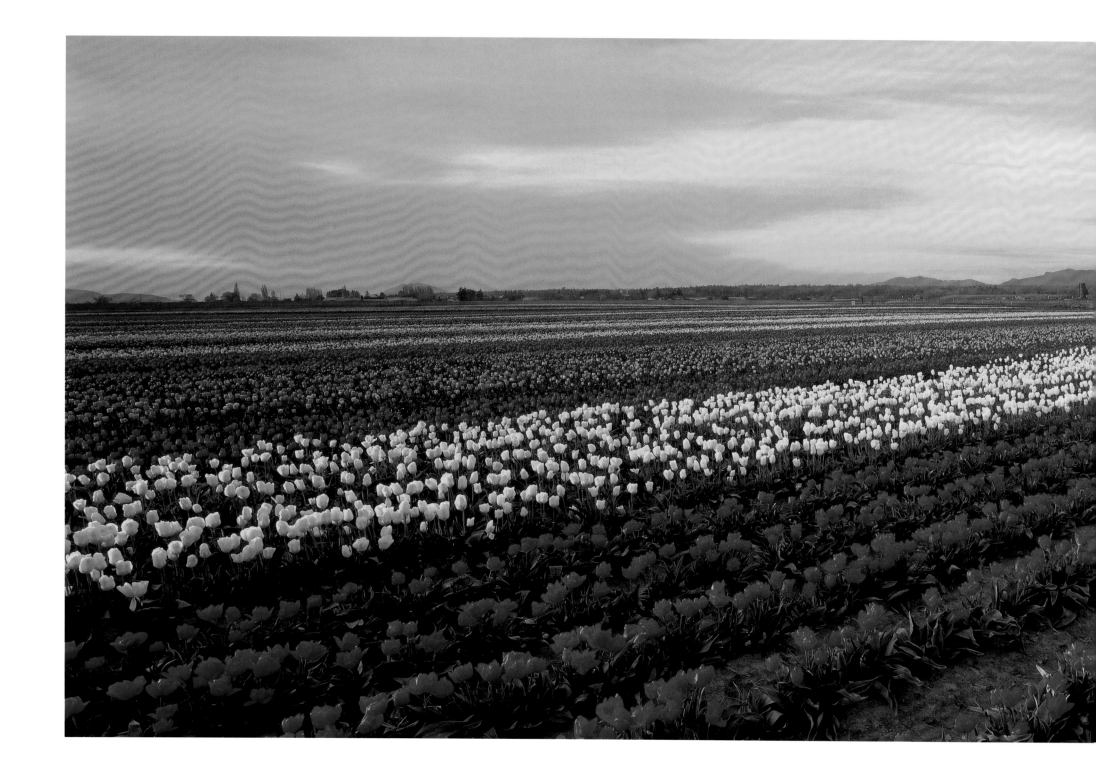

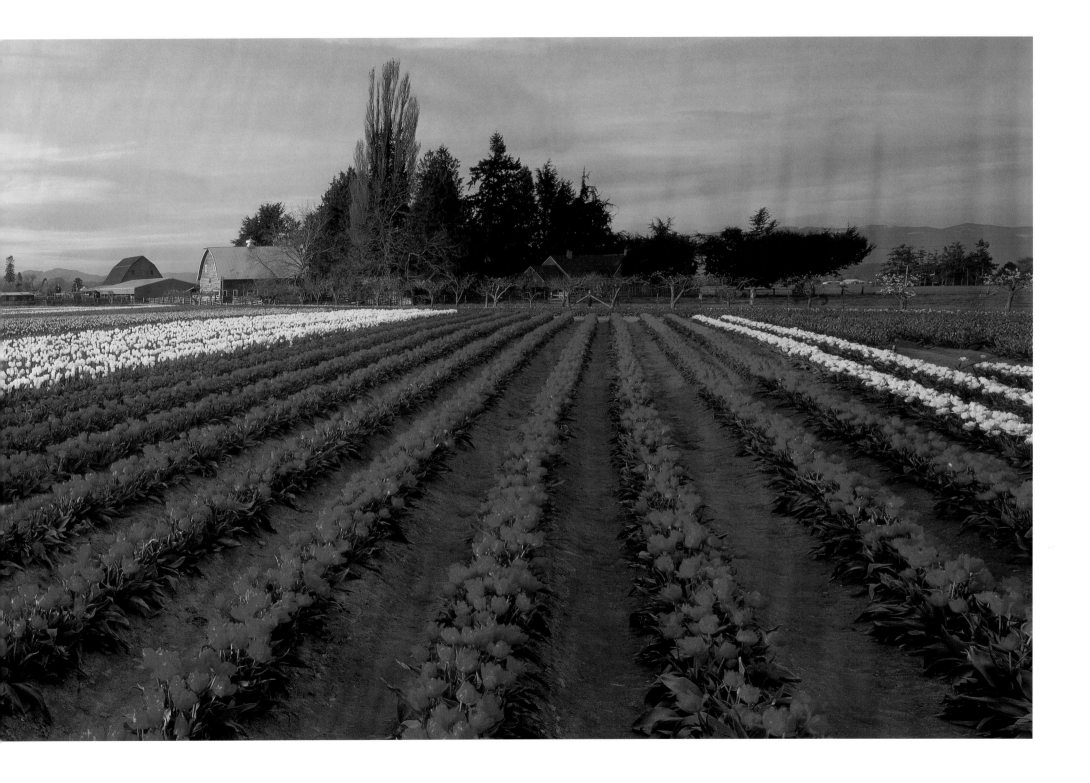

Contents

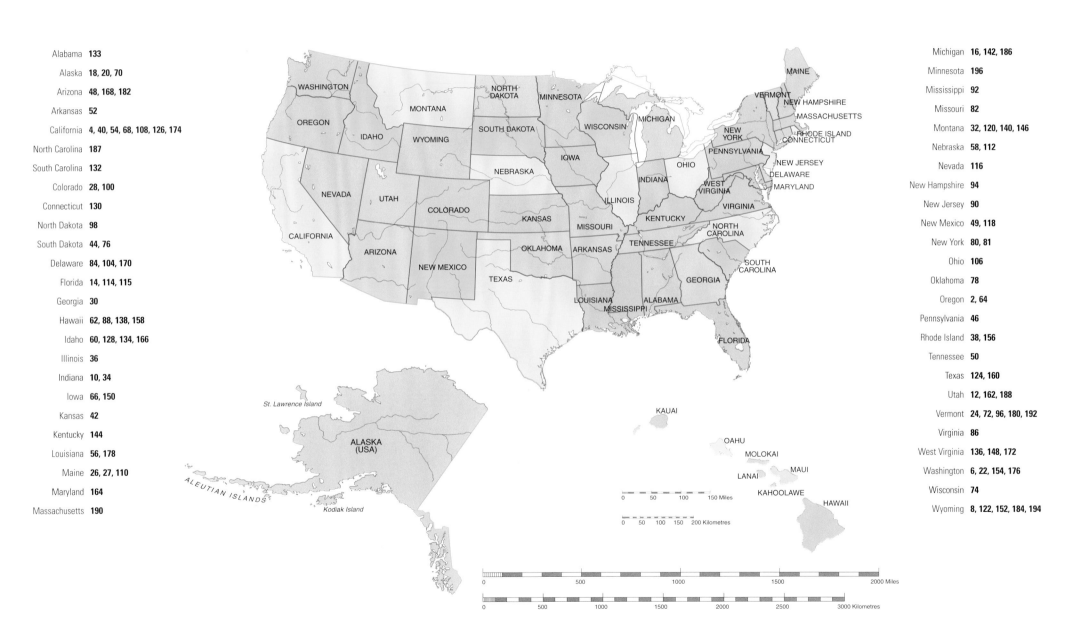

Introduction

n January 1838 in a church in Springfield, Illinois, Abraham Lincoln delivered a speech wherein he warned his nation of approaching danger.

"...At what point shall we expect the approach of danger? By what means shall we fortify against it? Shall we expect some transatlantic military giant to step the ocean, and crush us at a blow? Never! All the armies of Europe, Asia and Africa combined, with all the treasures of the earth (our own excepted) in their military chest; with a Bonaparte for a commander, could not by force, take a drink from the Ohio, or make a track on the Blue Ridge, in a trial of a thousand years.

"At what point then is the approach of danger to be expected? I answer, if it ever reach us, it must spring up amongst us. It cannot come from abroad. If destruction be our lot, we must ourselves be its author and finisher. As a nation of free men, we must live through all time, or die by suicide..."

When I first heard this speech of Abraham Lincoln's narrated, it touched me deeply. I felt as if the enemy of which he spoke was lurking in the shadows here and now, in the form of apathy, hopelessness, fear and division, and that his speech was a warning cry from the past. The United States of America displays the words "In God We Trust" on all its currency. But has the nation's trust in God been exchanged for the ever-changing passions of humanity? The Civil War in America gave testimony to the terrible cost of division. The year 2000 presidential elections showed how divided a nation could be when its hope is placed in mere mortals. A house that is divided can fall. Is there still trust in the Highest power, or do we place our hope in human authority?

The United States of America has been blessed beyond measure. No nation has been granted a more beautiful place to call home. I believe God has blessed this country so that it may be a beacon to others by upholding the belief that liberty, faith, hope and unity can conquer any adversity. The bounty of awesome natural wonders is a constant reminder that there is accountability to a power higher than oneself. My prayer is that the American people never forget where their help comes from – the Maker of heaven and earth.

Our roots provide the strength to withstand the storms of constant change. A hardy breed of men and women pioneered this great nation of America and bequeathed to all a land of hope and possibility – a land of freedom. They have shown the way to overcome obstacles and stand strong in times of adversity. The beginning of this new millennium is a time for all Americans to focus on where they have come from and what the foundation for the future will be.

I have journeyed through this land on a three-year pilgrimage endeavoring to capture the spirit of America. My aim is to show the awesome power of God through the beauty of His creation, for I believe it is the foundation of trust in God that has made America such a blessed nation. I hope the images in this book touch your heart.

Ken Duncan

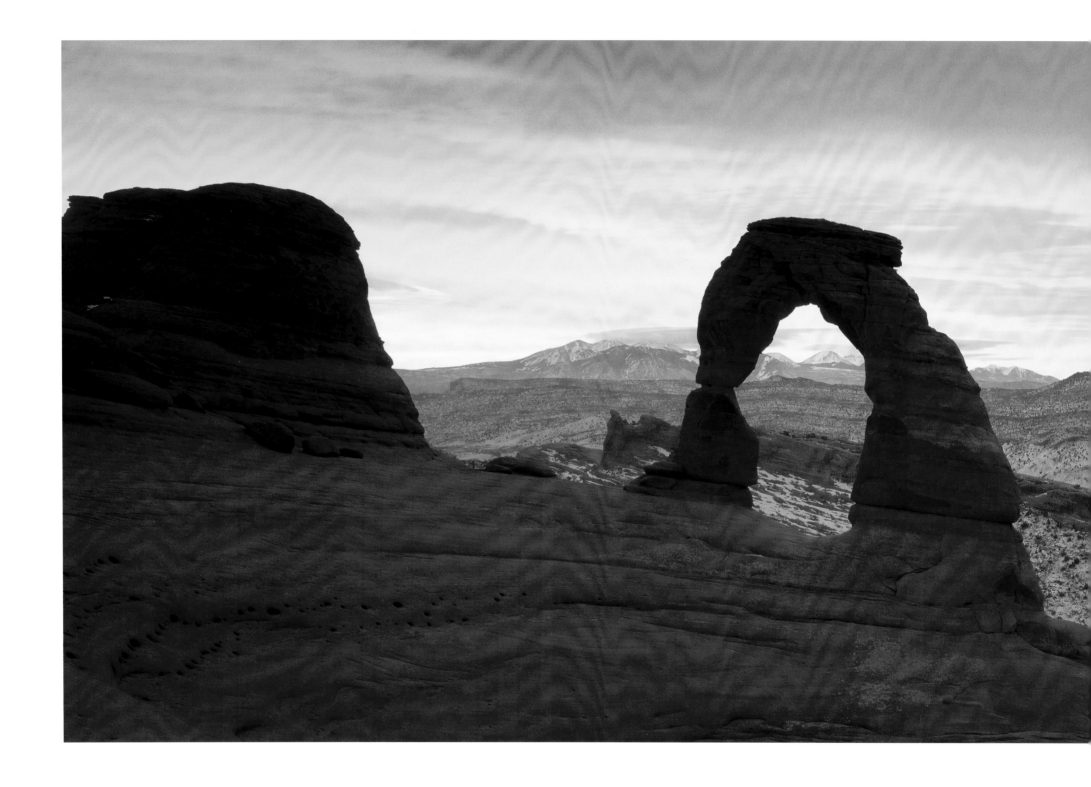

Sunrise at Delicate Arch, Utah

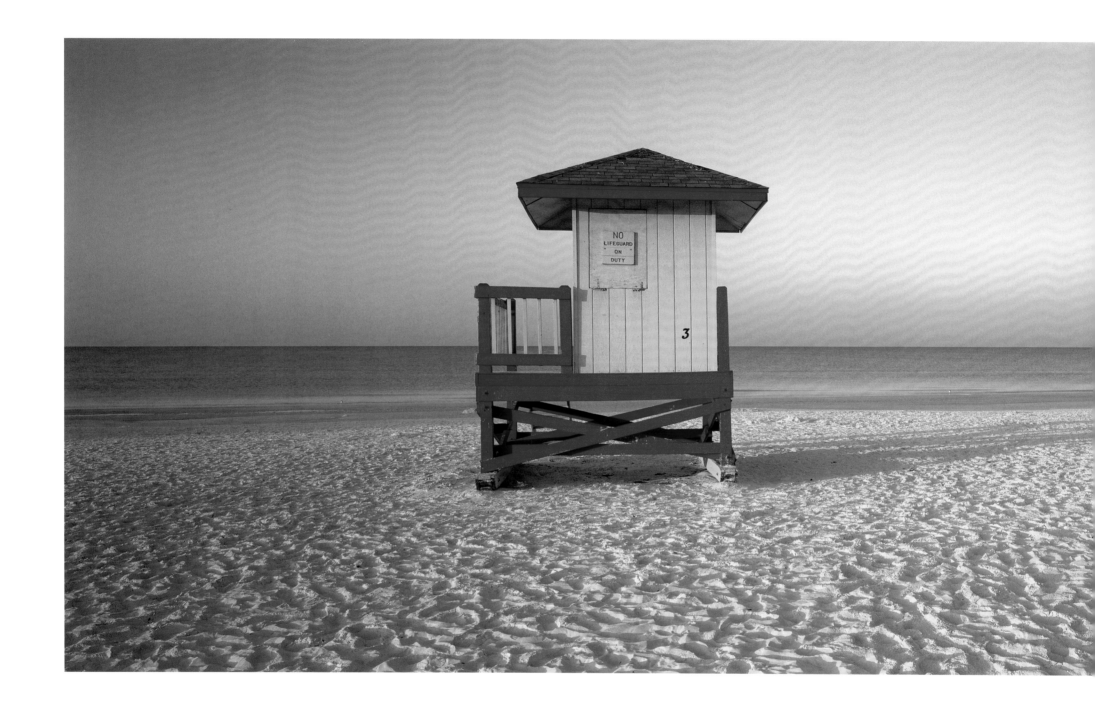

Siesta Beach, Sarasota, Florida

Siesta Beach – how appropriate the name. Imagine lying back on a big deck-chair, sunglasses in place, icy cold drink at hand, ready to drift off into dream time. Never get so busy making a living that you forget to make a life!

This is the land of Longfellow's "Hiawatha".
Long before white man set eyes on this river, the
abundance of fish in its waters and animals along its
shores attracted the Ojibwa people who camped,
farmed, fished and trapped along its banks. The air is
still charged with life and the thunderous roar of the
falls clears any troubling thoughts. All is well and the
river of life flows on.

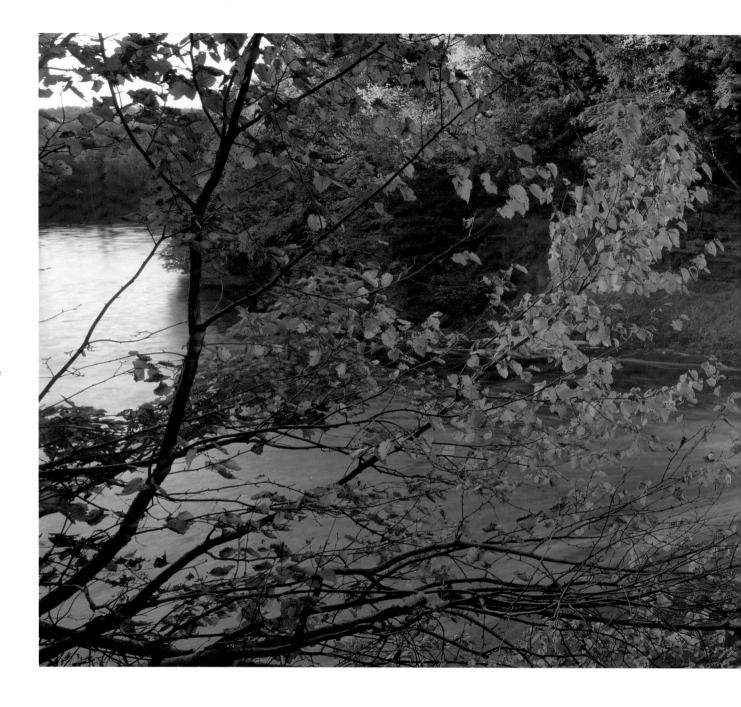

Upper Tahquamenon Falls, Michigan

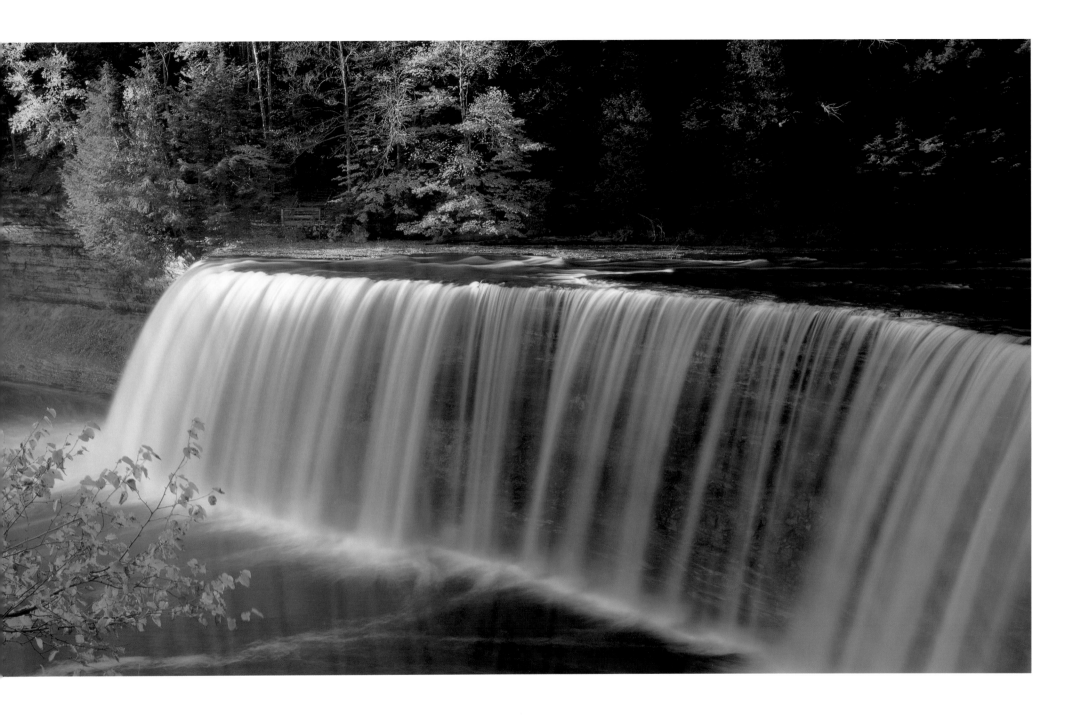

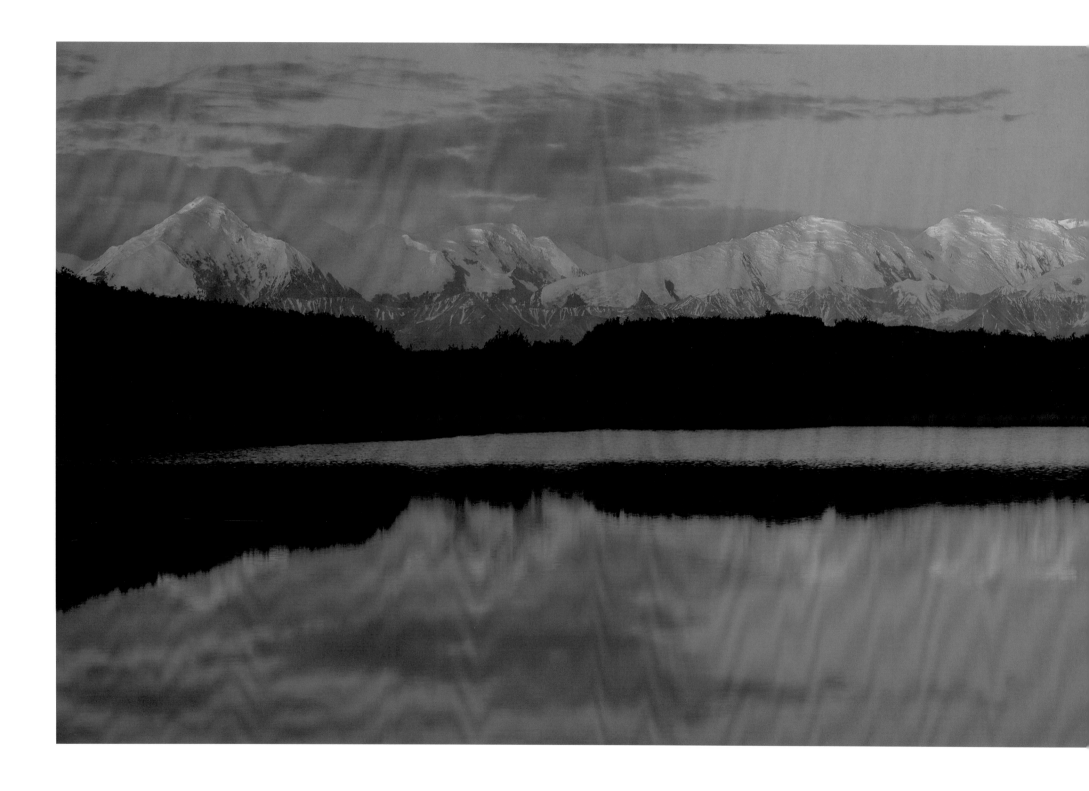

Moonlit Majesty, Denali National Park, Alaska

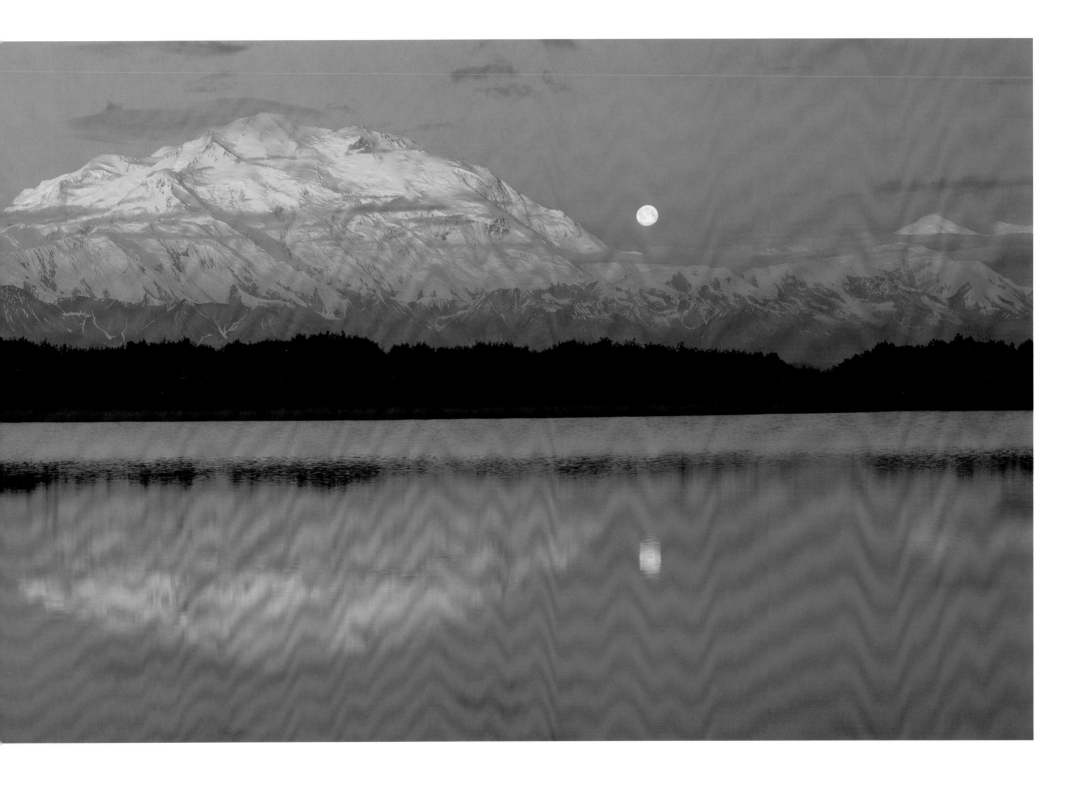

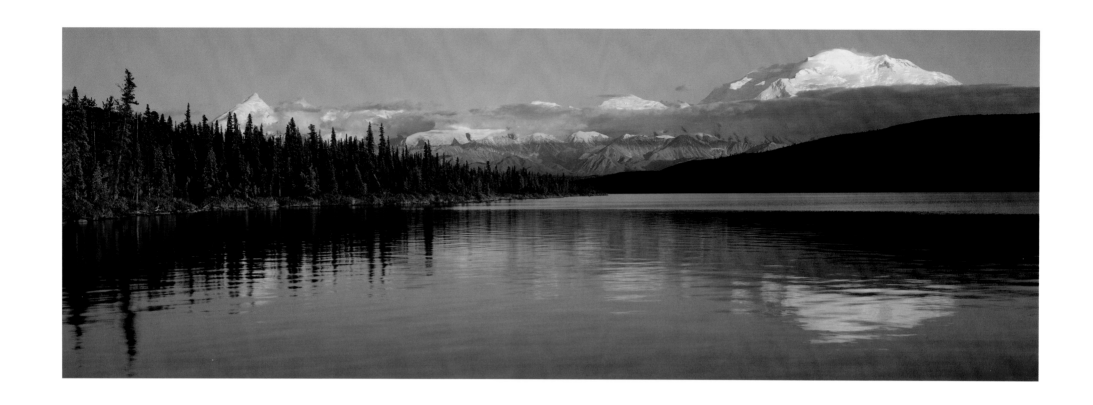

Overcoming Fear

When I'm traveling in America, people often pick up on my accent and tell me they would love to come to Australia but they believe we have too many dangerous animals. It's true we do have a few nasties, but they rarely bother you unless you do something silly. For example, if you swim in areas inhabited by saltwater crocodiles, then you could have a problem on your hands – or on any other part of your anatomy those primeval monsters take a liking to! But if you take reasonable care and show a little respect around crocodiles, you're fine. Crocodiles don't venture far from water, they can only run fast in a straight line on land, and they don't climb trees. Not so the American Grizzly Bear! That animal is one keen, mean fighting machine – not only can he run faster than a horse, but he can also swim and climb trees. It seems the only thing he can't do is fly, and that's not much comfort, because neither can I!

I went with a friend into Denali National Park in Alaska to photograph Mt. McKinley. In preparation for the trip, I tried to find out as much as possible about mountain biking, backpacking and camping out in bear country and how to deal with any other hazards we might encounter. All the people I spoke to kept drawing my attention to one thing – Grizzly Bears! One well-meaning adviser told me that if they run at you, they might simply be testing to see if you run. So, whatever you do, you shouldn't run. (Apparently bears like to play chicken!) He went on to say that if the bear keeps running, you should curl up in a ball and play dead. If he keeps attacking, then you must fight back. What a fine thought – hand to hand combat with a grizzly. I know who I'd put my money on! On and on went the horror stories about people being mauled by bears – even dragged from their tents – and many people suggested we should carry a gun.

It's amazing how fear can creep in and try to stop you fulfilling your destiny. Fear can be healthy in certain situations – like preparing us for fight or flight – but that nagging worry of 'What if a bear comes' can be a total waste of time and energy. Sure, it's good to have knowledge – I have learned that preparation helps avoid desperation - but in the end the journey must go on and it doesn't make sense to let fear put fences around our dreams. We must trust in something bigger or we will always be living in the smallness of our emotions. I told our informant we would put our trust in God and He would look after us. In the end we settled for bear bells and decided we'd make as much noise as possible on our way through the park so as not to surprise a dozing grizzly.

Although we had no problems with bears, we did meet up with another of Denali National Park's infamous residents. We had just finished shooting a full moon at sunrise over Wonder Lake. (Wonder is the perfect name for this lake, as the beauty of God's creation touched me deeply and it is an experience I will always carry in my heart.) We had made our way back to the bikes and I was just strapping the tripod onto the carrier rack, when I saw my friend – his eyes as big as saucepans – looking over towards another small lake and mumbling something. He was making weird hand signals, sticking his thumbs in his ears and wiggling his fingers. Then, in exasperation, he just pointed to the lake. I looked across and got his message straight away. "Moose!" I yelled. "Yes," he shouted in reply, "and it's huge!" He jumped onto his bike and took off as the moose came thundering towards us. With one eye on the advancing moose, I secured the tripod to my bike rack and then started pedaling to catch my friend. Thanks to a bit of healthy fear, I pedaled like I've never done before – my legs were going like pistons – and I didn't look back again until I reached the top of the hill. Fortunately for us, the moose stopped halfway up the hill. People told us later that moose can be more dangerous than Grizzly Bears and proceeded to relate a string of horrific moose tales.

To me, life is a lot like that. We can spend an enormous amount of time worrying about the bears that may come and trying to anticipate every twist of fate. But often, in the end, it's not the bear that comes at all – it's the giant moose!

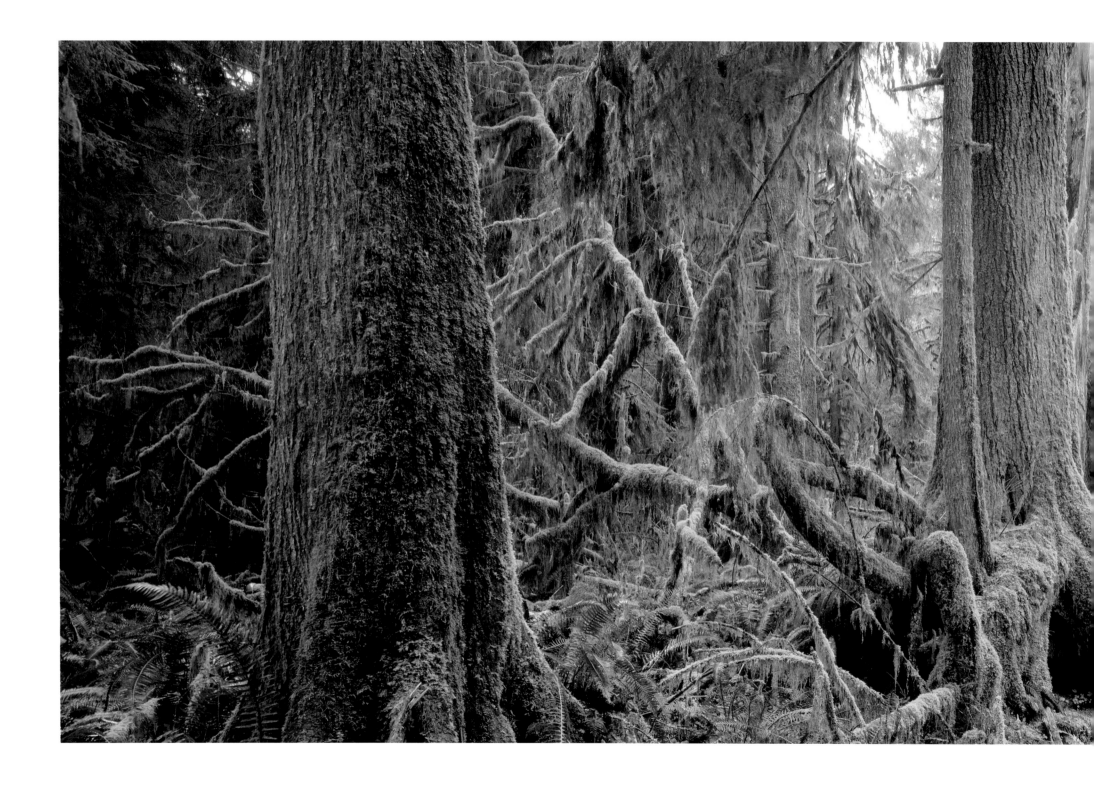

Hoh Rain Forest, Olympic National Park, Washington

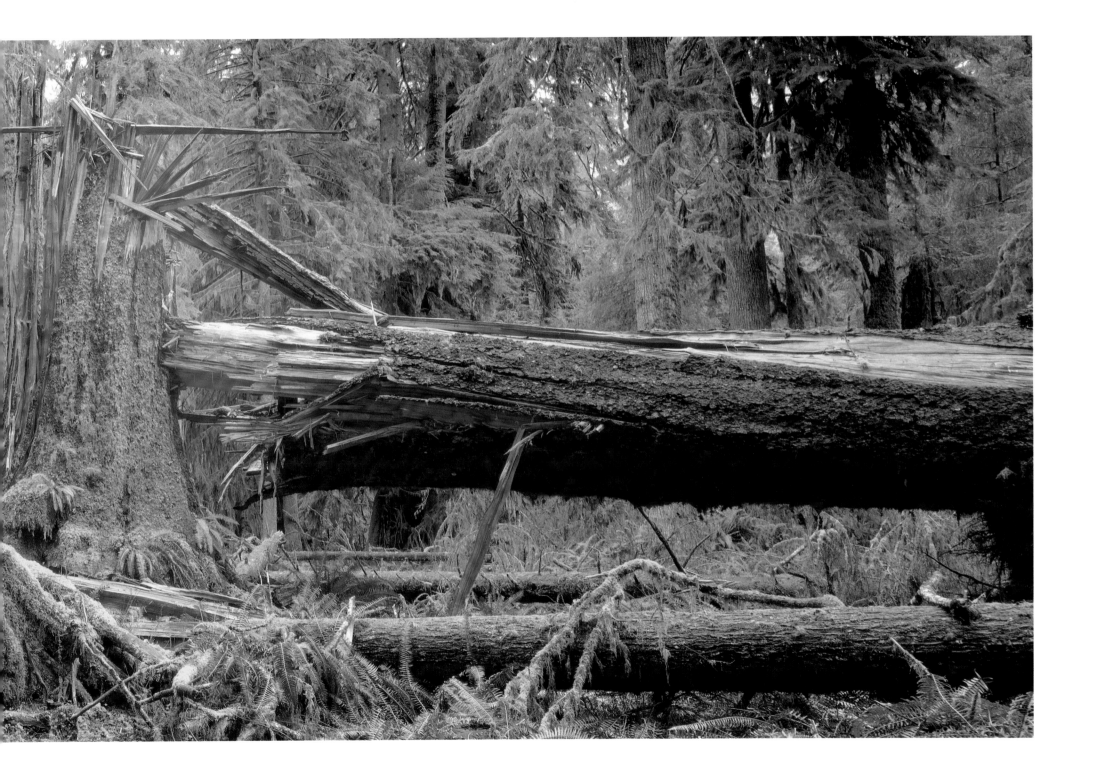

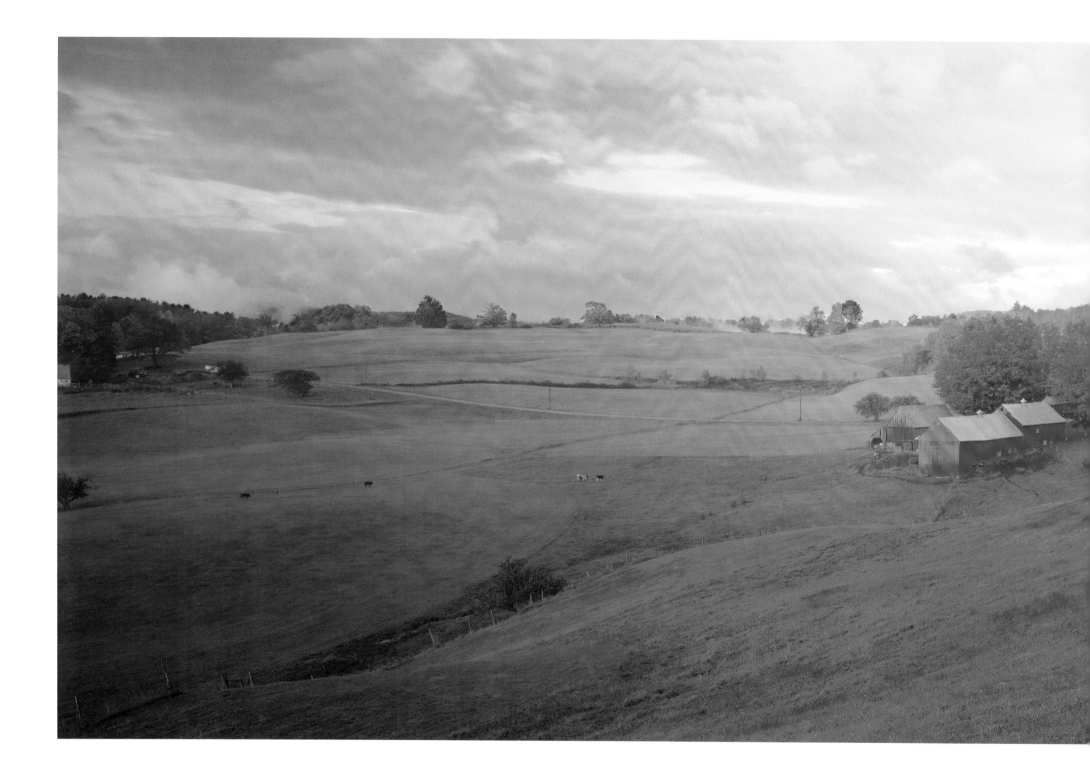

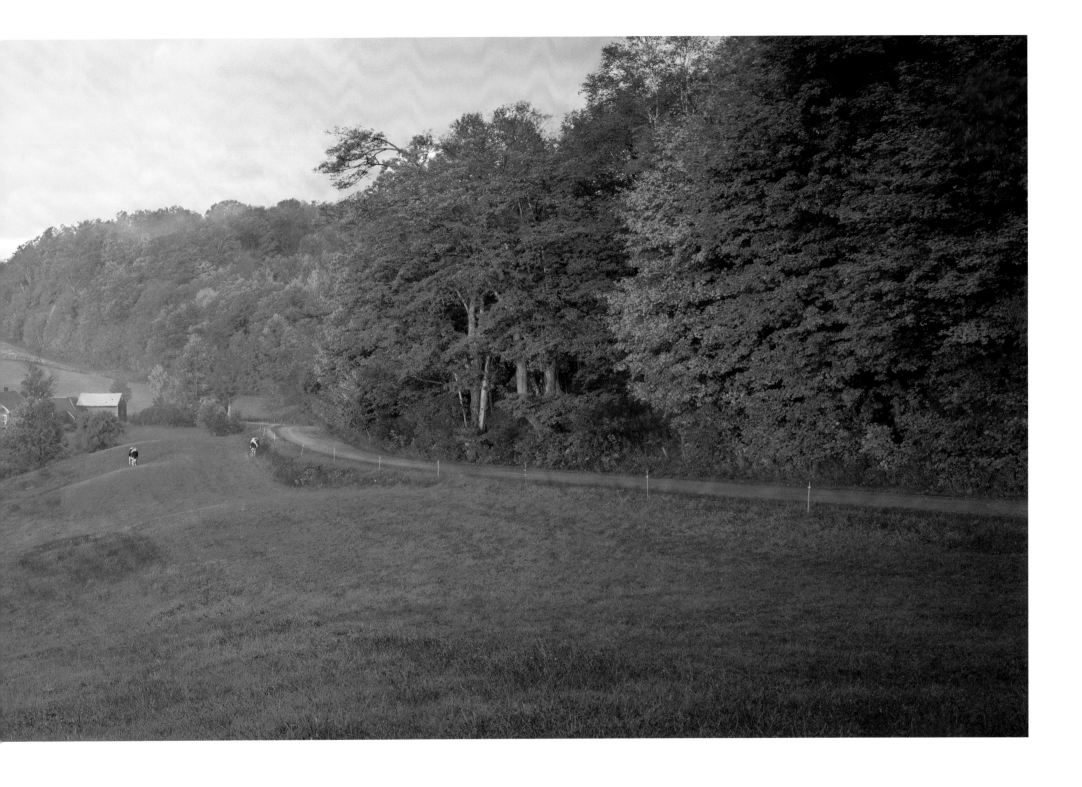

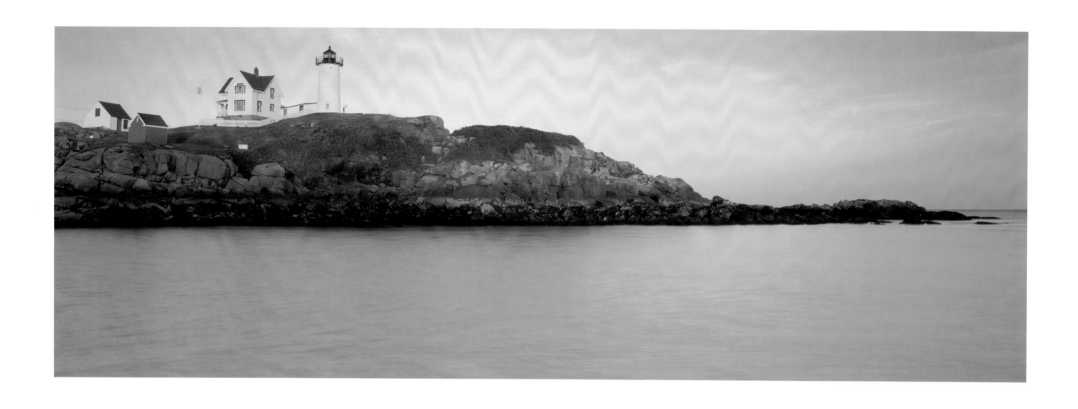

Cape Neddick Lighthouse, Maine

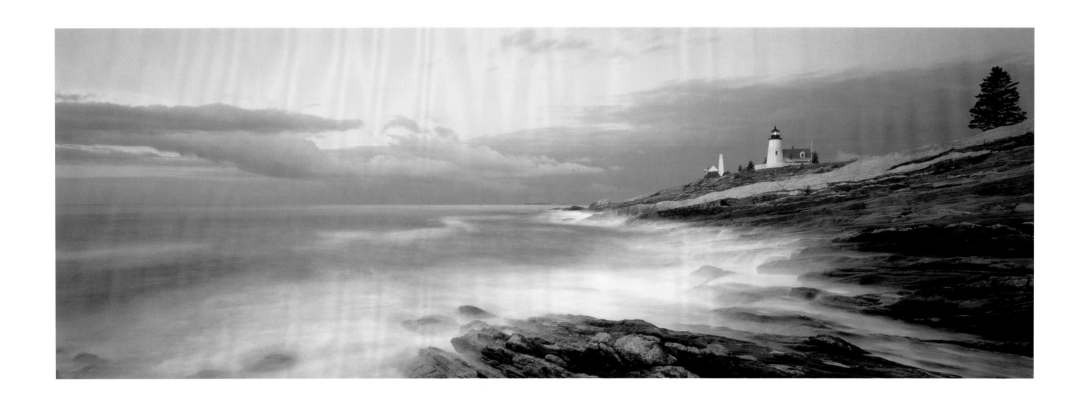

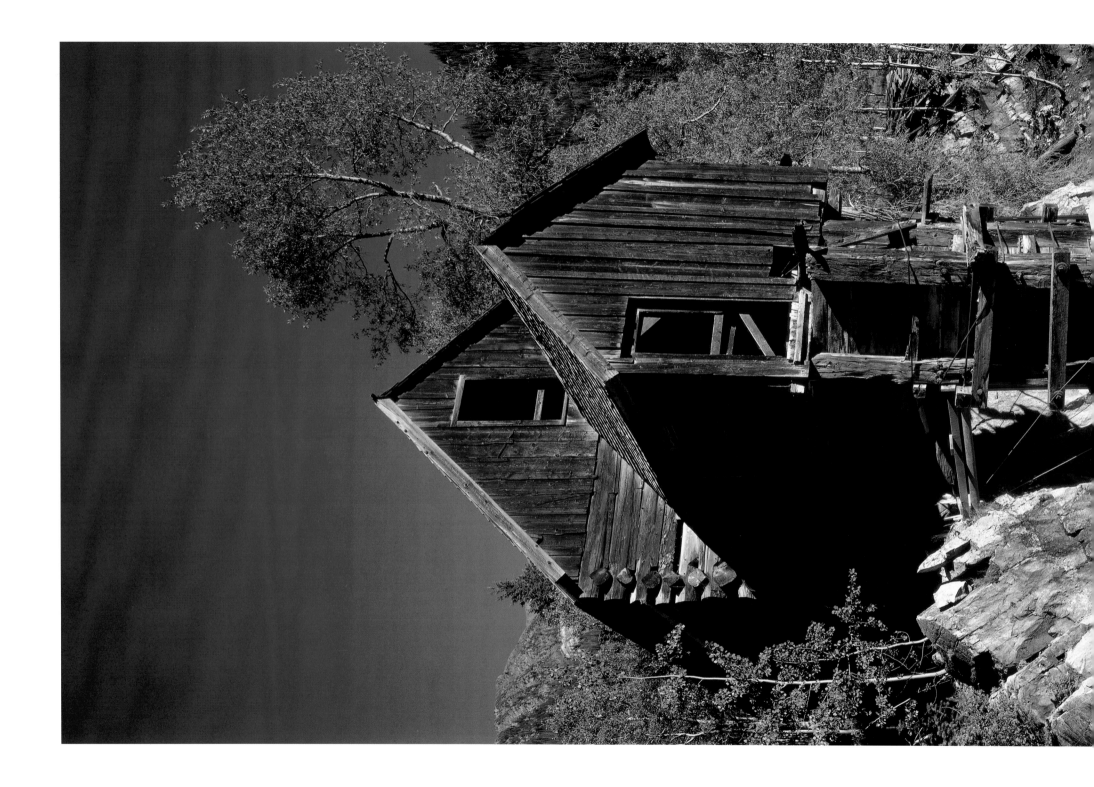

Crystal Mill, Colorado

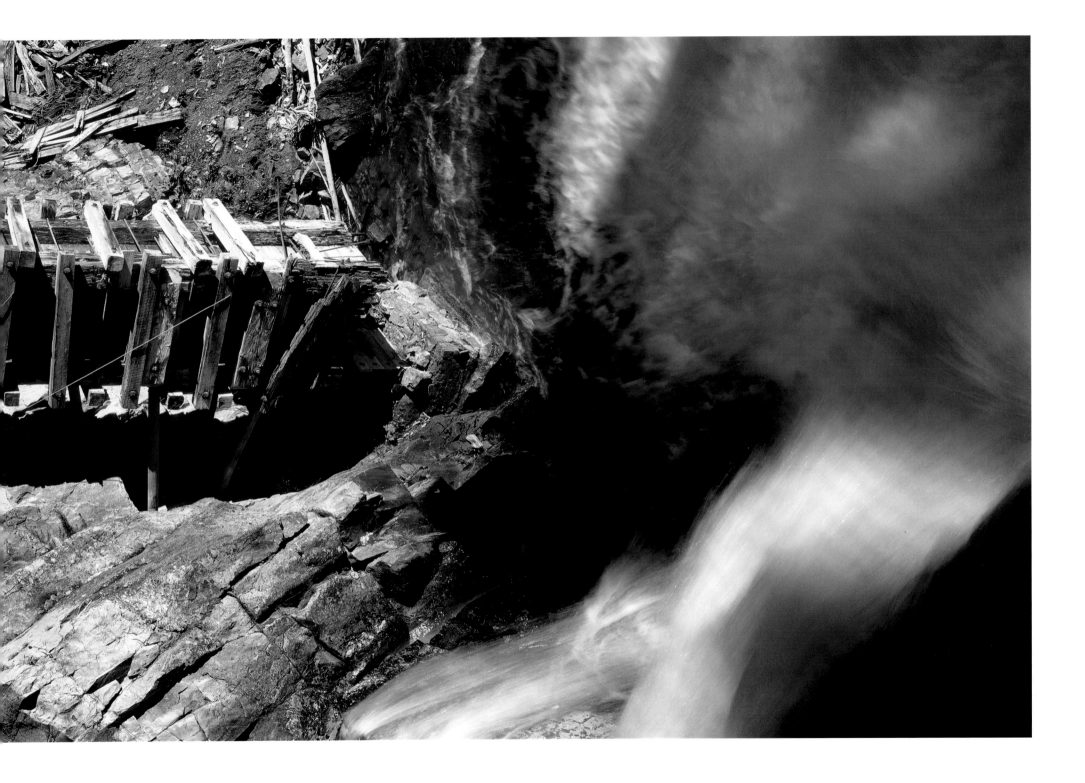

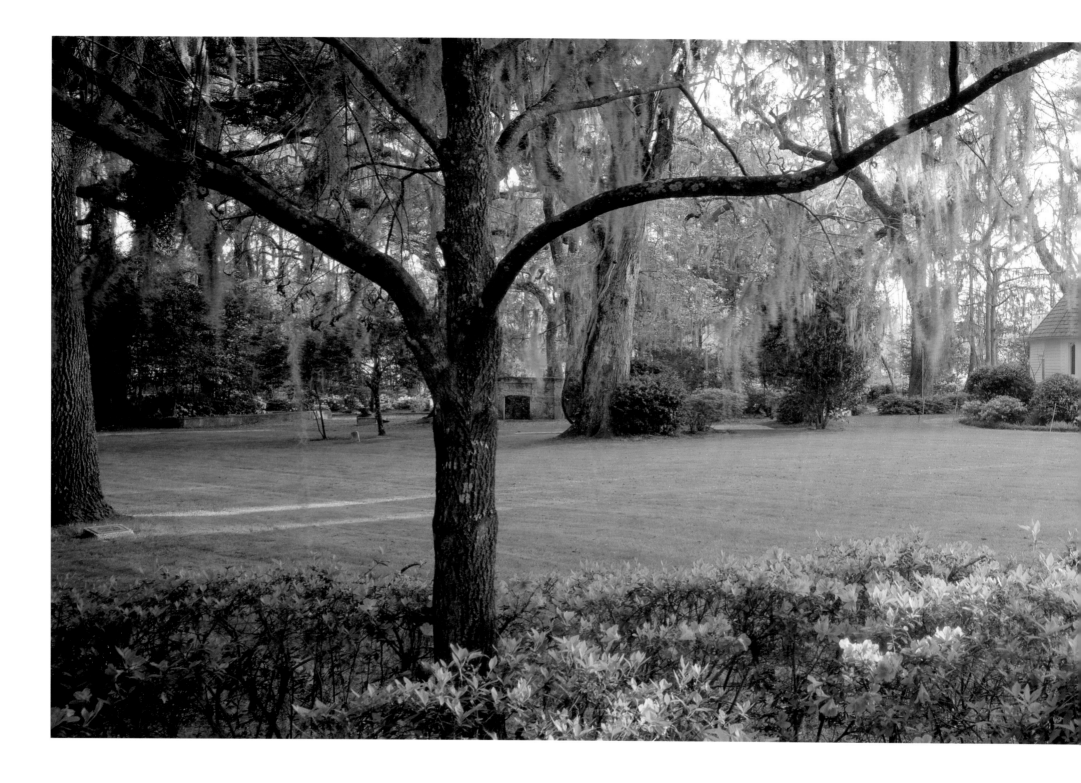

Christ Church, Saint Simons Island, Georgia

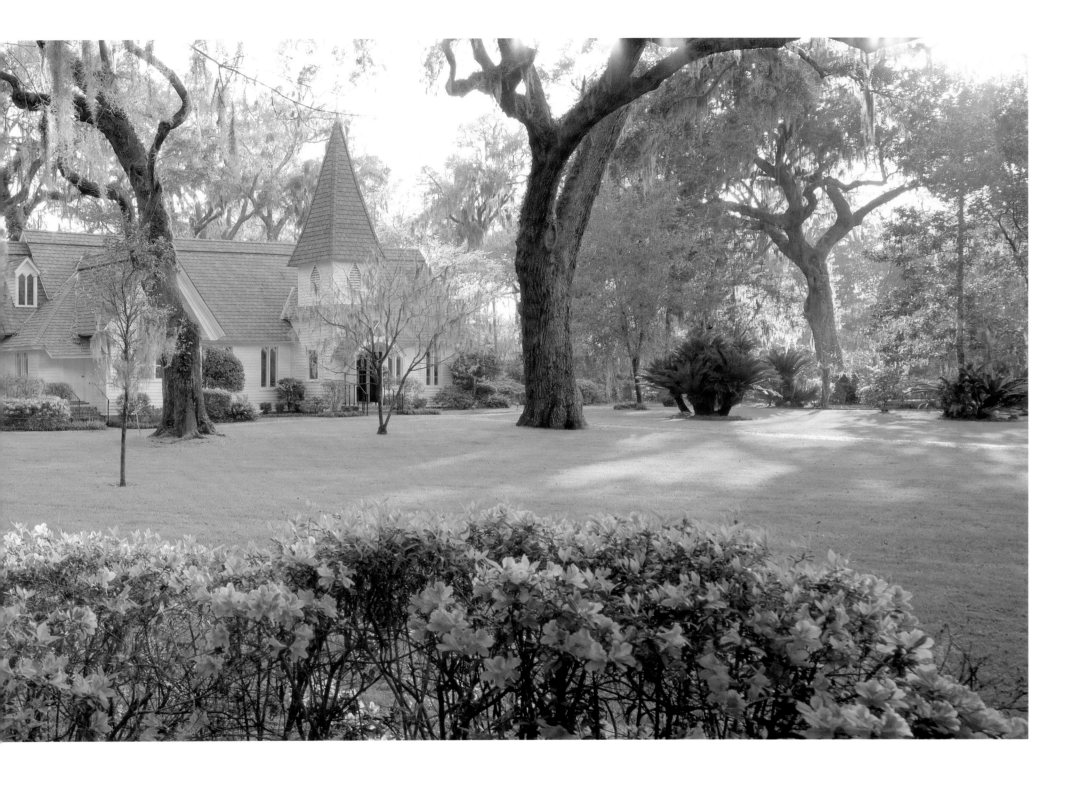

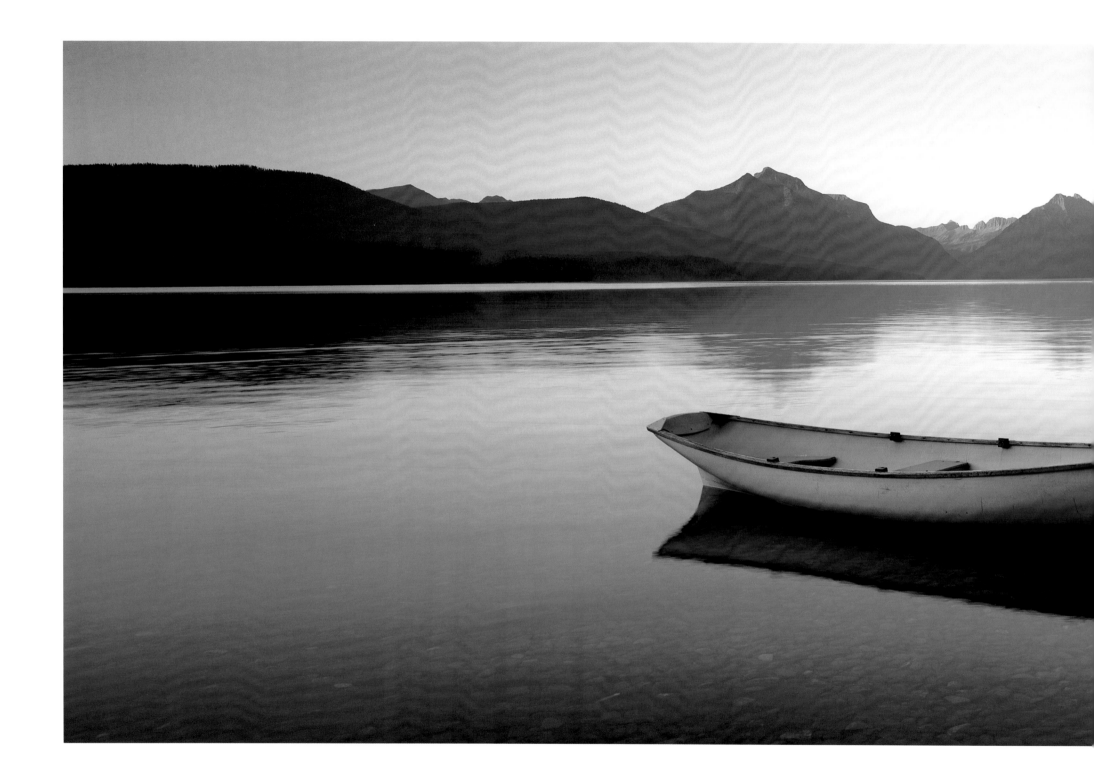

Lake McDonald, Glacier National Park, Montana

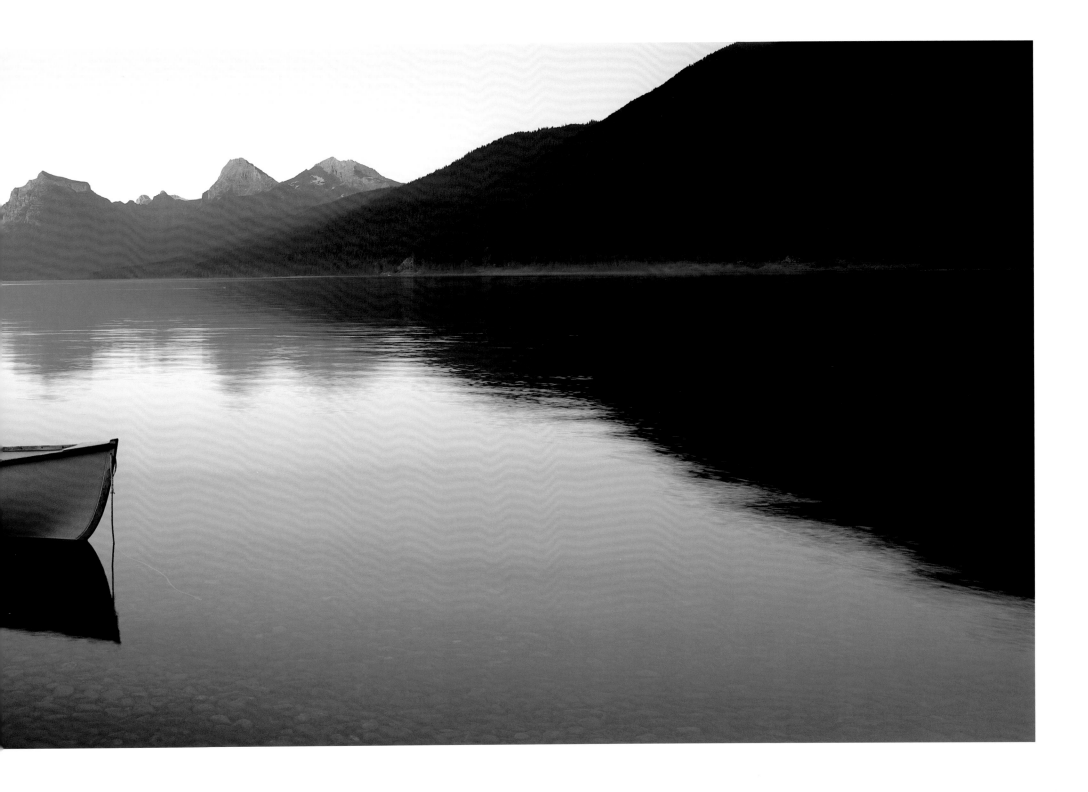

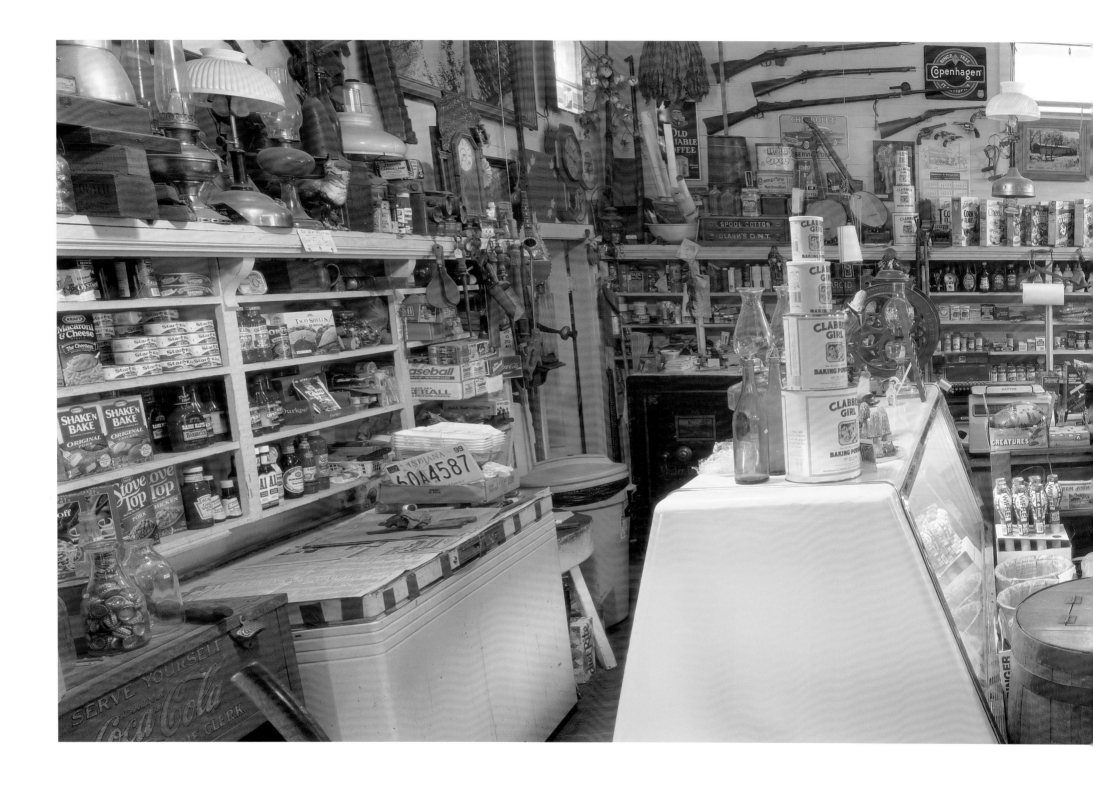

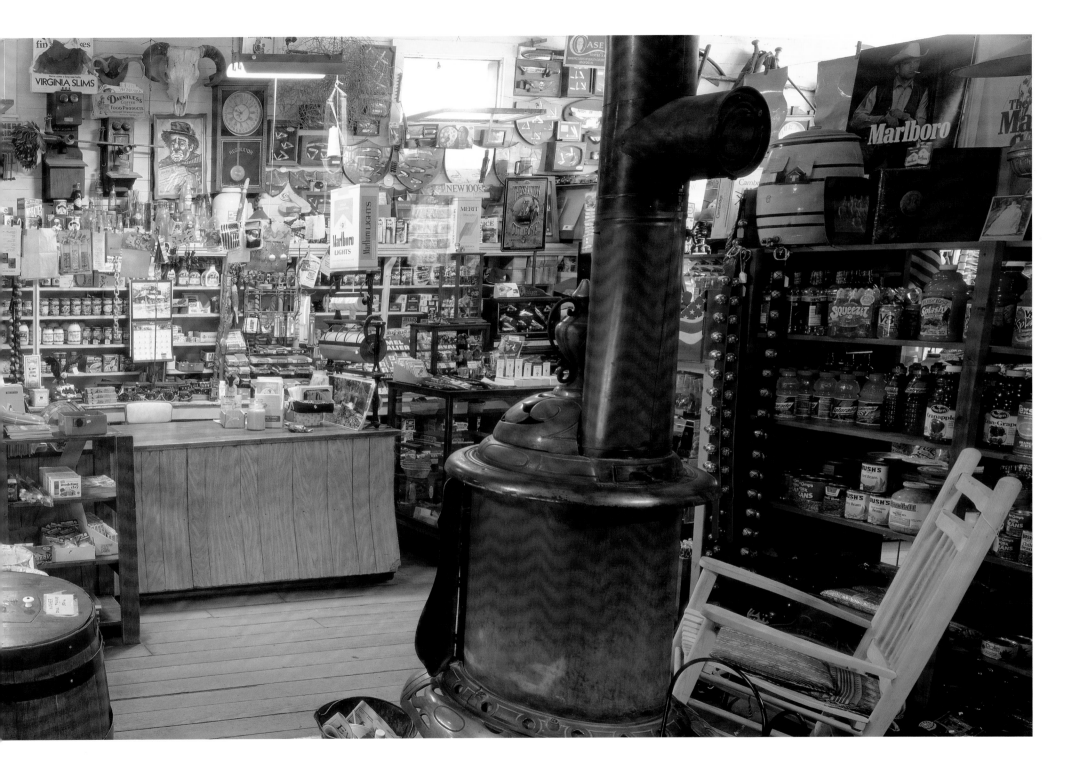

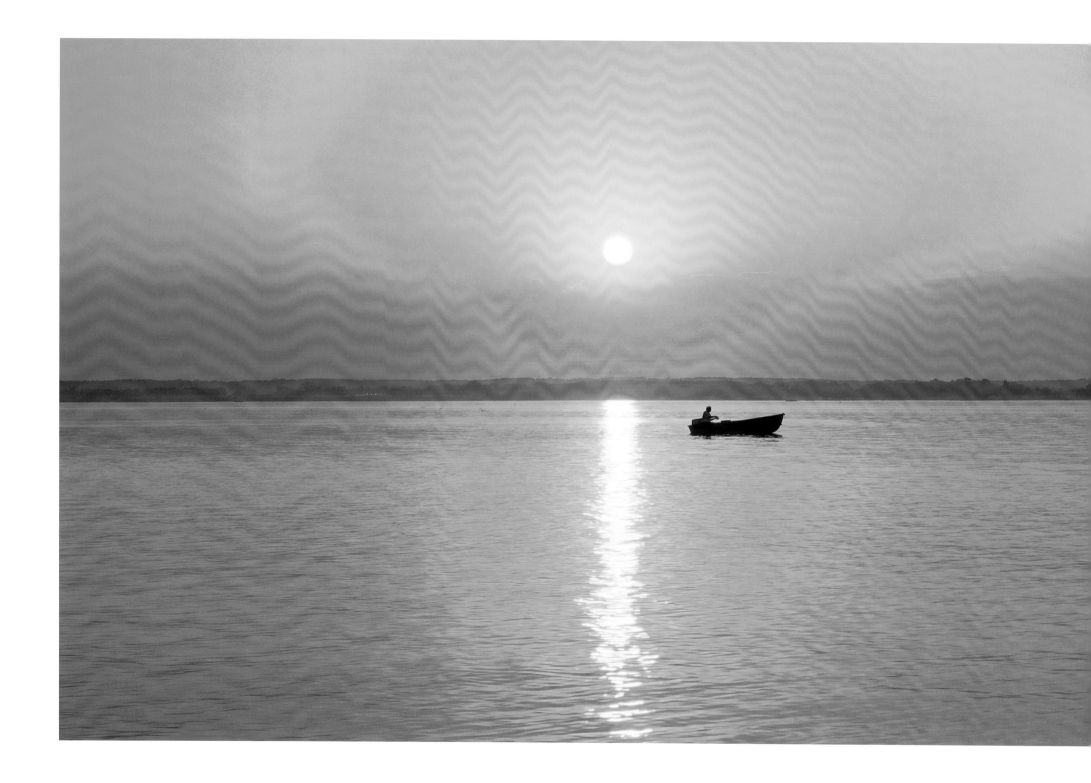

Mississippi River, Nauvoo, Illinois

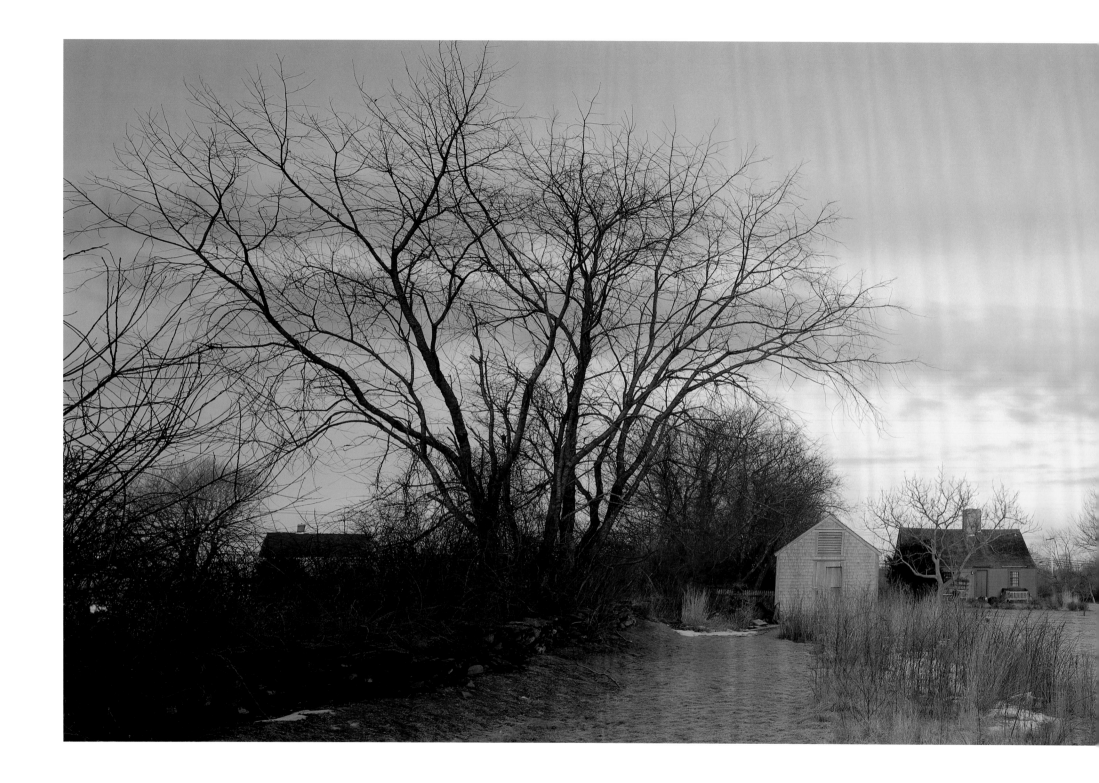

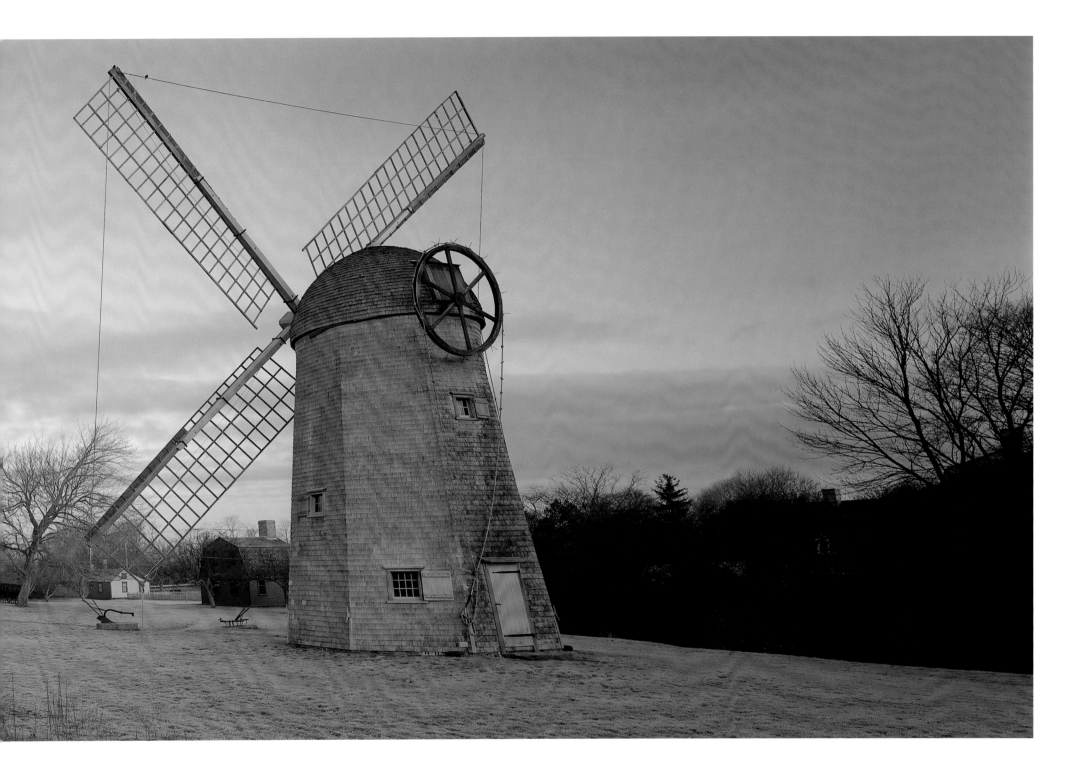

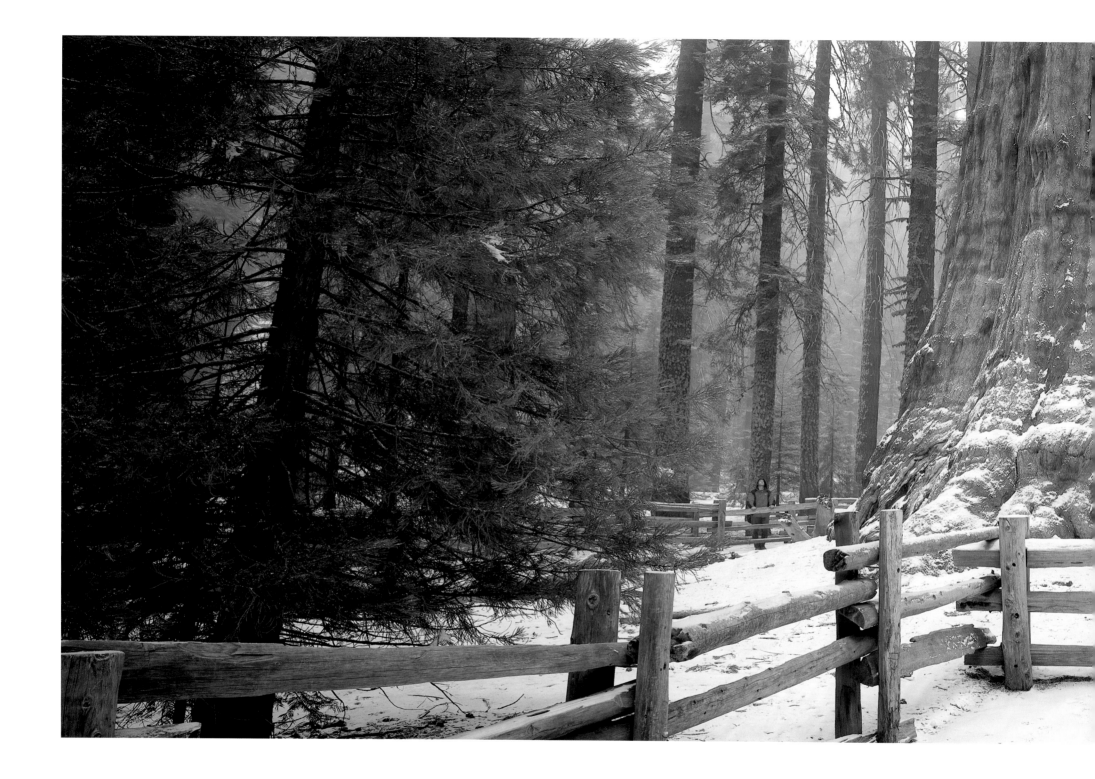

General Sherman Tree, Sequoia National Park, California

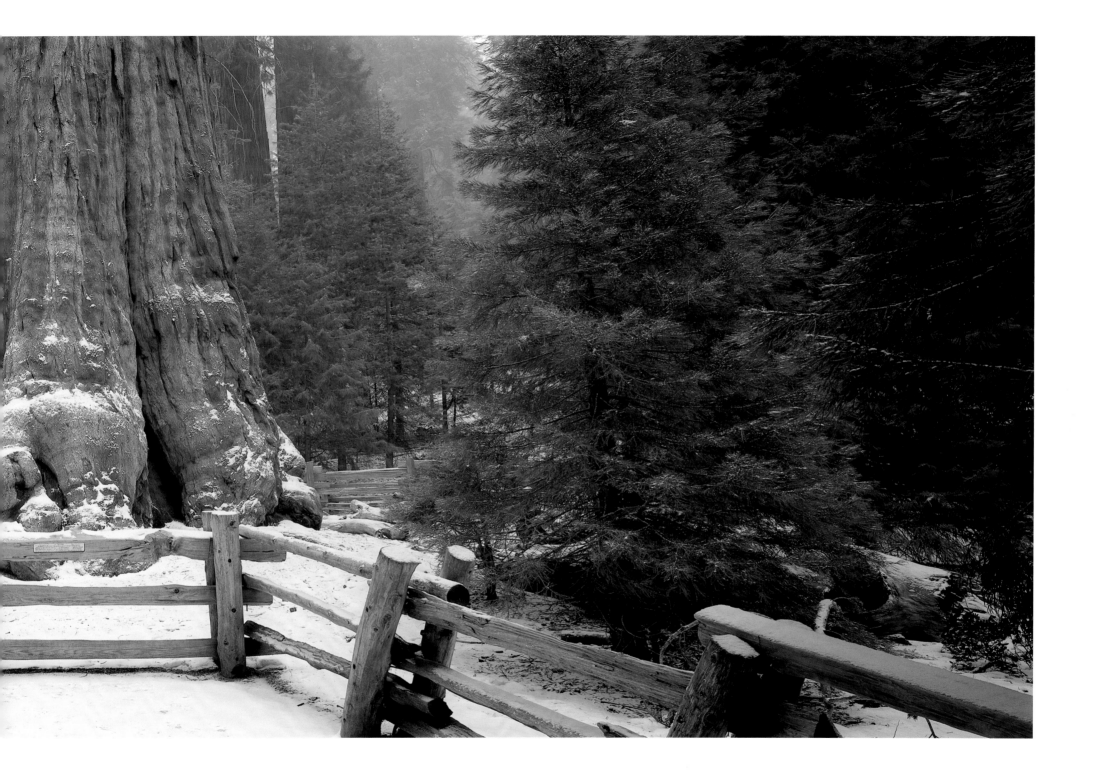

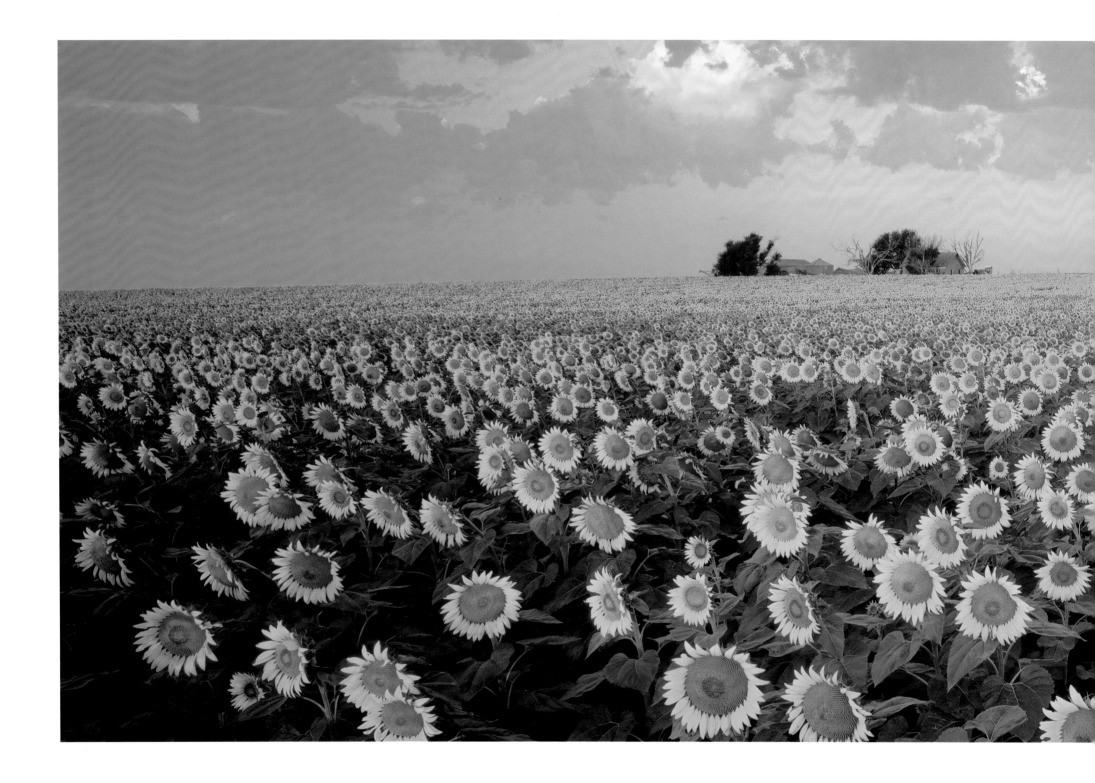

Sunflower Sunrise, Goodland, Kansas

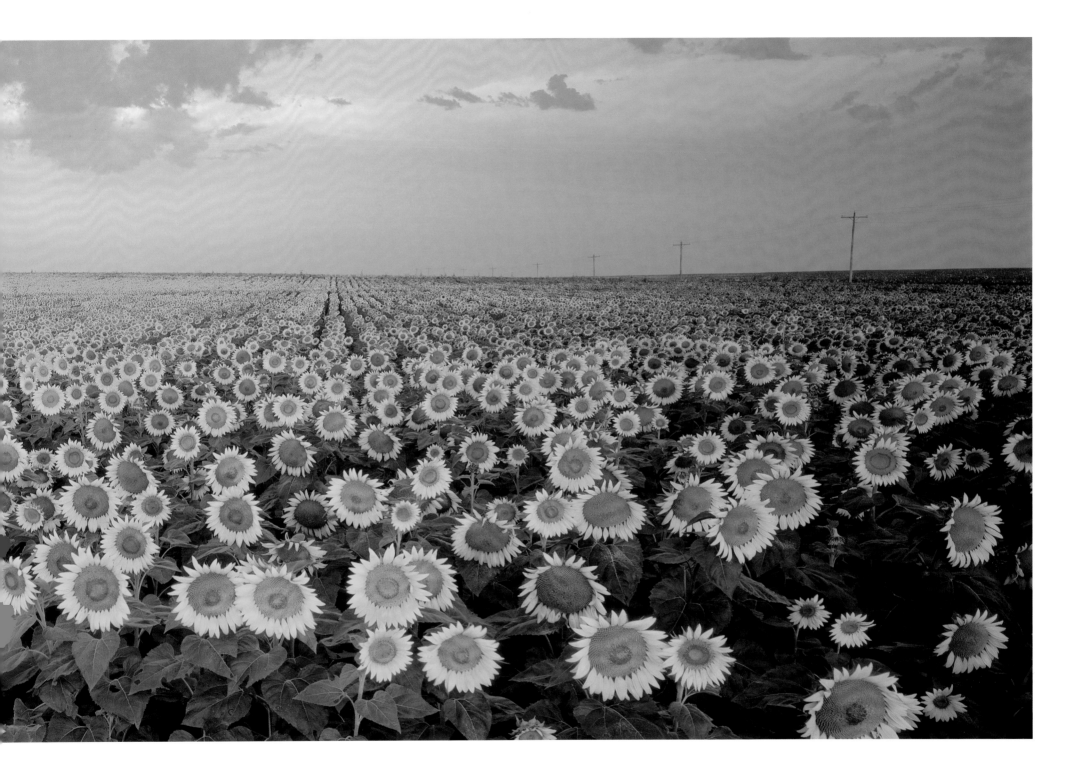

Four of America's most influential Presidents – Washington, Jefferson, Roosevelt and Lincoln – are immortalized as eternal watchmen over the land they once served. The grandeur of this monument is hard to appreciate until you stand in its presence, dwarfed by its magnitude, and ponder the mighty accomplishments of these giants of history.

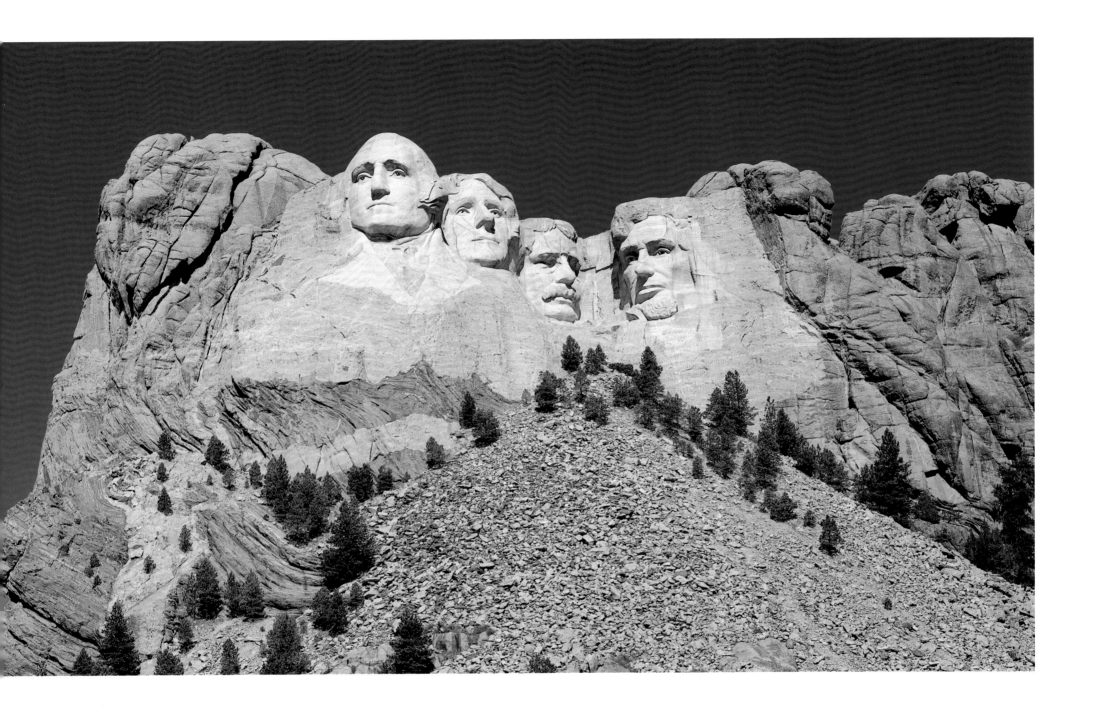

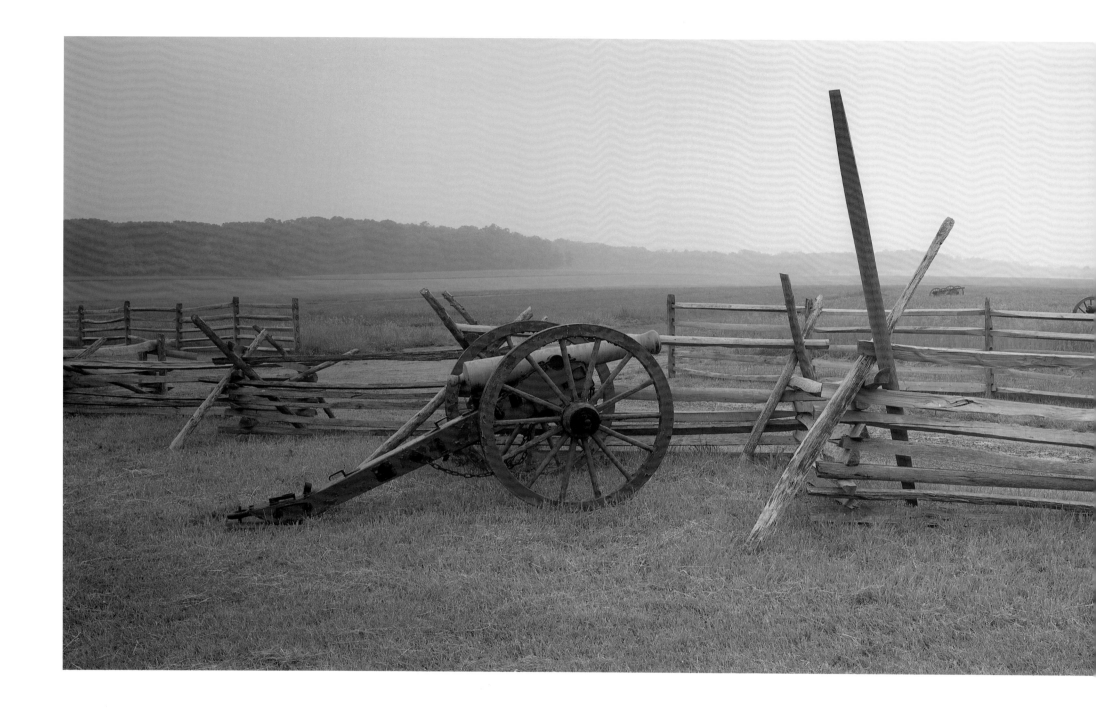

Pickett's Charge Battlefield, Gettysburg, Pennsylvania

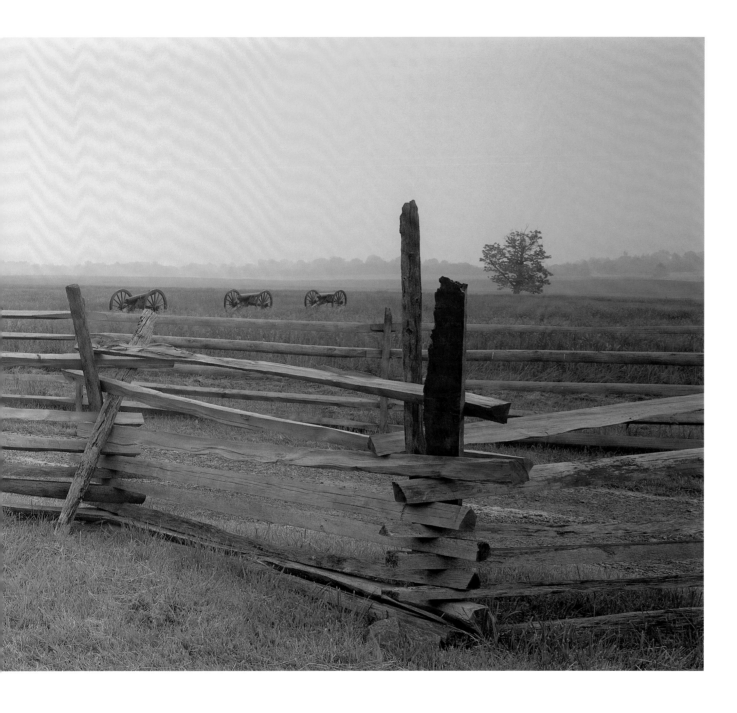

On July 3rd 1863, some 12,000 Confederate soldiers advanced across these open fields towards the Federal center in an attack known as Pickett's Charge. More than 5,000 soldiers fell in one hour. An eerie presence still lingers as the sun rises over the fields, and cries of anguish from the past seem to echo in the haze. Oh, the unquenchable thirst of war, and what terrible cost when brother fights brother.

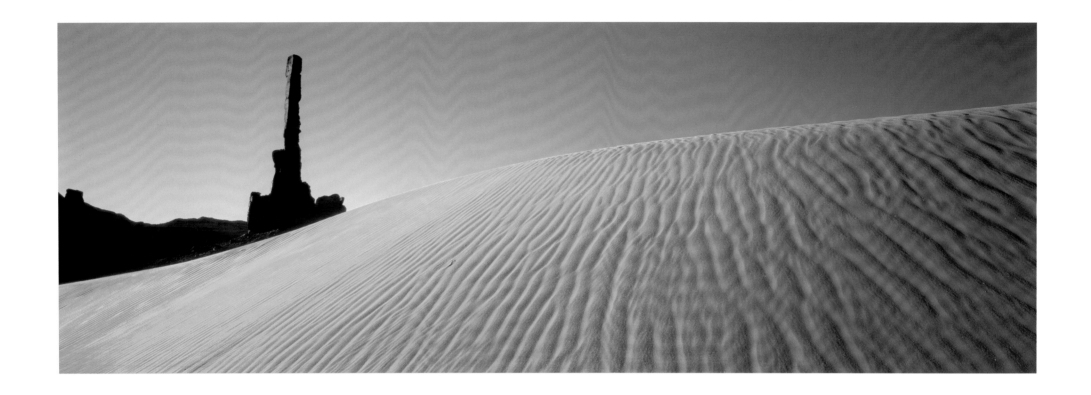

Ice crystals sparkle on red sand as early morning
sunlight begins to thaw the evening chill. The Totem
Pole points its finger towards the heavens, greeting
the sunshine of a new day.

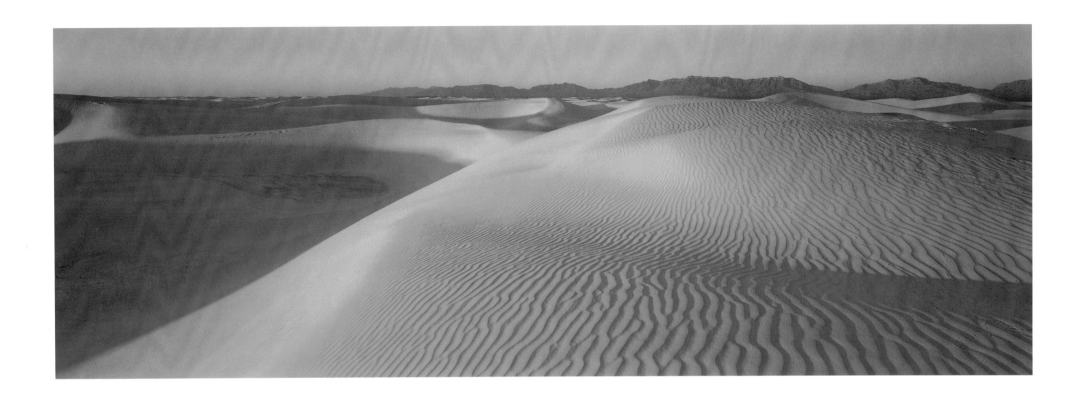

To escape the imprint of humanity, I walked miles into the heart of the dunes. Adrift in a sea of sand, like a small boat bobbing on the crest of a wave, I was humbled by the sheer magnitude of creation.

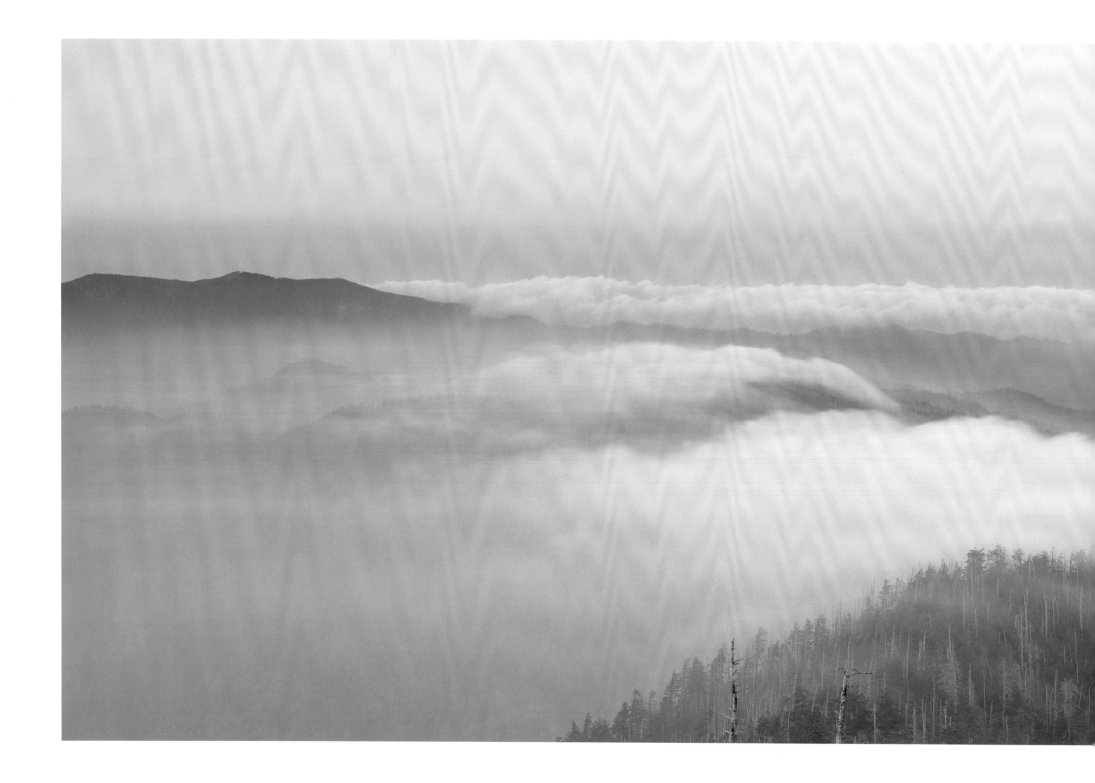

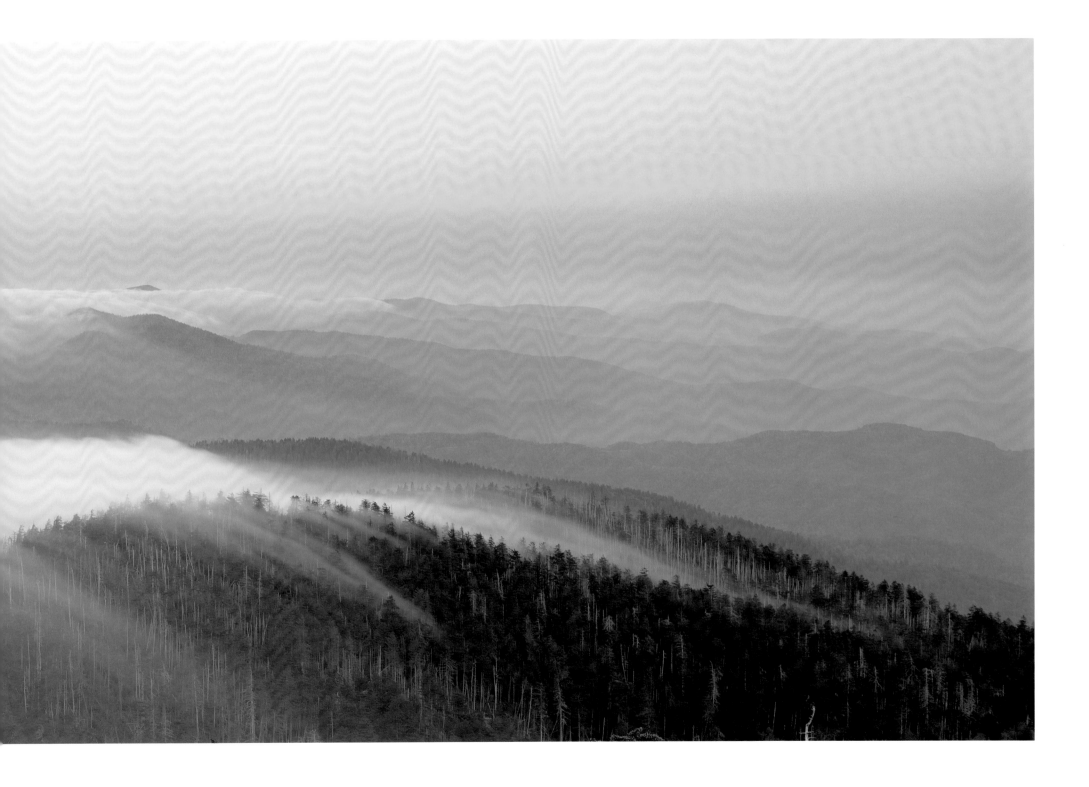

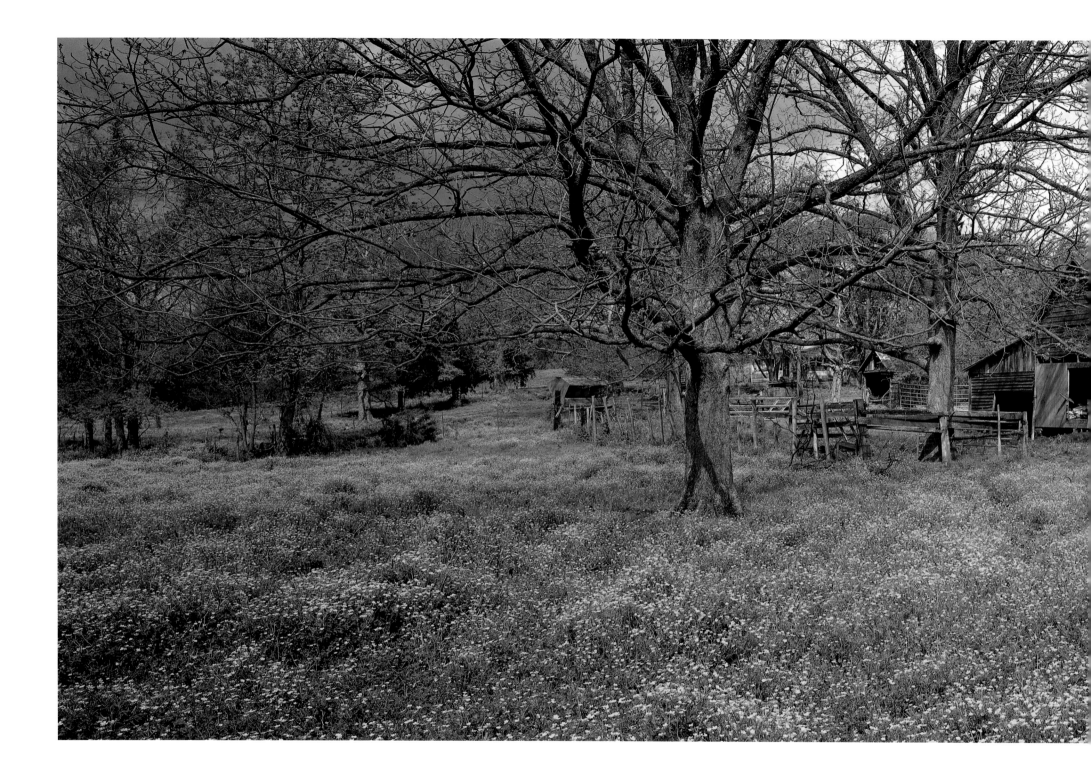

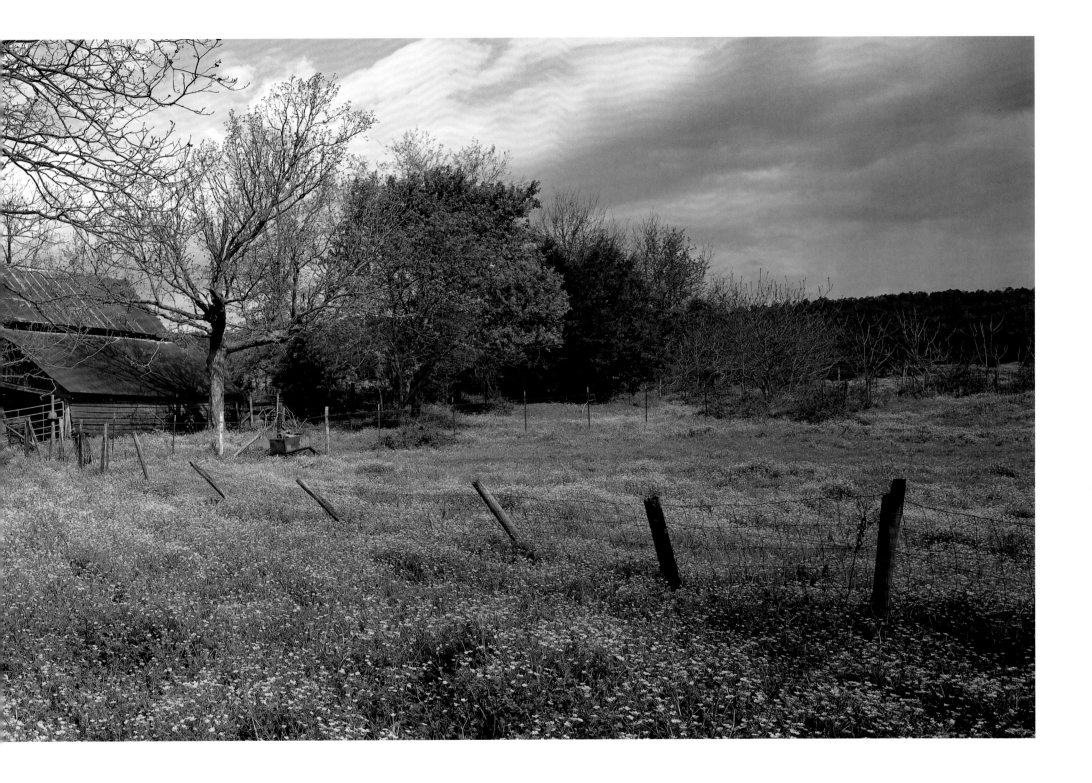

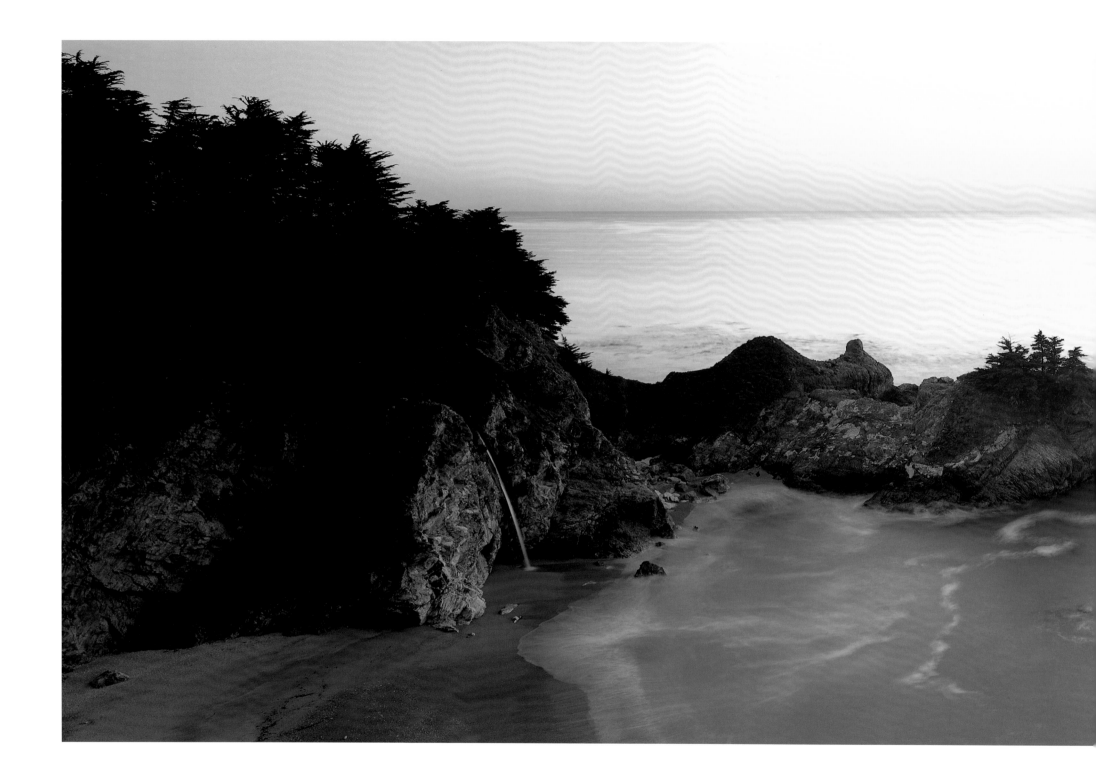

Julia Pfeiffer Burns State Park, California

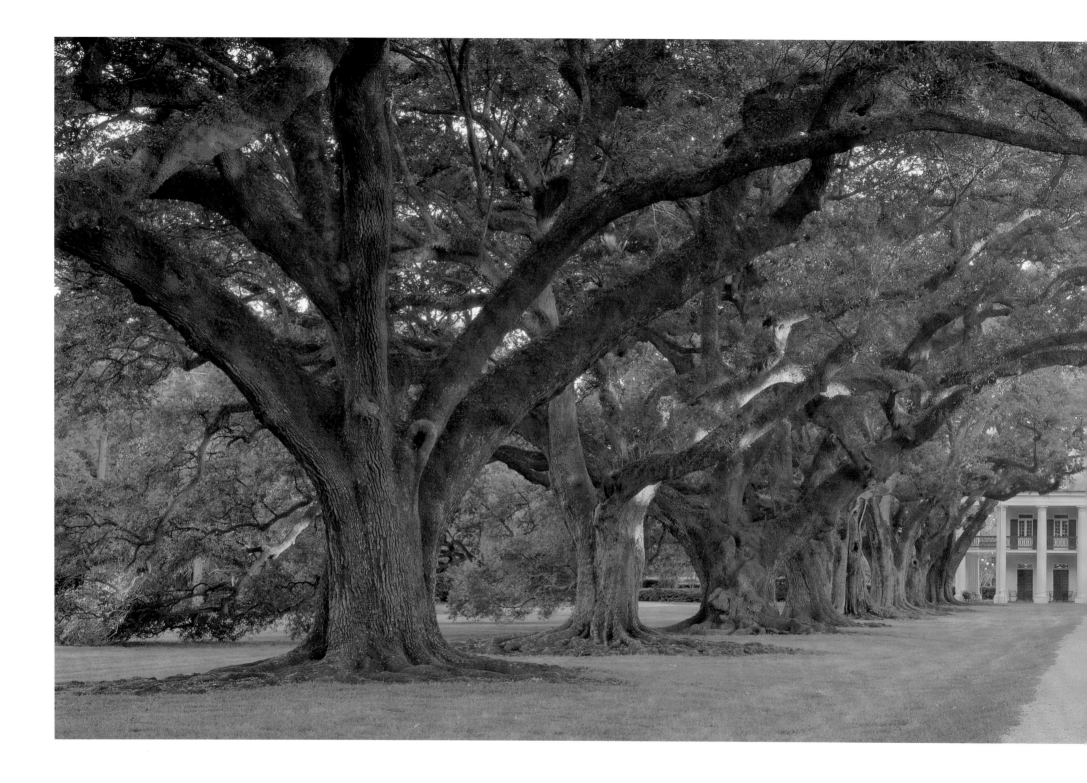

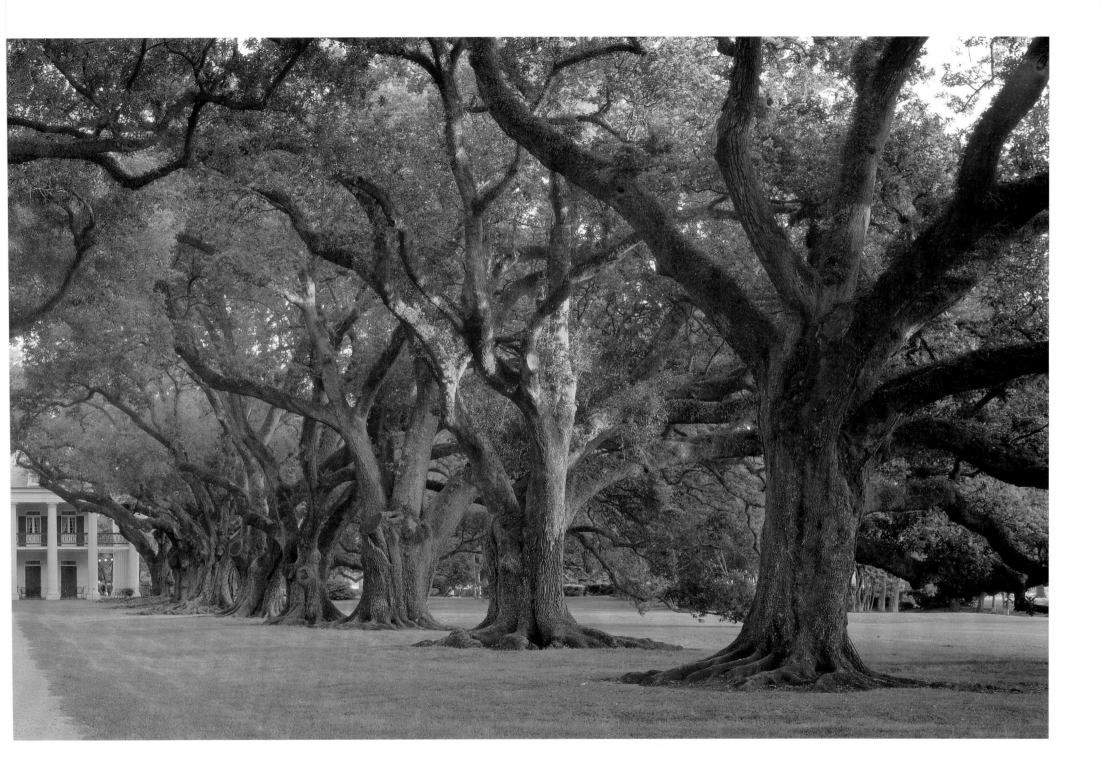

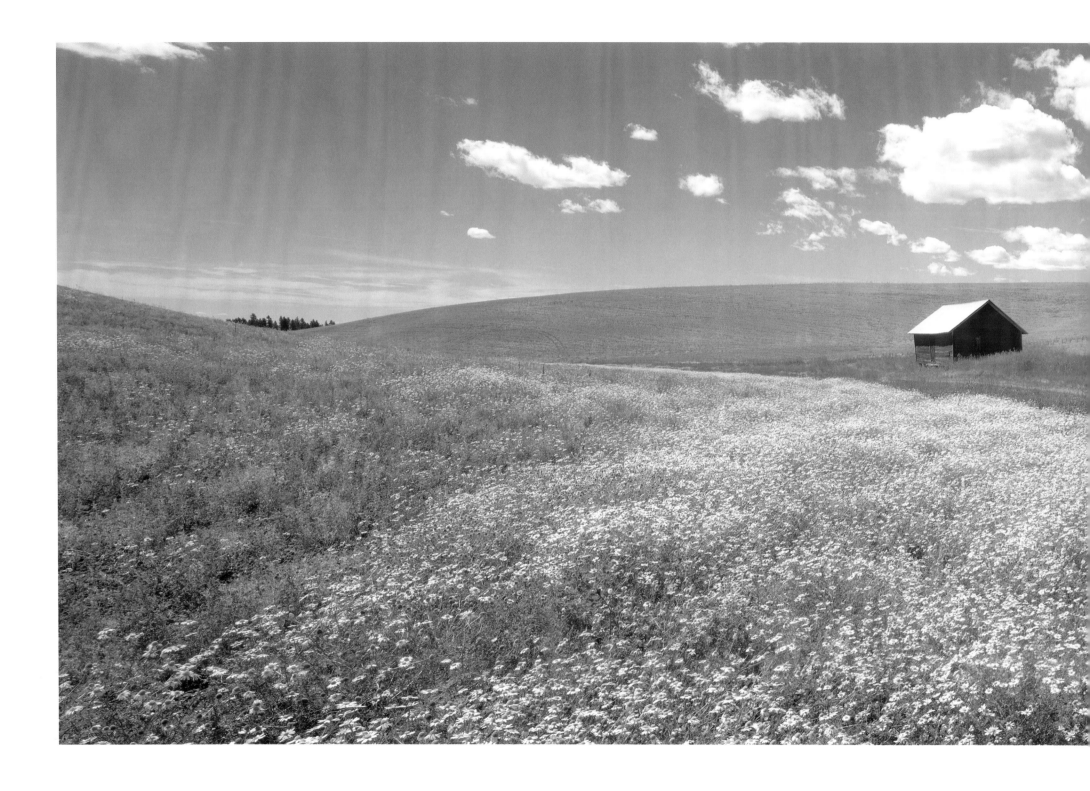

Rolling Hills, Troy, Idaho

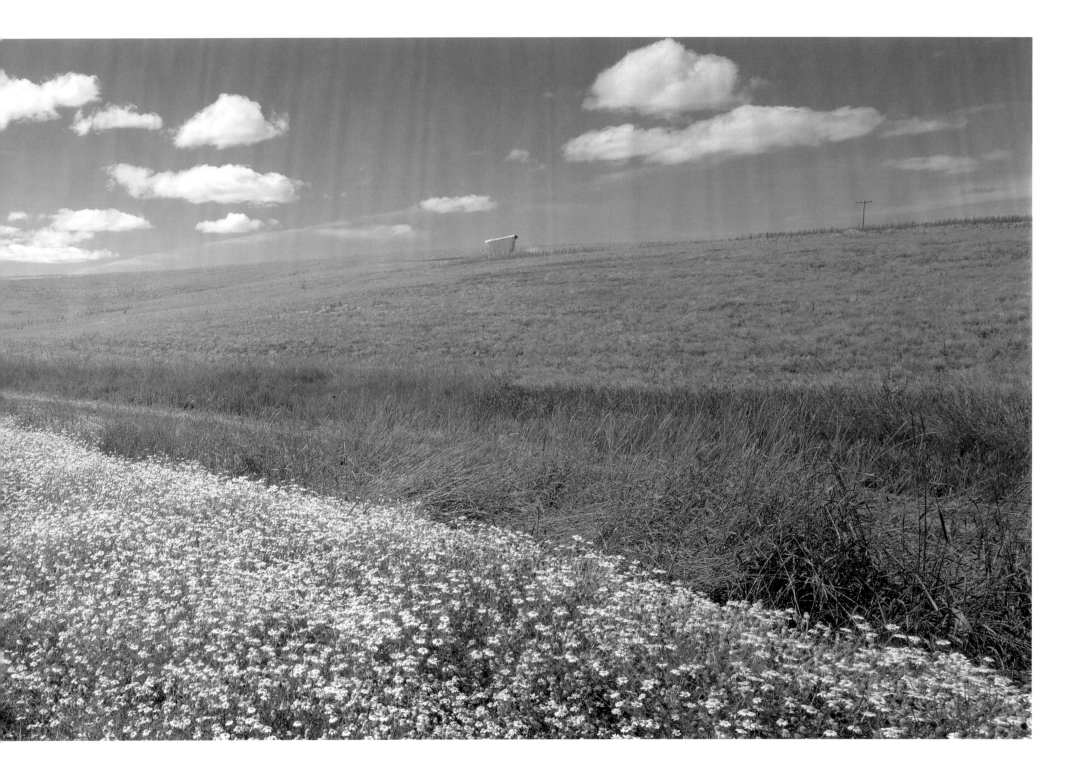

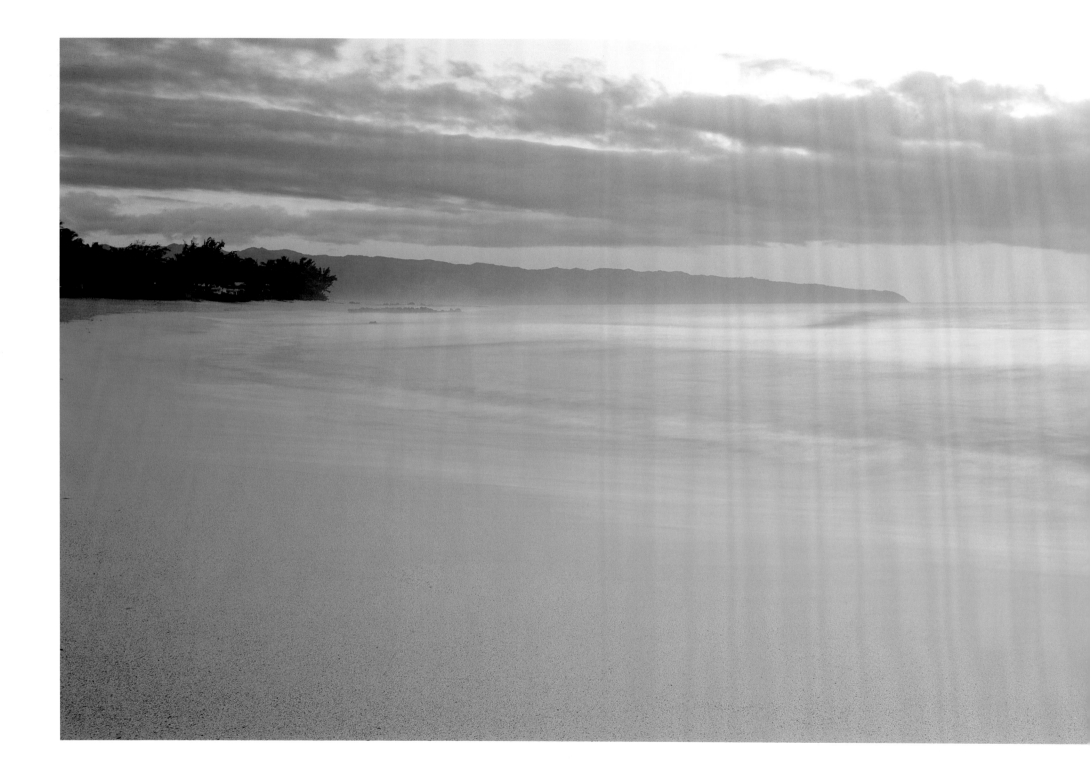

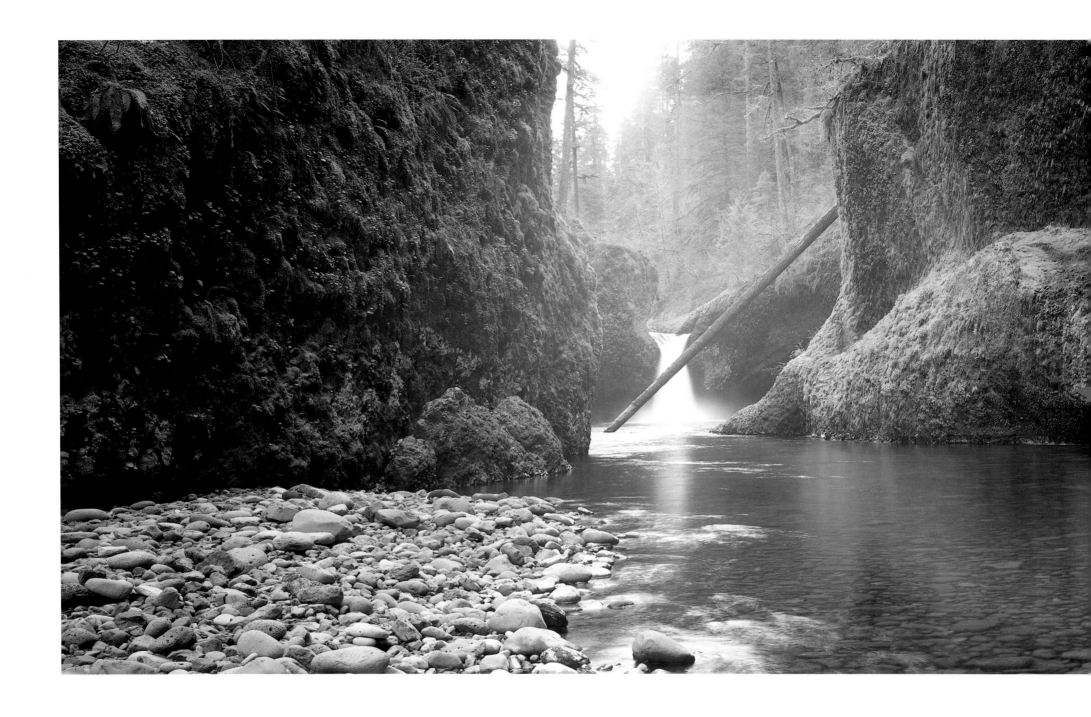

Punch Bowl Falls, Eagle Creek, Oregon

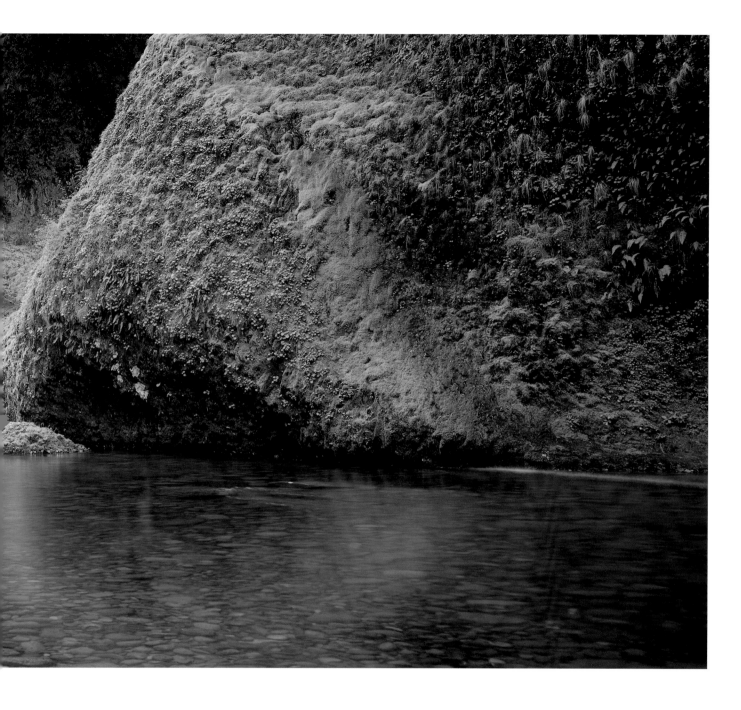

From deep within the Columbia Wilderness, Eagle Creek threads its way through dense forest and down steep ravines on its tireless journey to the sea. The relentless weathering of the water's flow has carved a bowl-shaped pool at the base of Punch Bowl Falls. Waterfalls always remind me of God's love for us, flowing from above to bring life and hope to all who will draw from the stream.

"The heavens declare the glory of God;
the skies proclaim the work of His hands.
Day after day they pour forth speech;
night after night they display knowledge.
There is no speech or language
where their voice is not heard.
Their voice goes out into all the earth,
their words to the ends of the world."

PSALM 19:1-4

Marion Lutheran Church, Gunder, Iowa

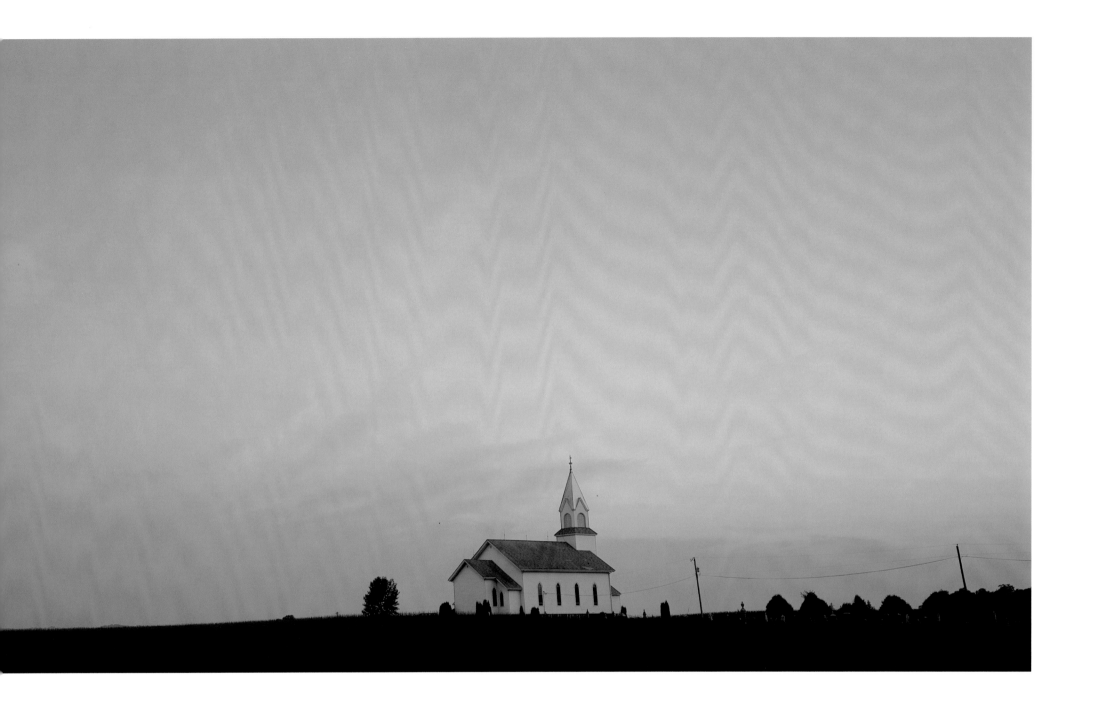

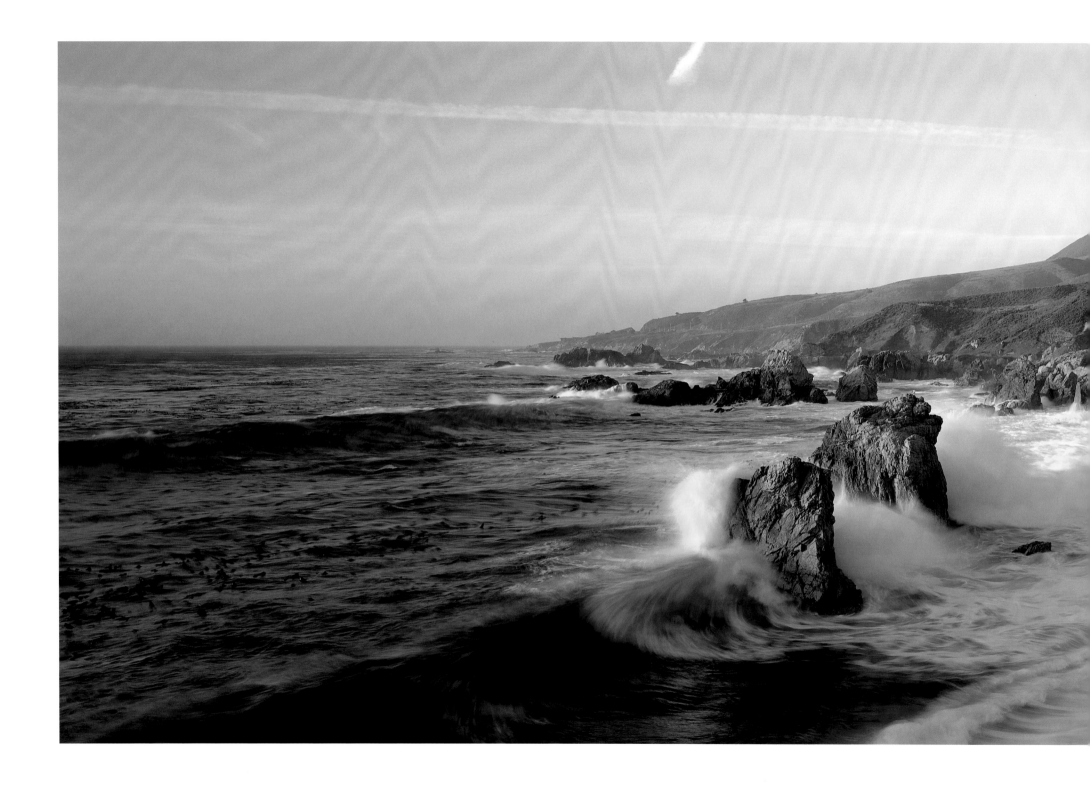

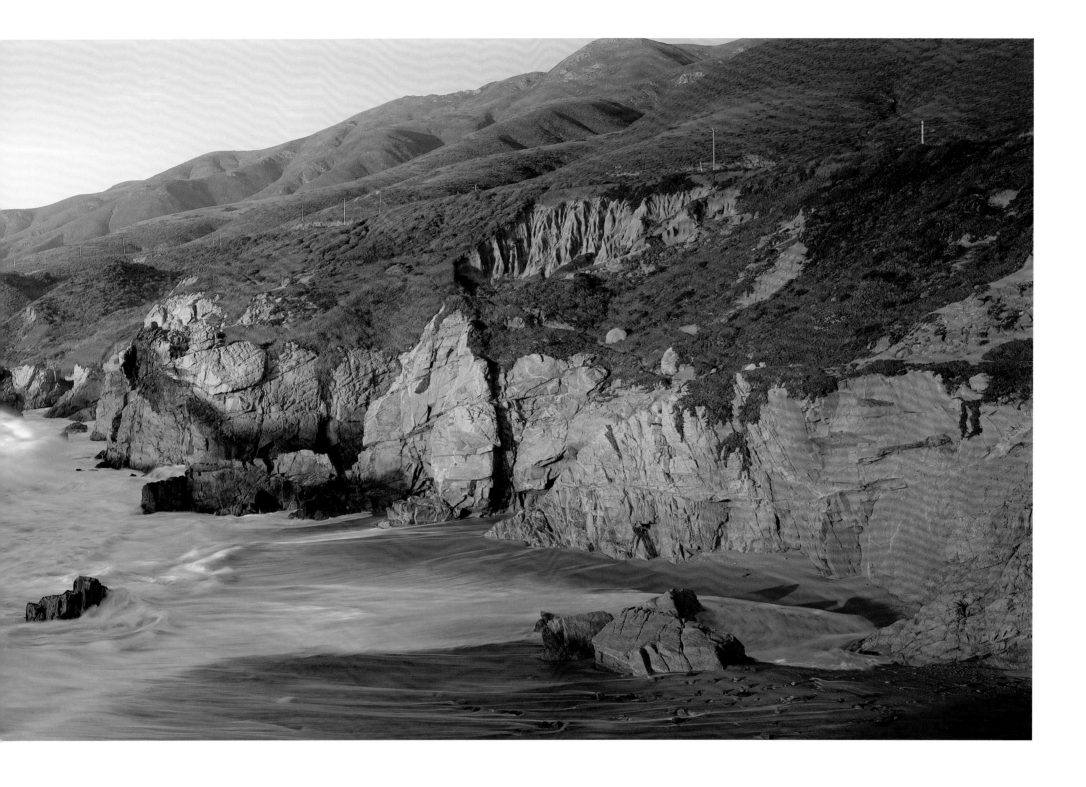

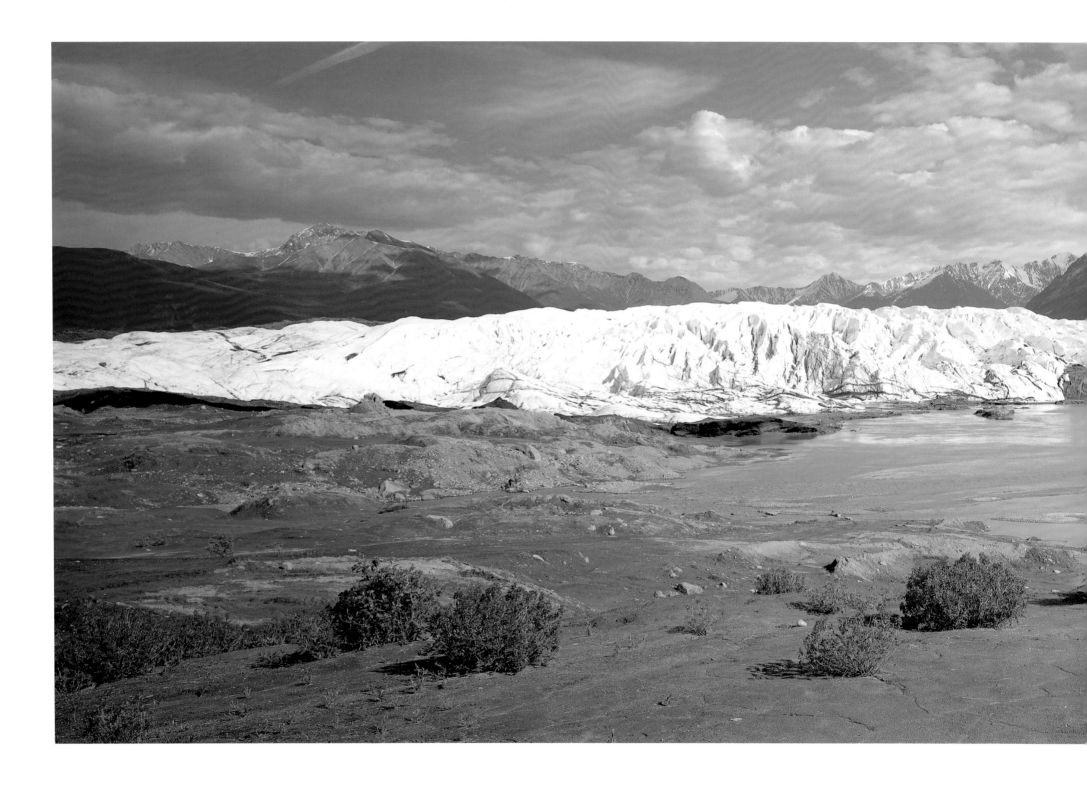

Matanuska Glacier, Alaska

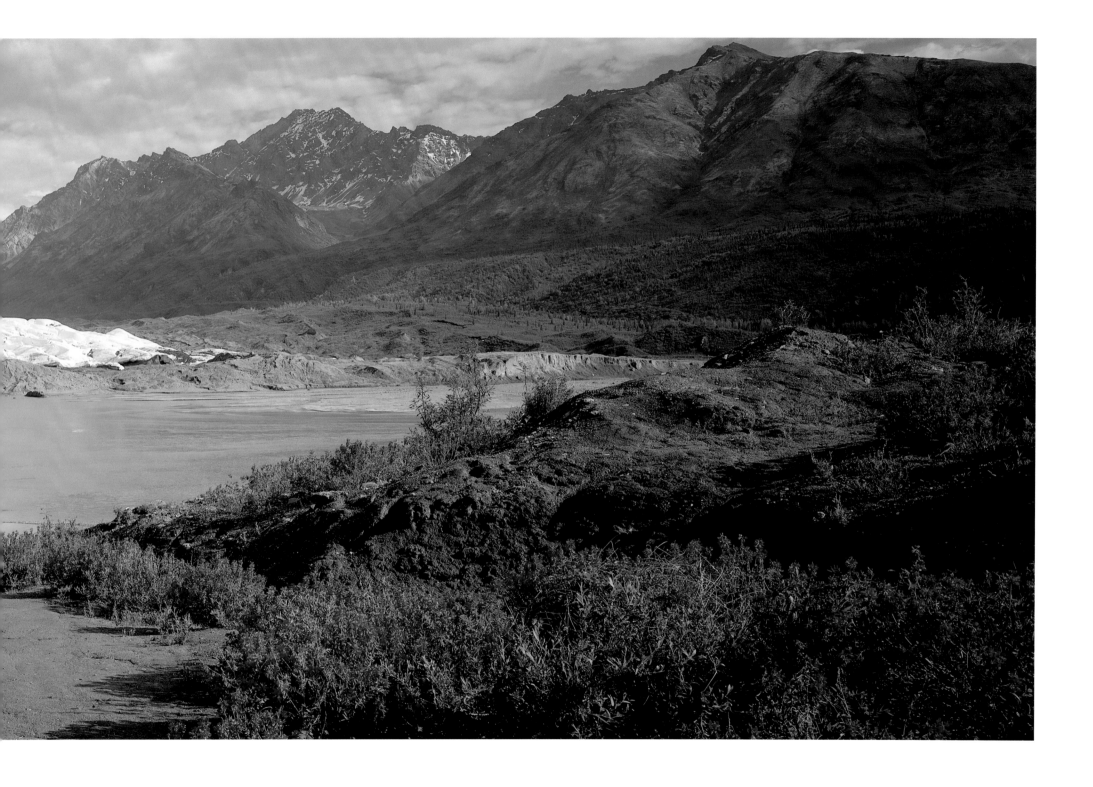

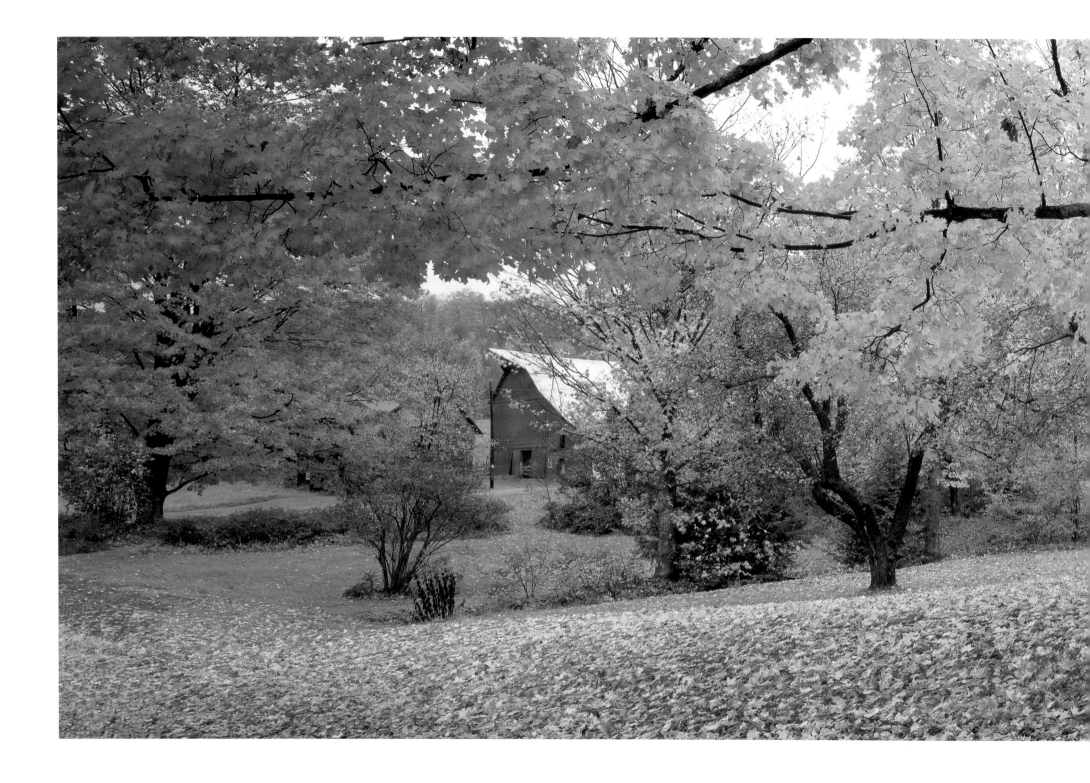

Autumn Colors, Woodstock, Vermont

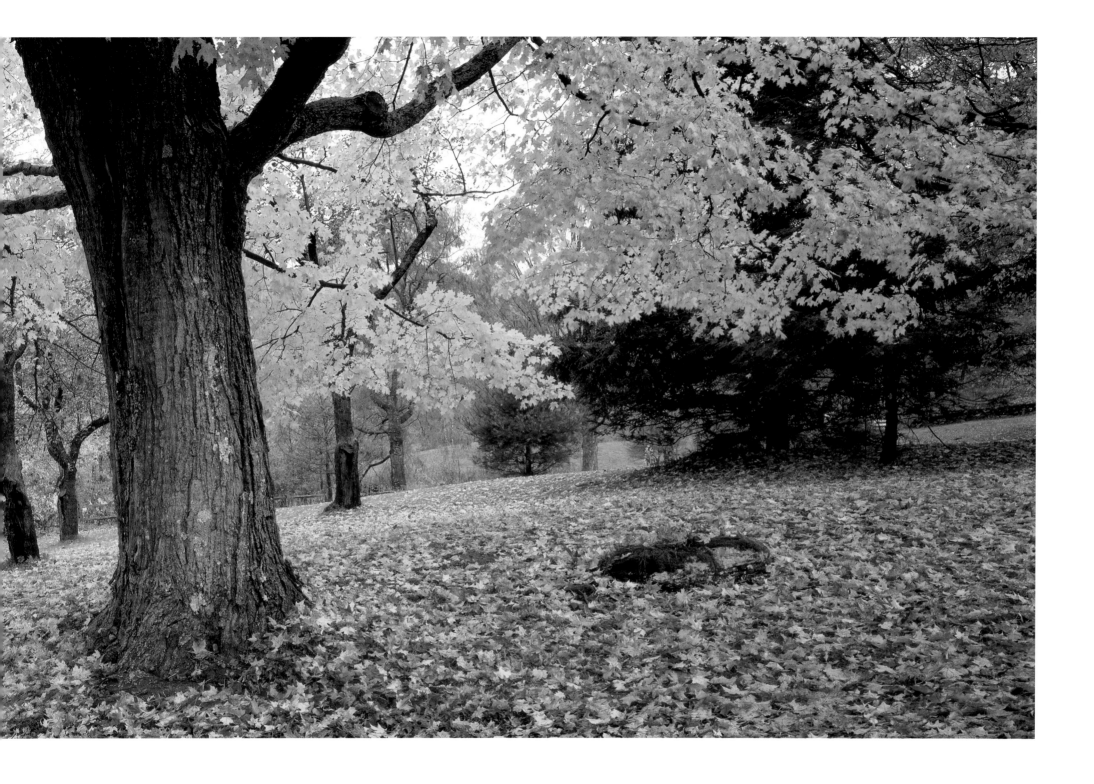

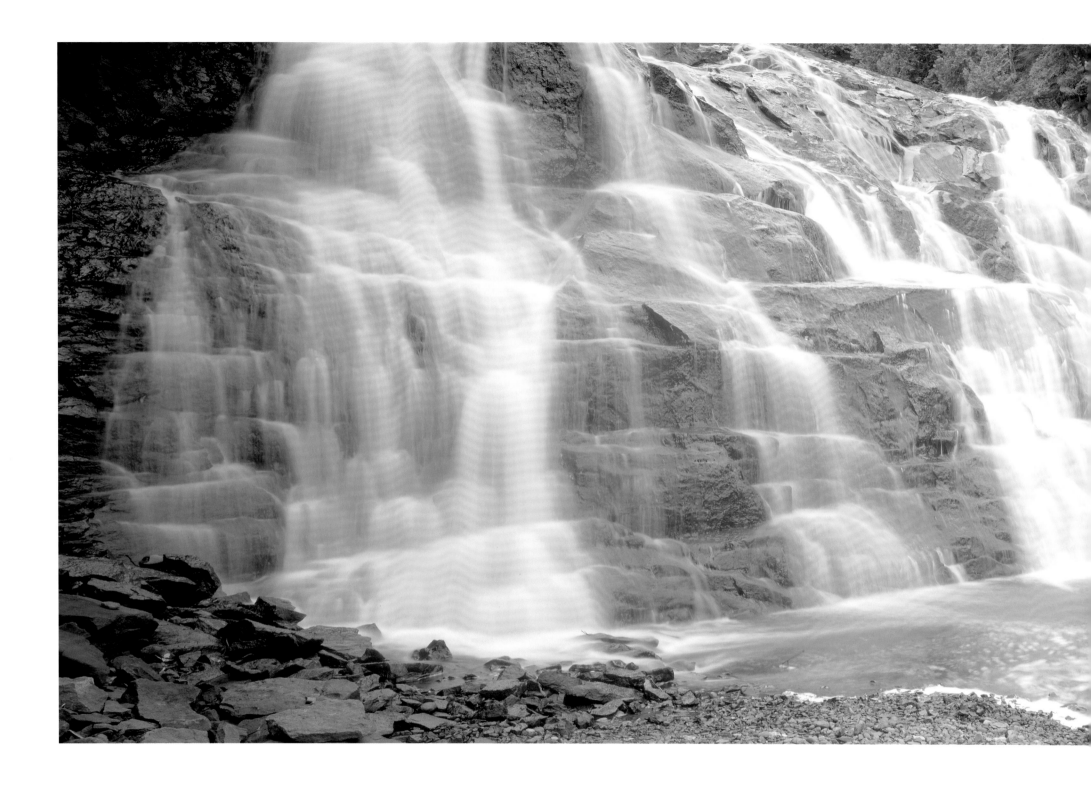

Lower Potato River Falls, Wisconsin

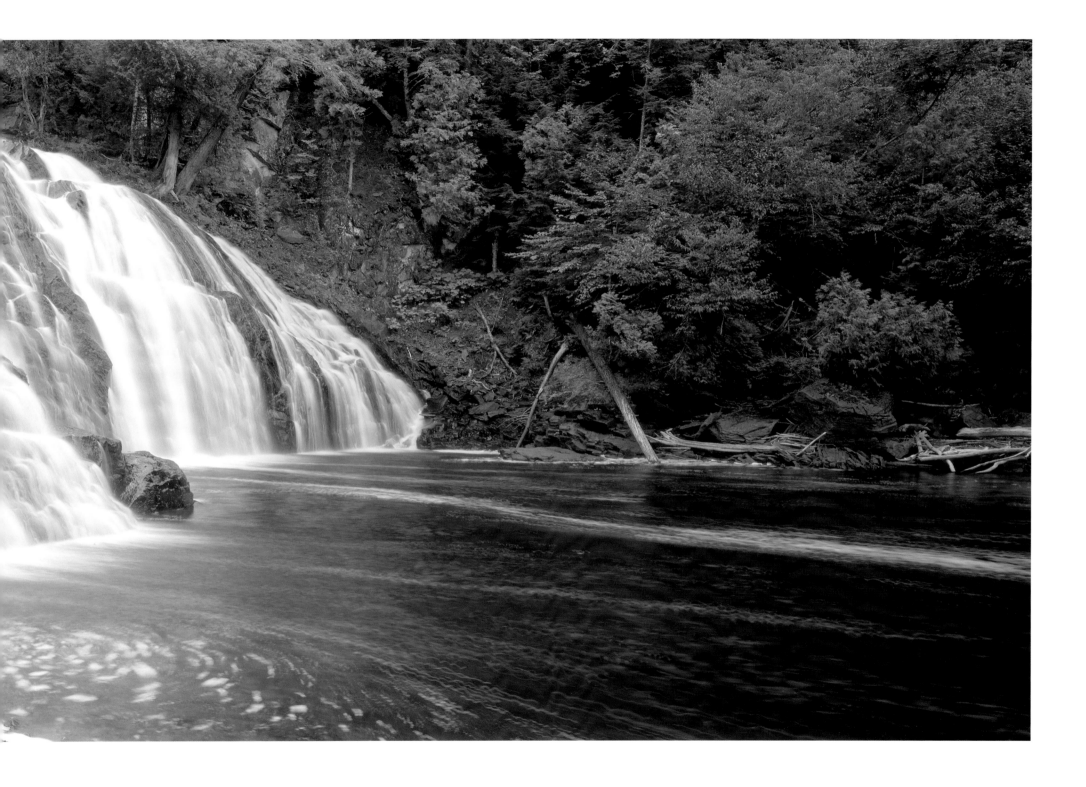

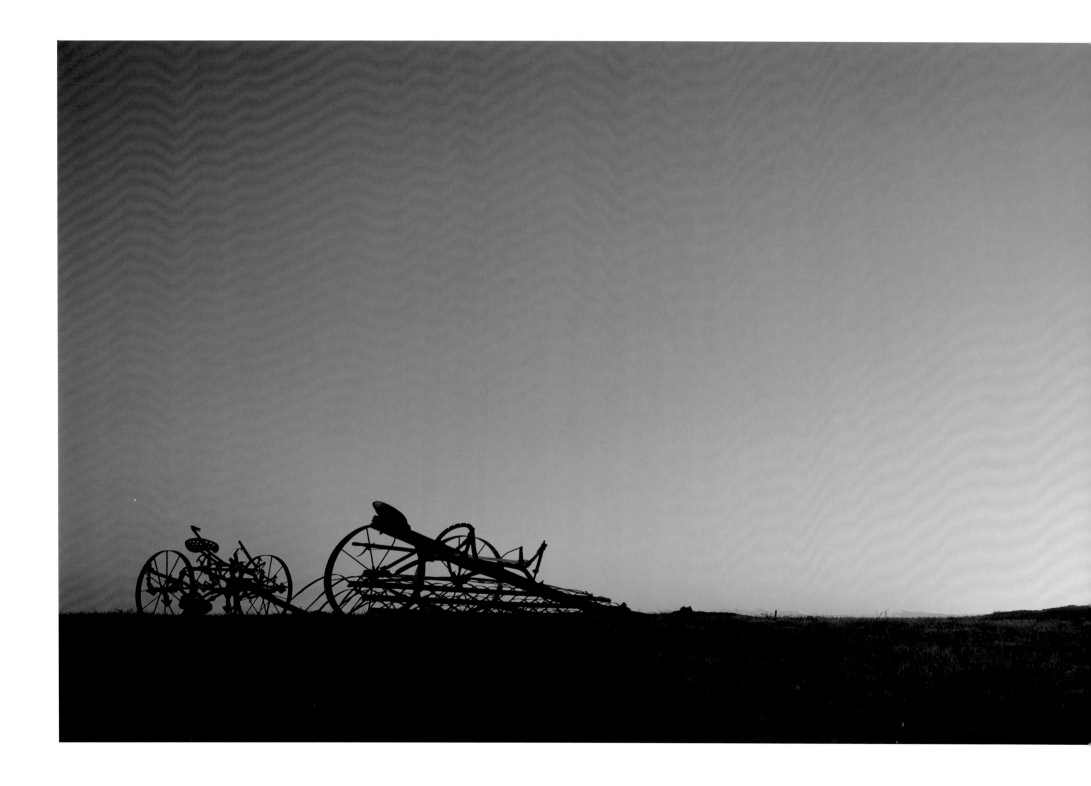

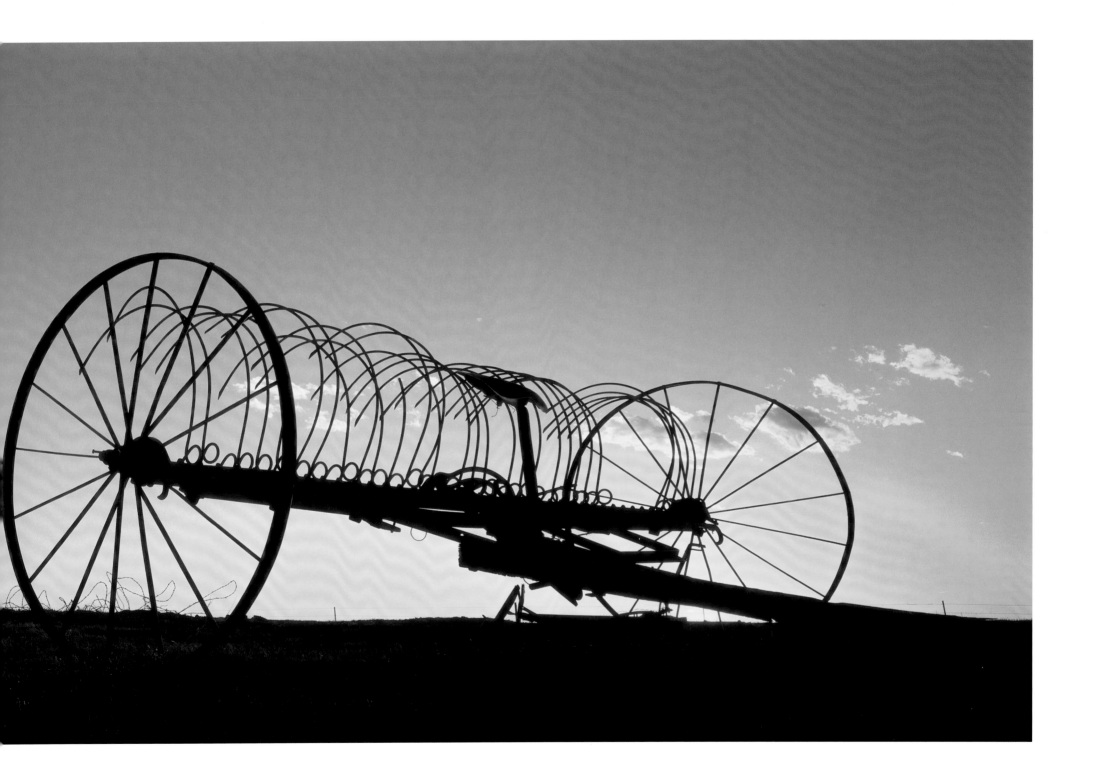

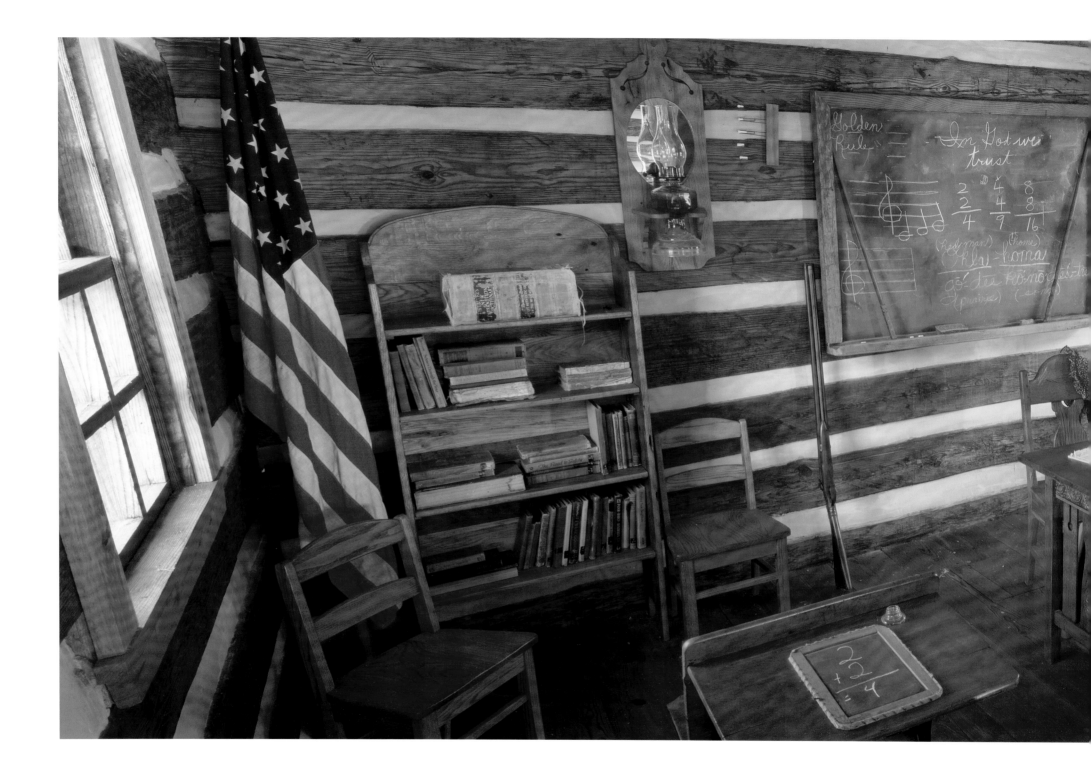

Scudder School, Prairie Song, Oklahoma

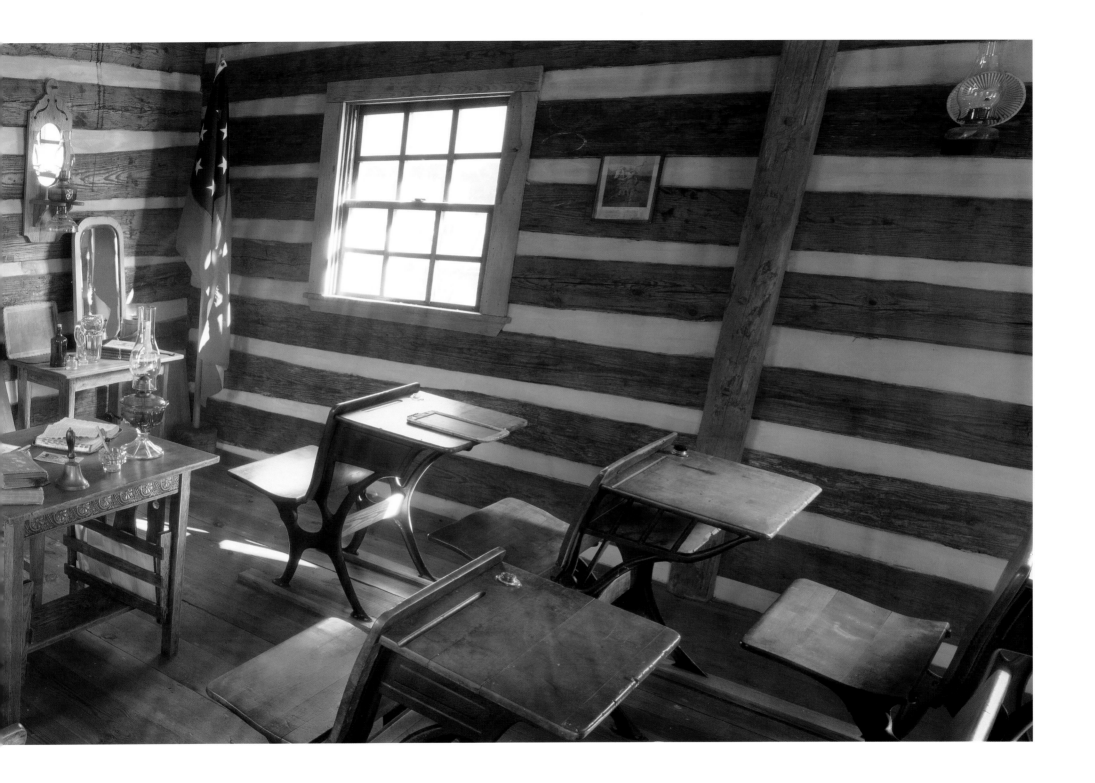

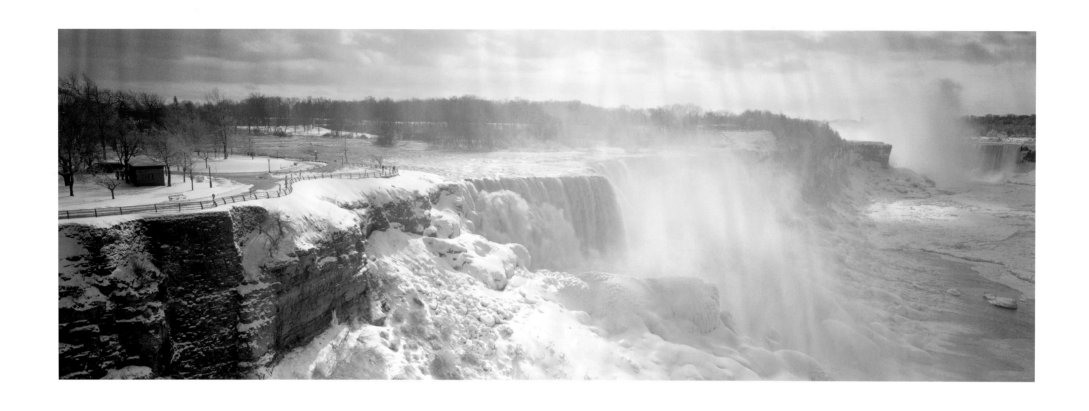

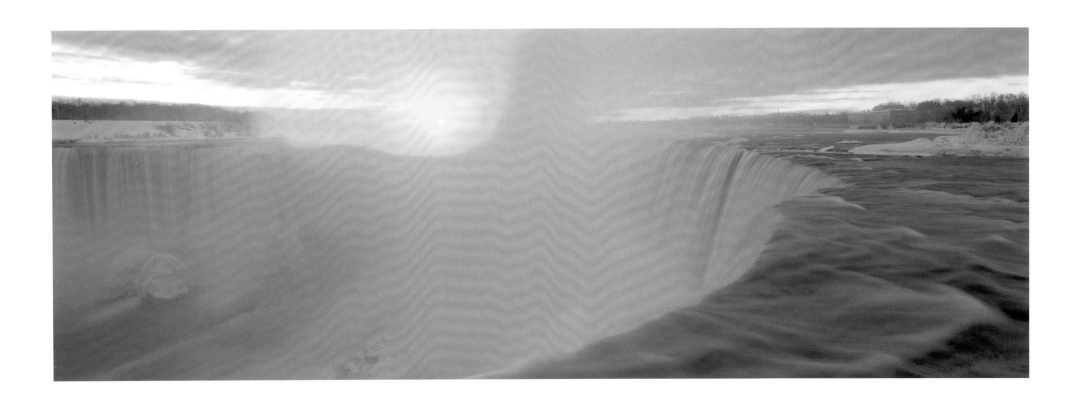

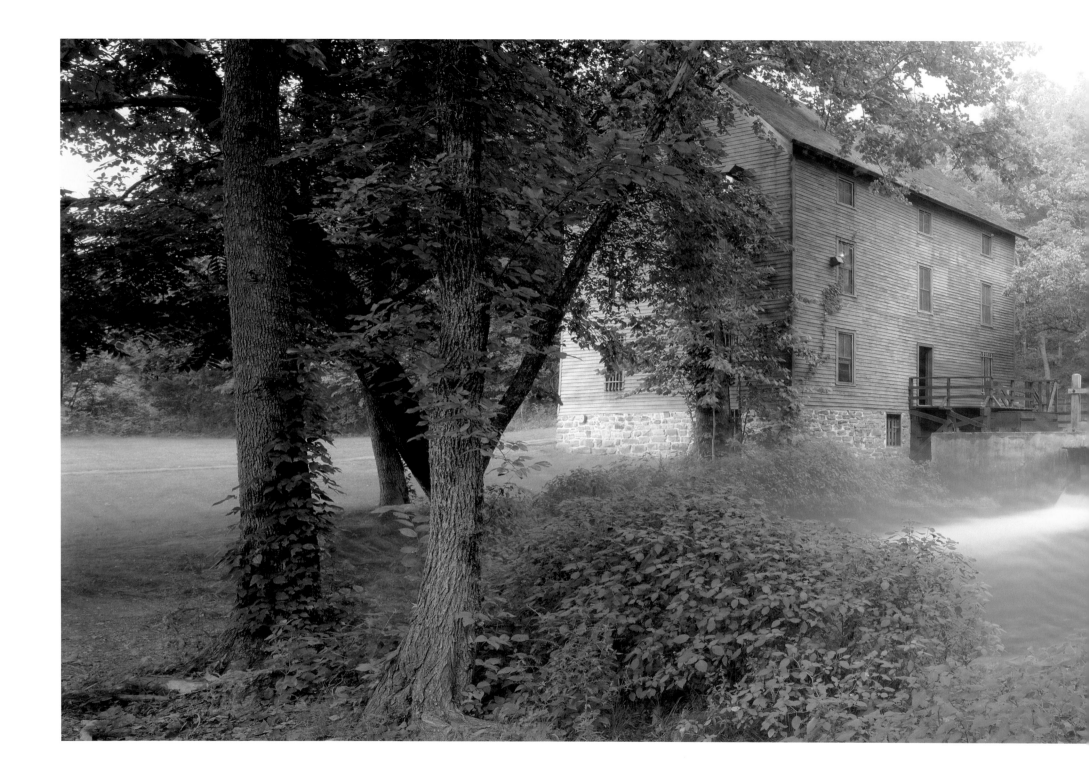

Alley Spring Mill, Missouri

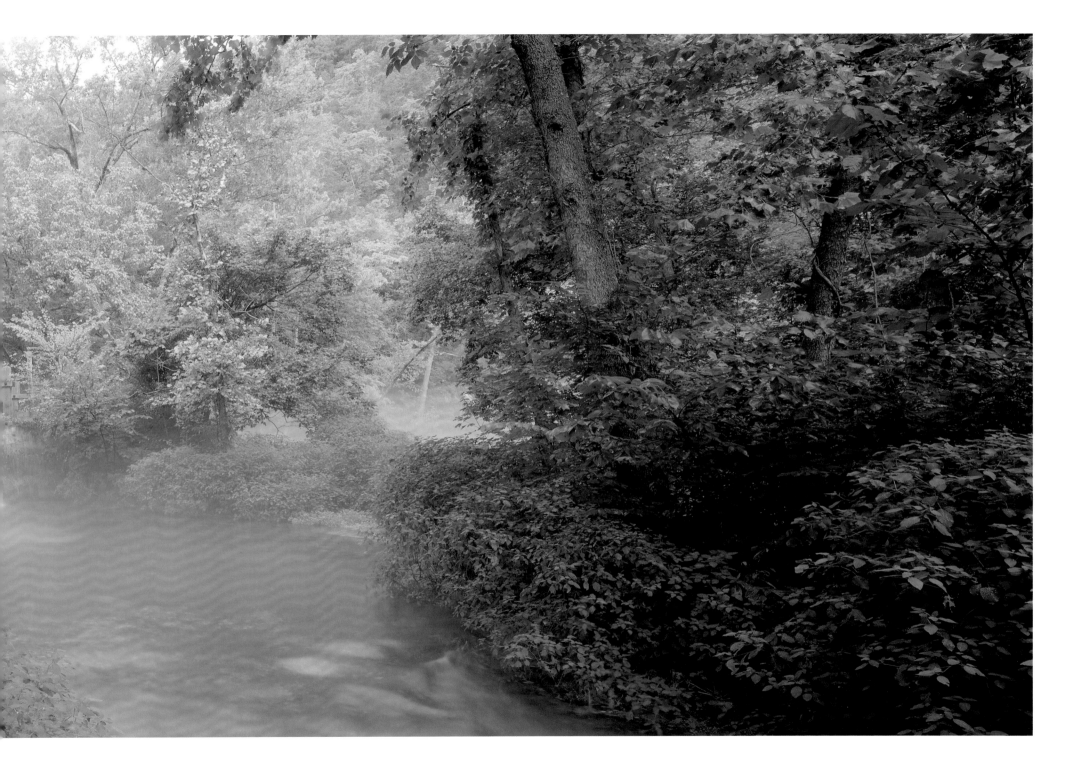

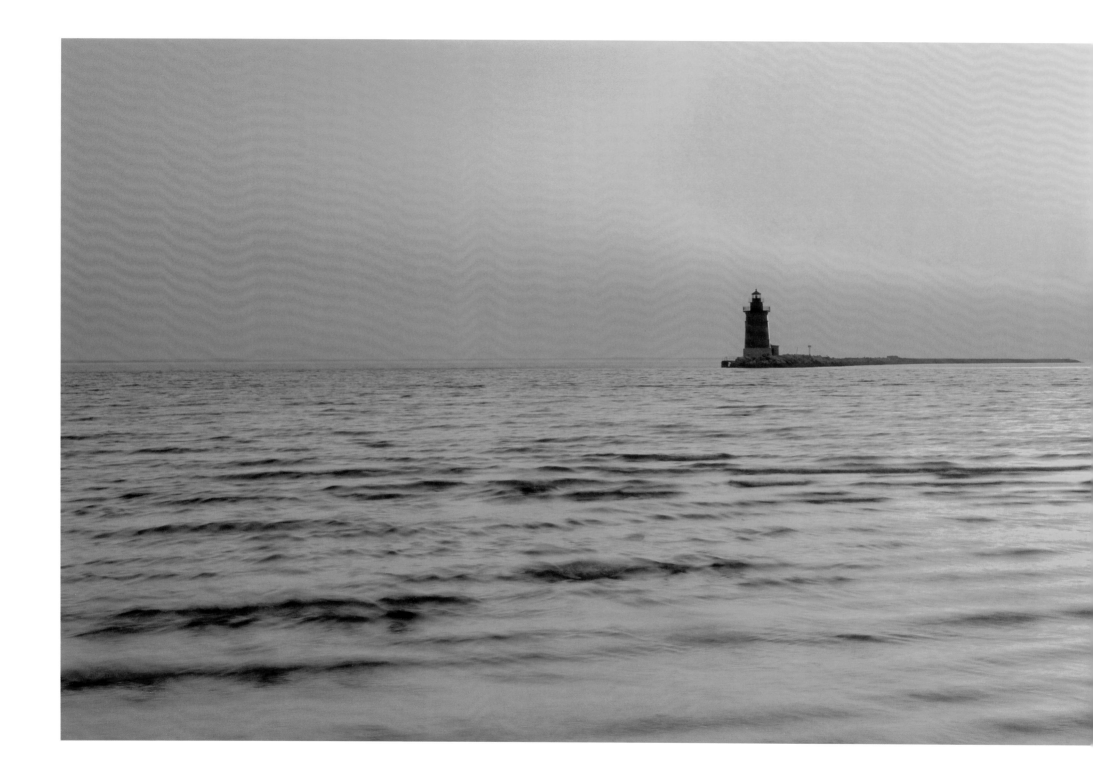

Sunset, Breakwater Lighthouse, Delaware

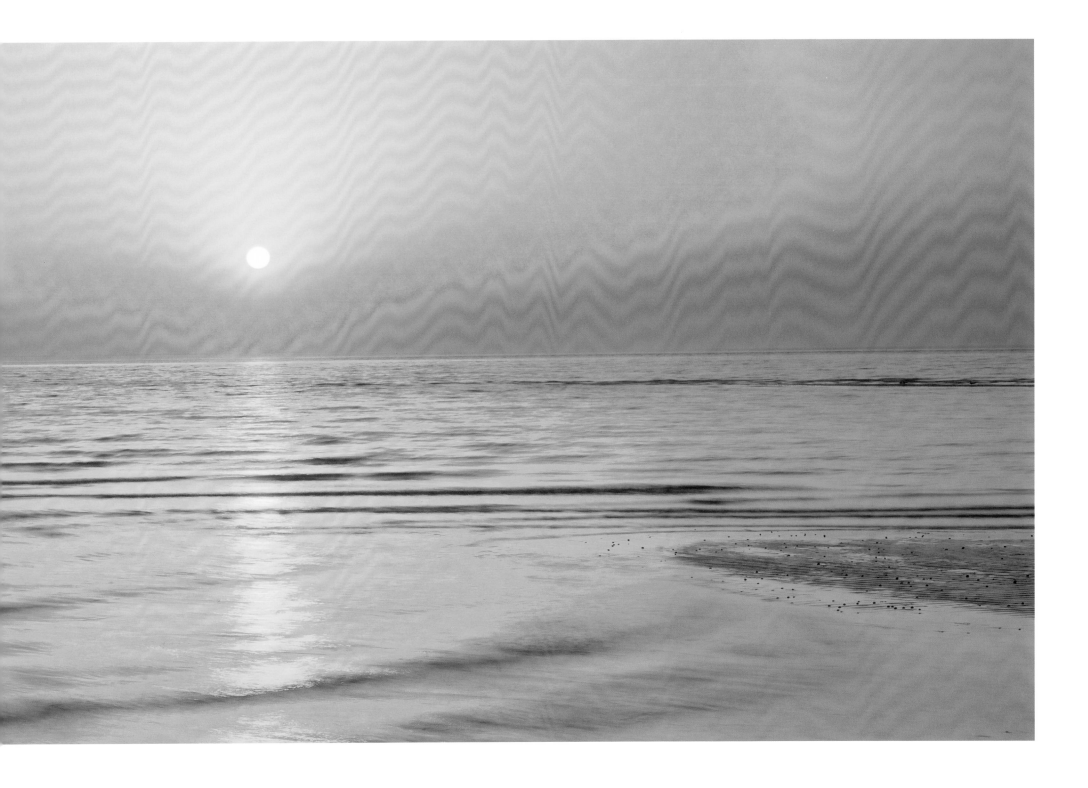

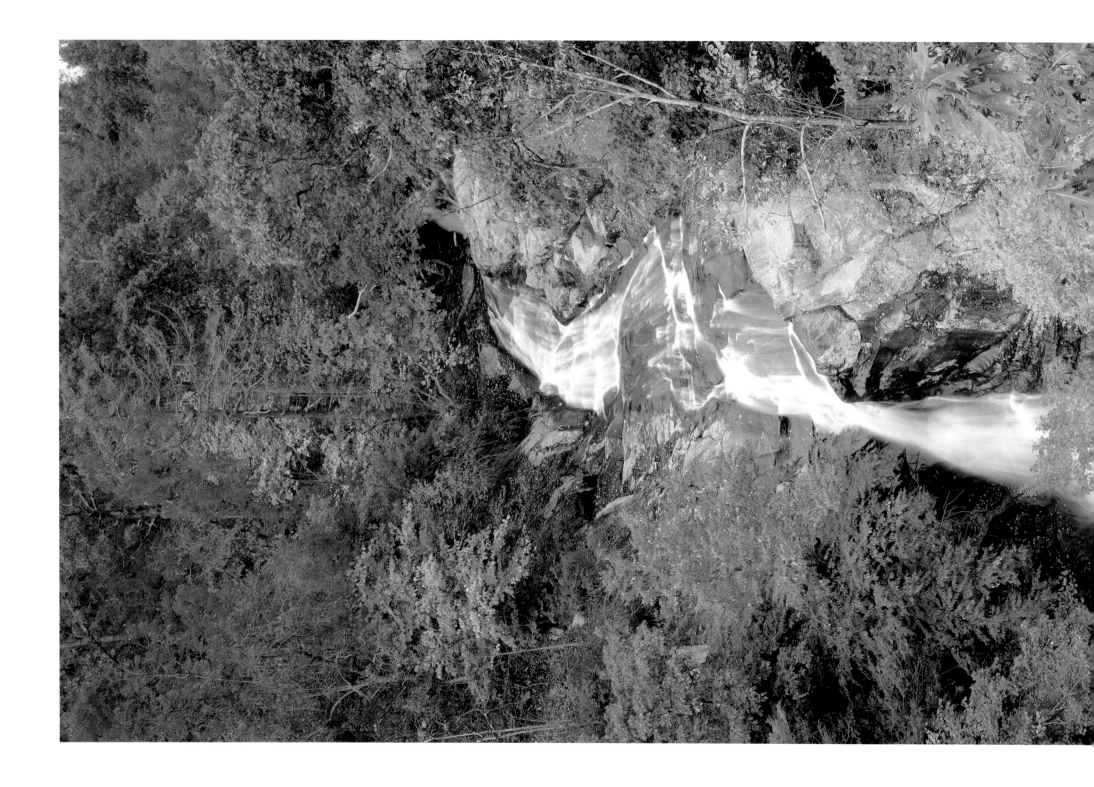

White Oak Falls, Shenandoah National Park, Virginia

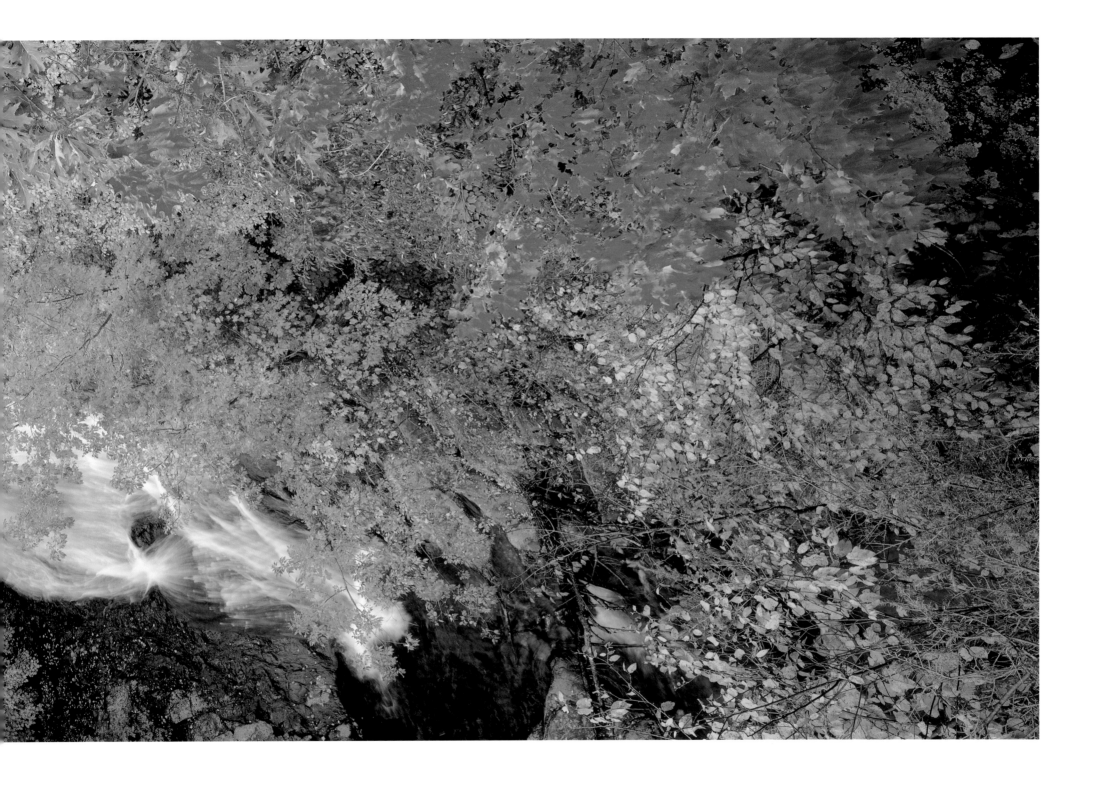

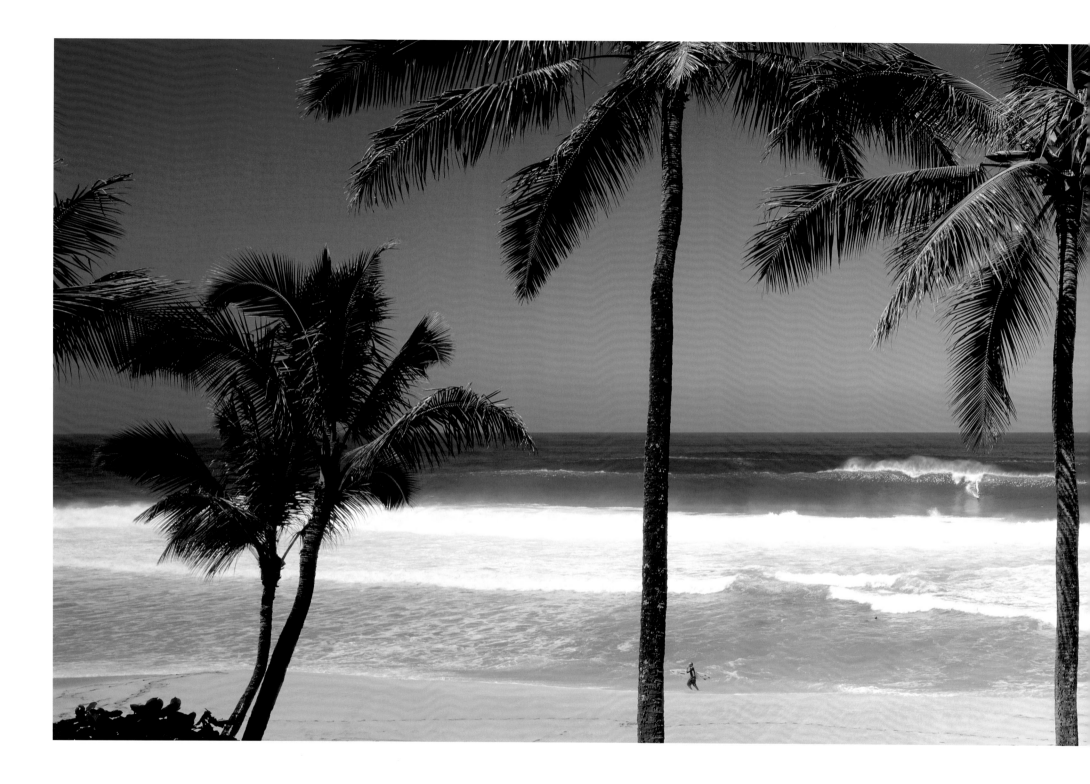

Pipeline, Oahu, Hawaii

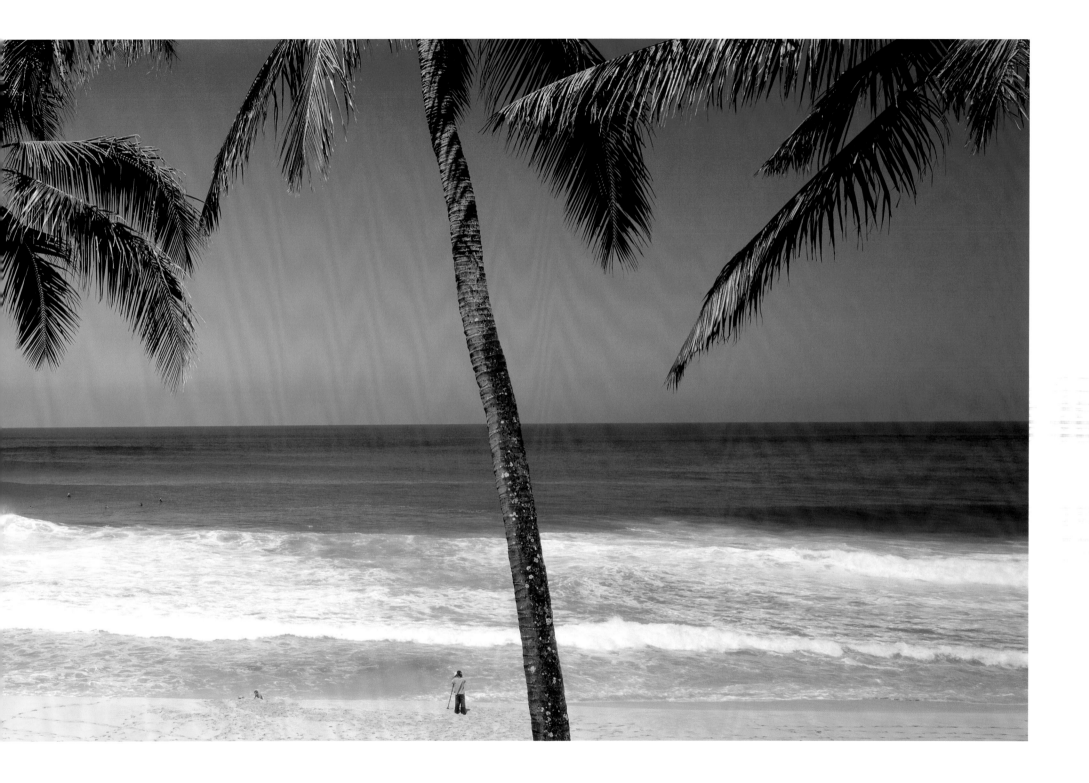

A contented cat sits in the window of a genteel Victorian home at Cape May. Wide verandahs and comfortable chairs give these houses a welcoming and tranquil atmosphere. Garden beds ablaze with color set off a picture-perfect scene.

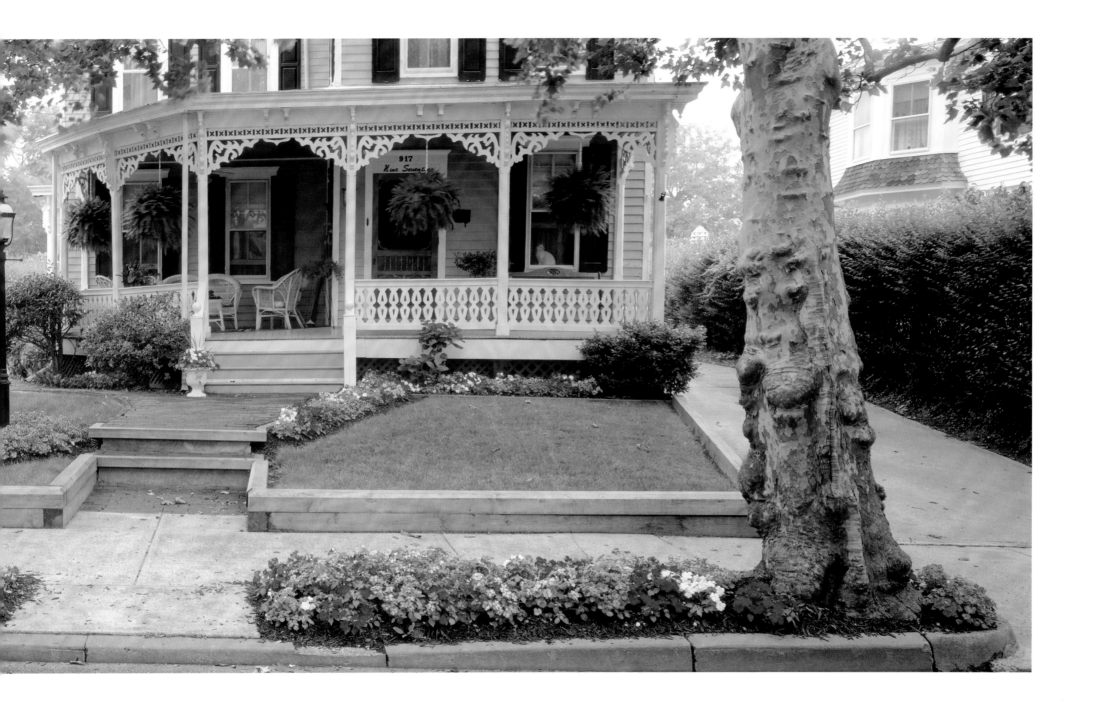

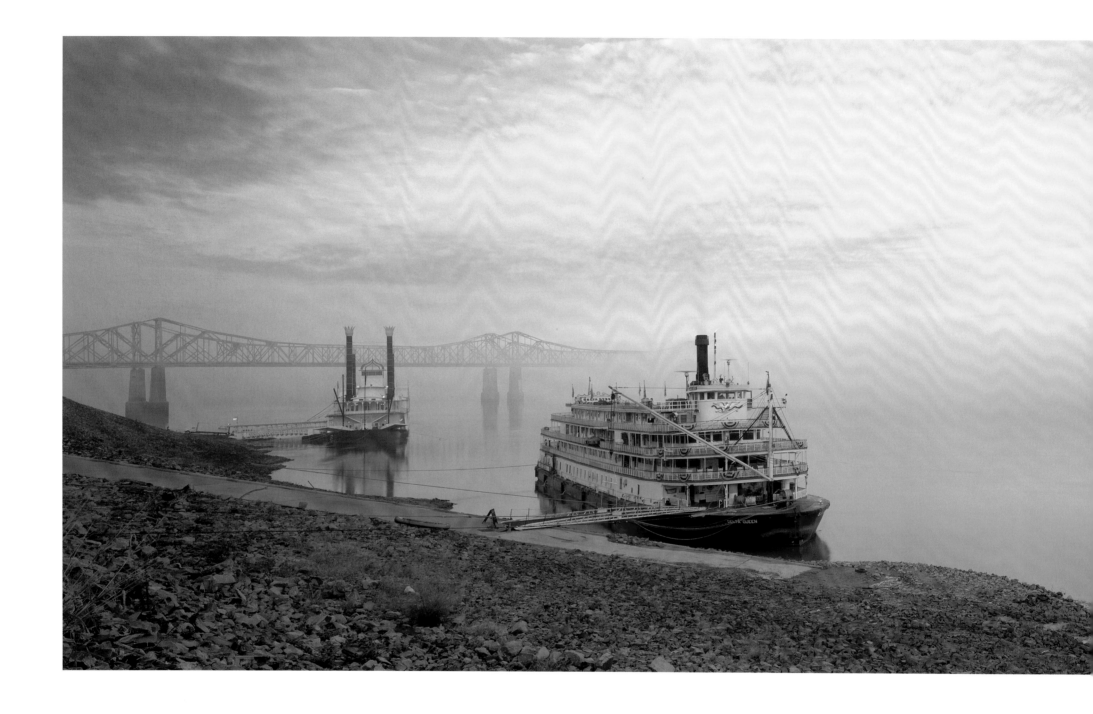

This gracious lady of the river helps sustain the romance of a bygone era. In the golden years from 1811 until the turn of the century, paddle-wheel steamboats were directly responsible for accelerating the development of the American frontier. The Delta Queen, one of the few remaining original paddle steamers, is shown here moored for the evening before continuing her adventure up the grand old Mississippi. Mark Twain once said, "The river is a wonderful book, with a new story to tell every day."

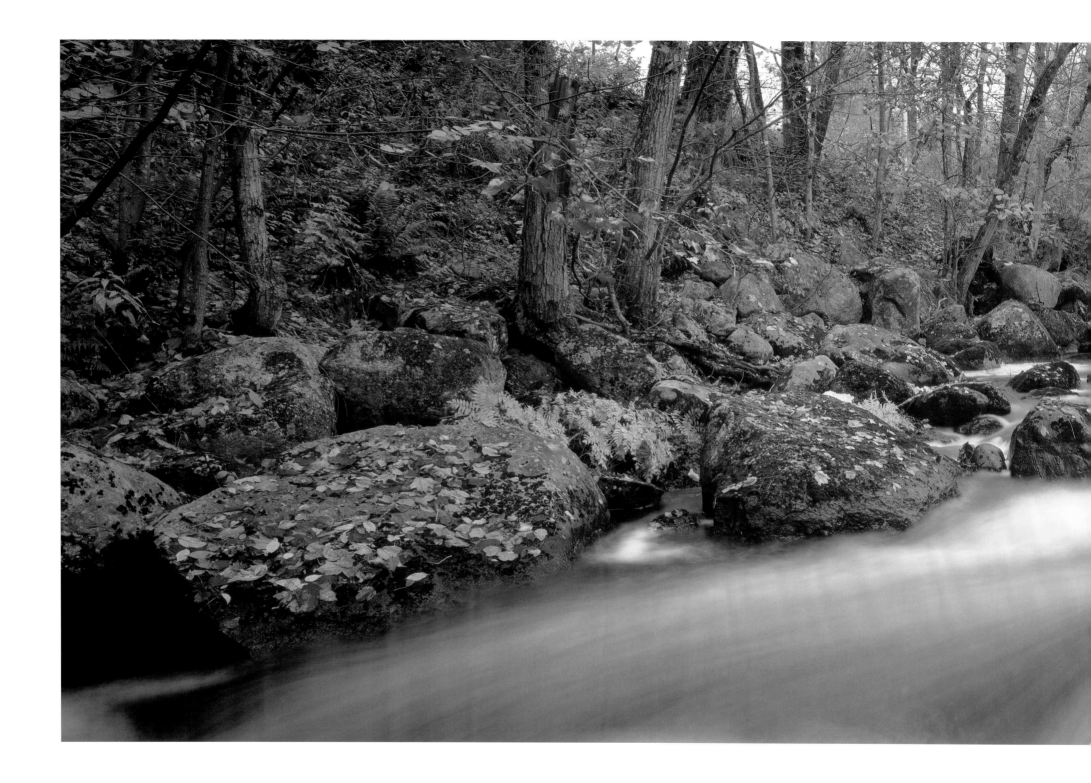

Waterloo Covered Bridge, Warner, New Hampshire

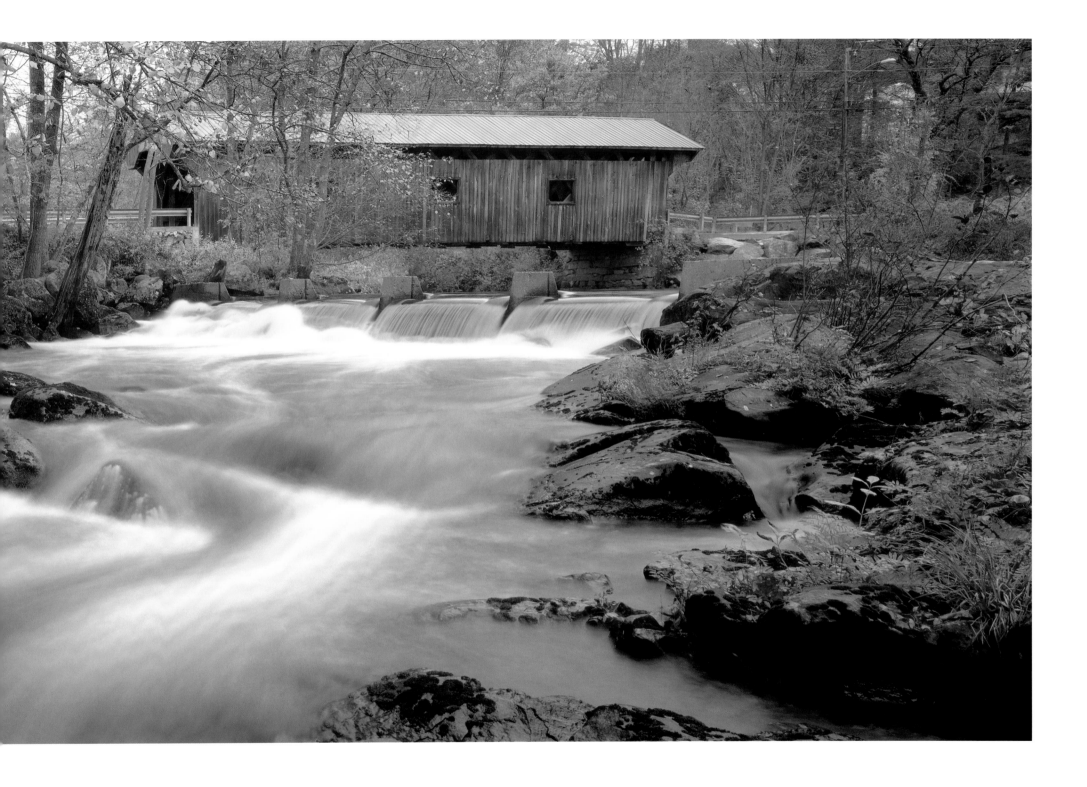

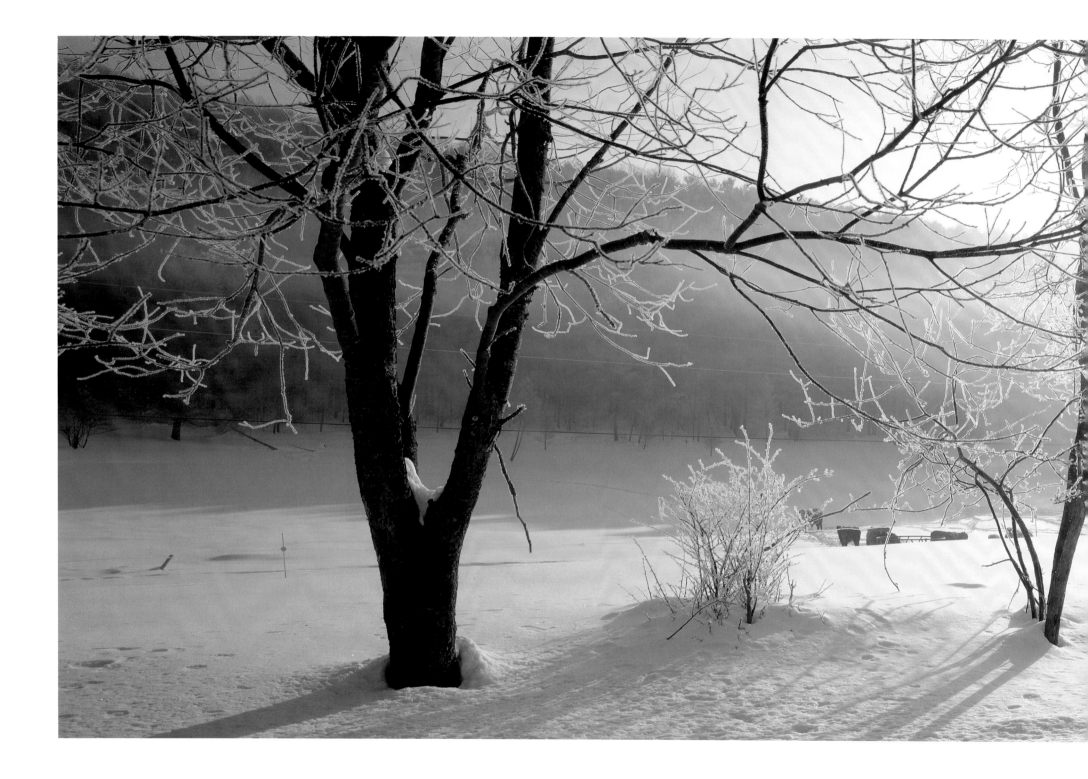

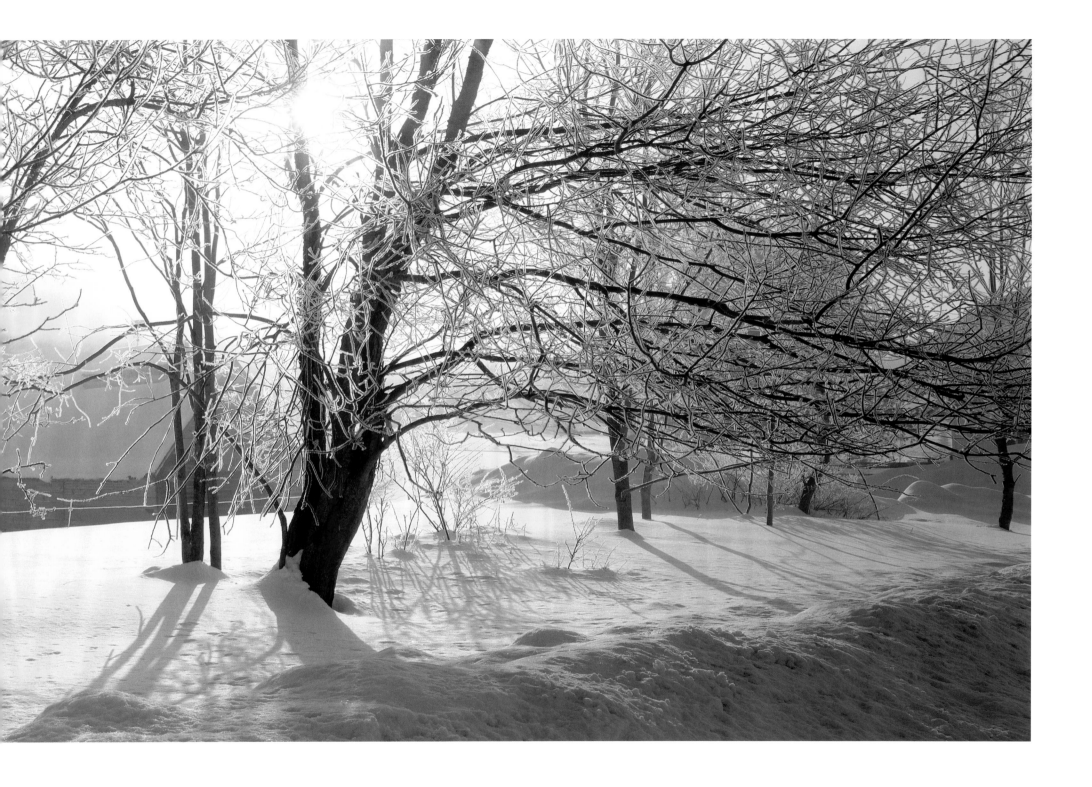

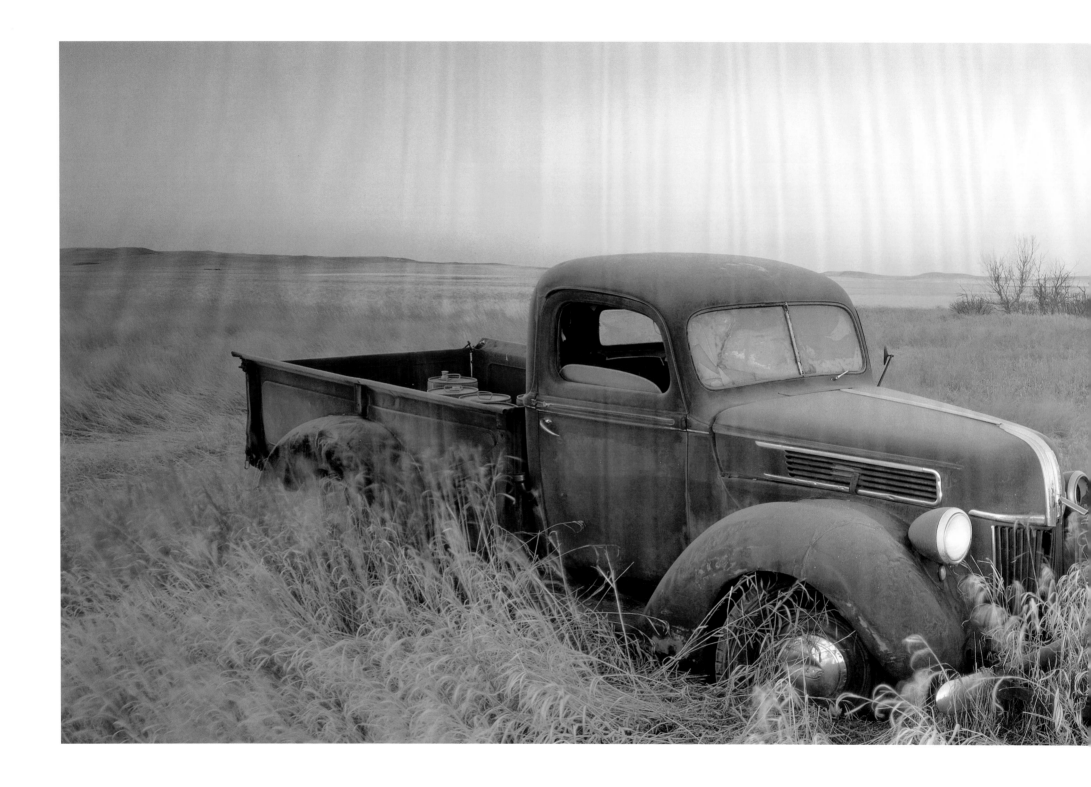

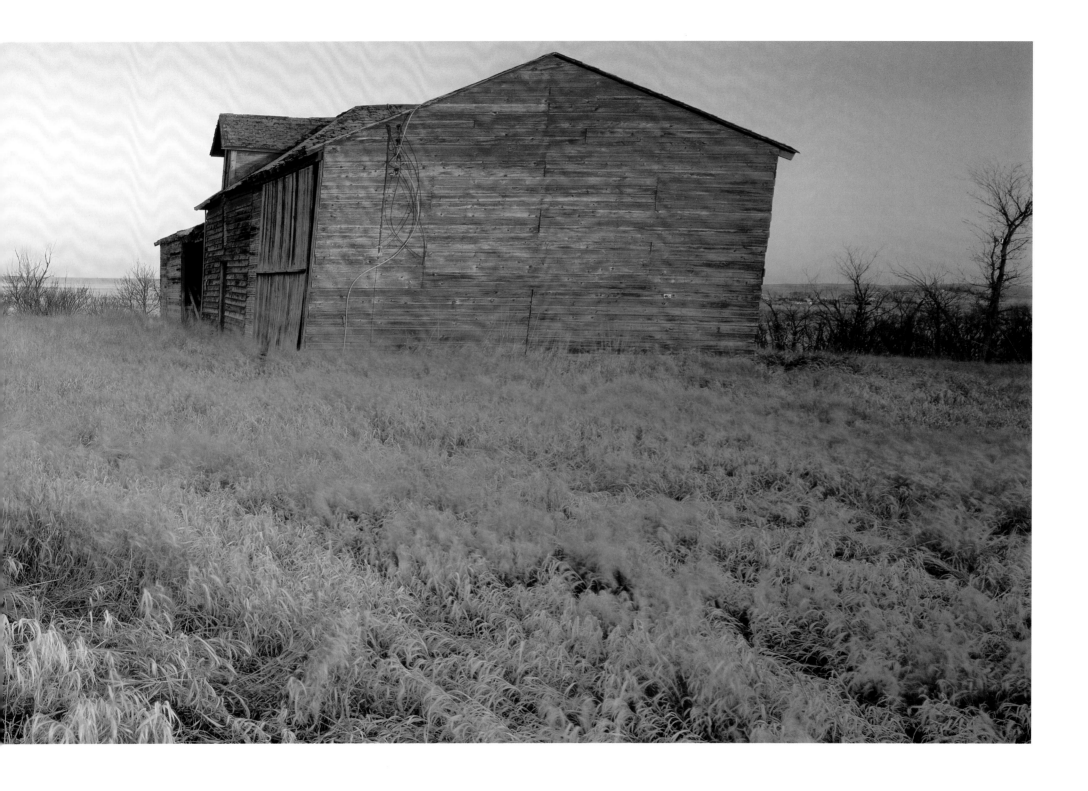

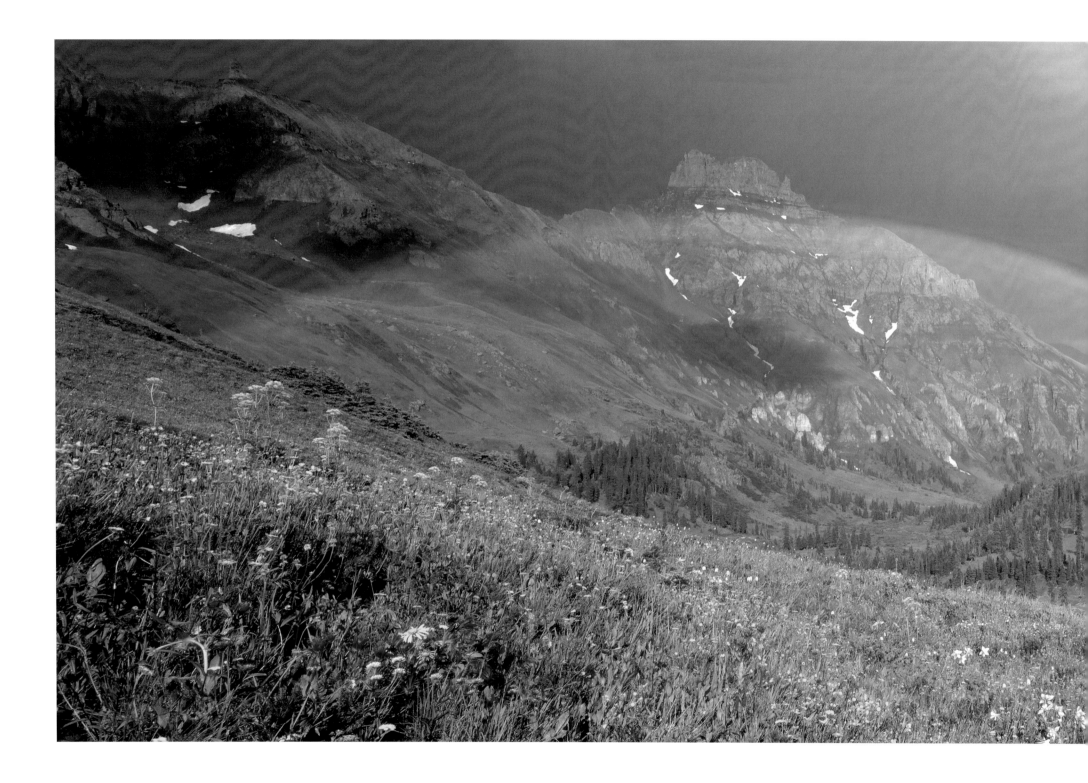

Rainbow, Yankee Boy Basin, Colorado

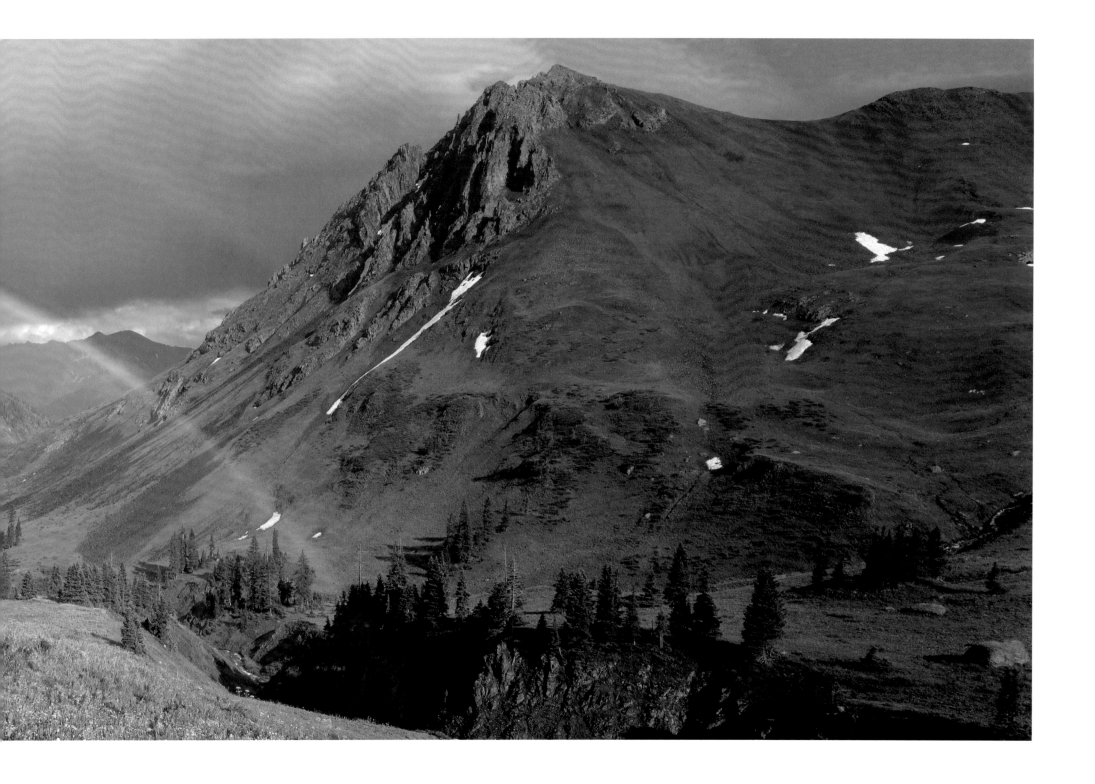

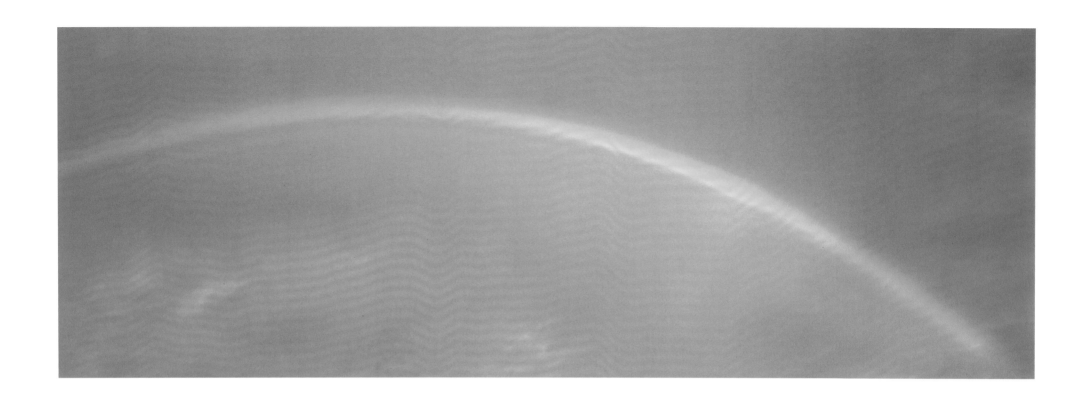

Waiting for rainbows

For over a week, I had been in Colorado searching for that quintessential shot of wildflowers in a mountain setting. My time was running out, as I was due to return to Australia the following day. I had found a beautiful location in Yankee Boy Basin but the morning light had been bland, not allowing the area to fully reveal its beauty. To make matters worse, many other photographers had joined me and were tramping through the fields on their own quests. One particular photographer was so absorbed in his own journey that he would walk right in front of where others had set up to shoot, often flattening the flowers as he went.

I was getting a bit irritated at his selfish attitude and was almost at the point of offering a few pointers on photo etiquette. The guy was like an insect – buzzing around, landing here, landing there – being generally annoying. I knew I shouldn't be angry, but I was, and it was useless to pretend otherwise. I realized that the way I was feeling was wrong and in that frame of mind I would not be sensitive to God's presence nor able to capture the spirit of the moment in this place. So I left that location and went for a drive.

Traveling through the wonderful Colorado countryside, my anger washed away. I marveled at the awesome creation around me and how small I was in comparison. At peace once more, I asked God where He wanted me to go and felt He wanted me to revisit the site of my earlier frustration.

When I returned to the location, the weather had turned really cloudy and overcast and had chased away all the other photographers. I wondered whether I had misunderstood God. What could I possibly photograph in these conditions? Then I felt God was telling me to set my gear up and get ready to take a shot. I had nothing better to do, so why not?

After I was all set up, it began to rain. There I sat under a huge multi-colored umbrella looking very obviously like an idiot out in a field getting rained on. Two hours passed with people occasionally driving by. With looks of amazement, they would look my way. I was really bored with the rain and began to ponder the situation. I suggested to God that if He could just give me a small break in the clouds and let the light through, maybe we could have a little rainbow. After all, nothing is impossible with God!

Suddenly there was a huge clap of thunder that made my hair stand on end. I thought either God had heard me and was going to do something or I was going to be hit by lightning. So guess what happened? It rained even harder! I tried to cover up as best I could and wondered whether I was kidding myself. But I was not ready to give in. I still believed God was going to come through so I decided not to worry about getting drenched but to stick it out.

The torrential rain only lasted about ten minutes. Then the clouds parted slightly, the sun broke through for a few brief moments and a marvelous rainbow appeared over the field of wild flowers. It was absolutely breathtaking – far more spectacular than I had dared to imagine – and I was there alone to capture the glorious spectacle on film (see pages 100-101). Just as another photographer arrived and took out his camera, the magnificent light disappeared. The other photographer ran up to me and said, "Man, you were lucky!" I replied, "No, I was blessed."

The moral of the story is – have faith. We often need to stand firm through the rainy season until the blessing comes, as it takes a little rain to bring forth rainbows in our lives.

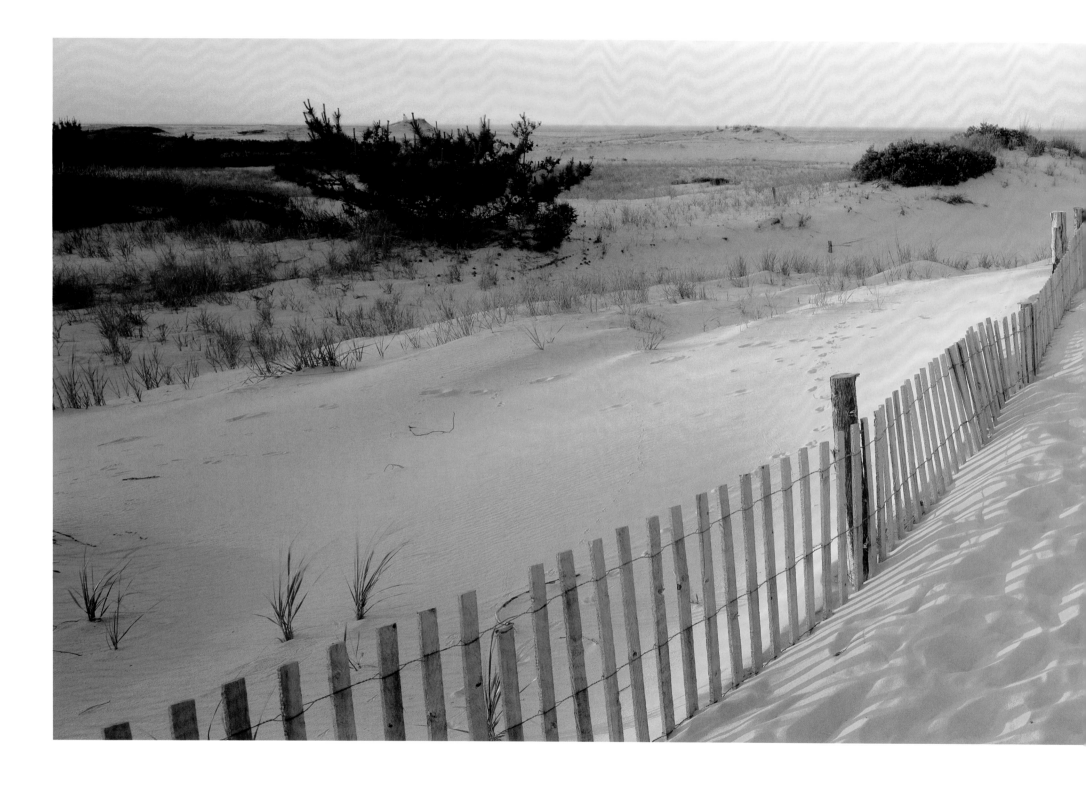

Sand Dunes, Cape Henlopen State Park, Delaware

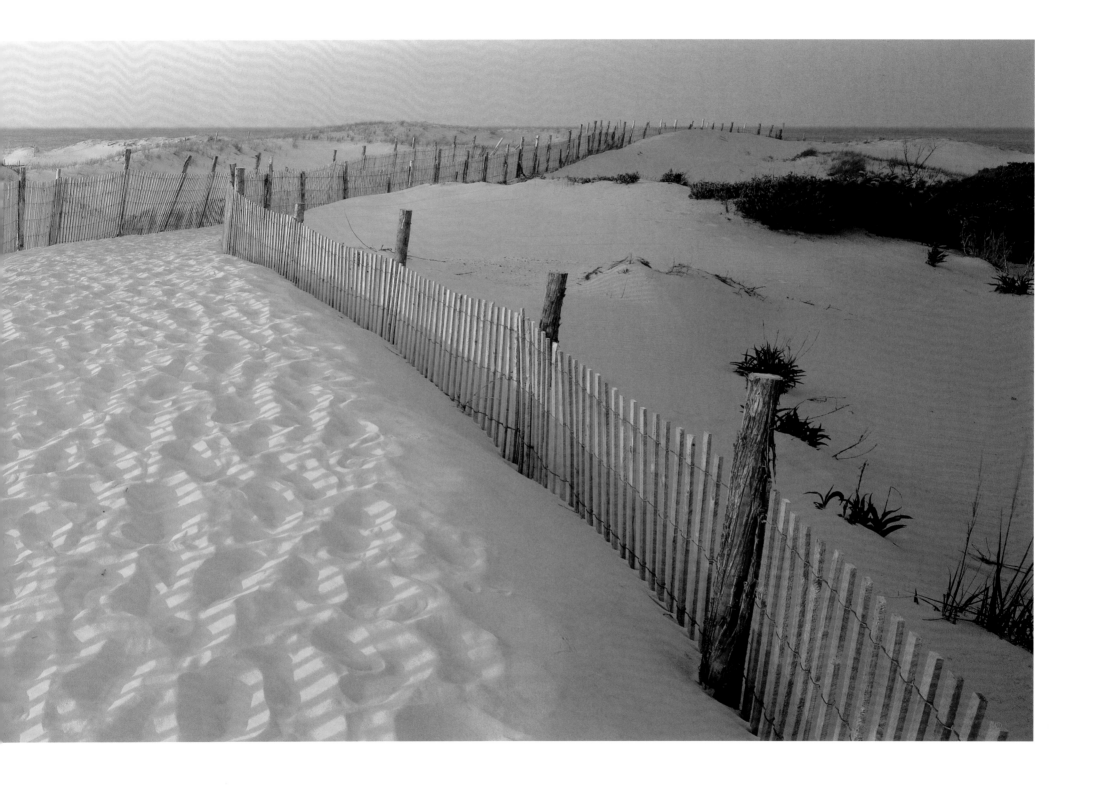

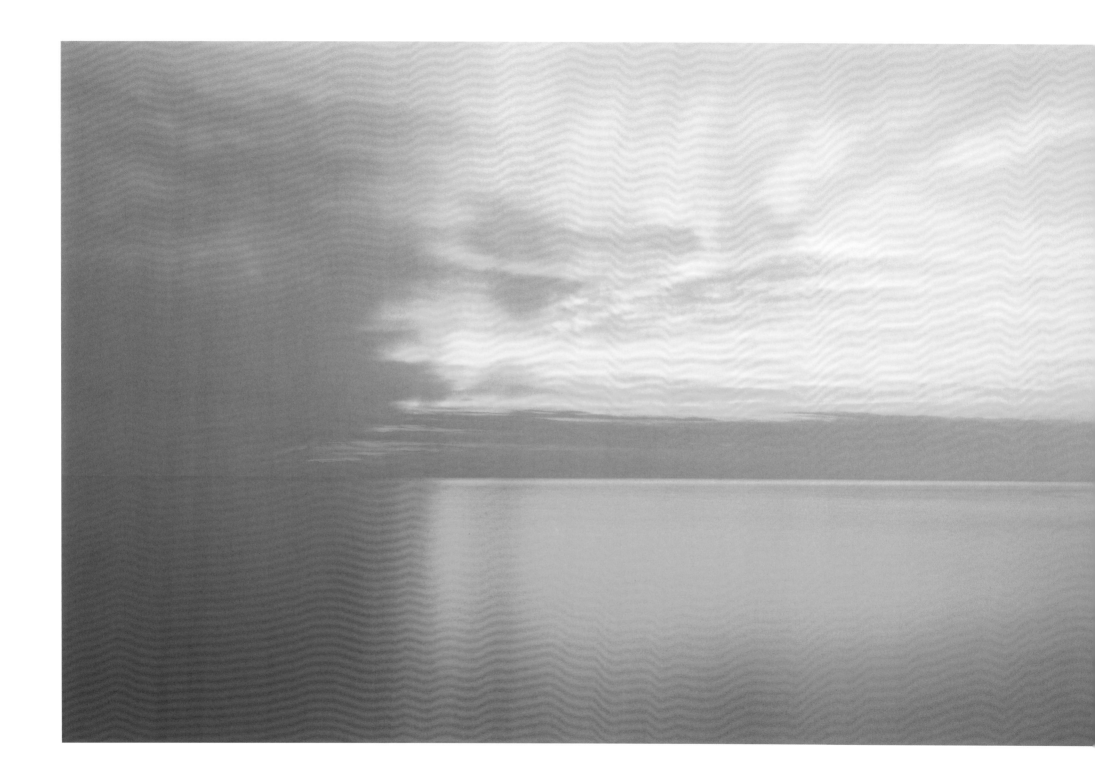

Marblehead Lighthouse, Lake Erie, Ohio

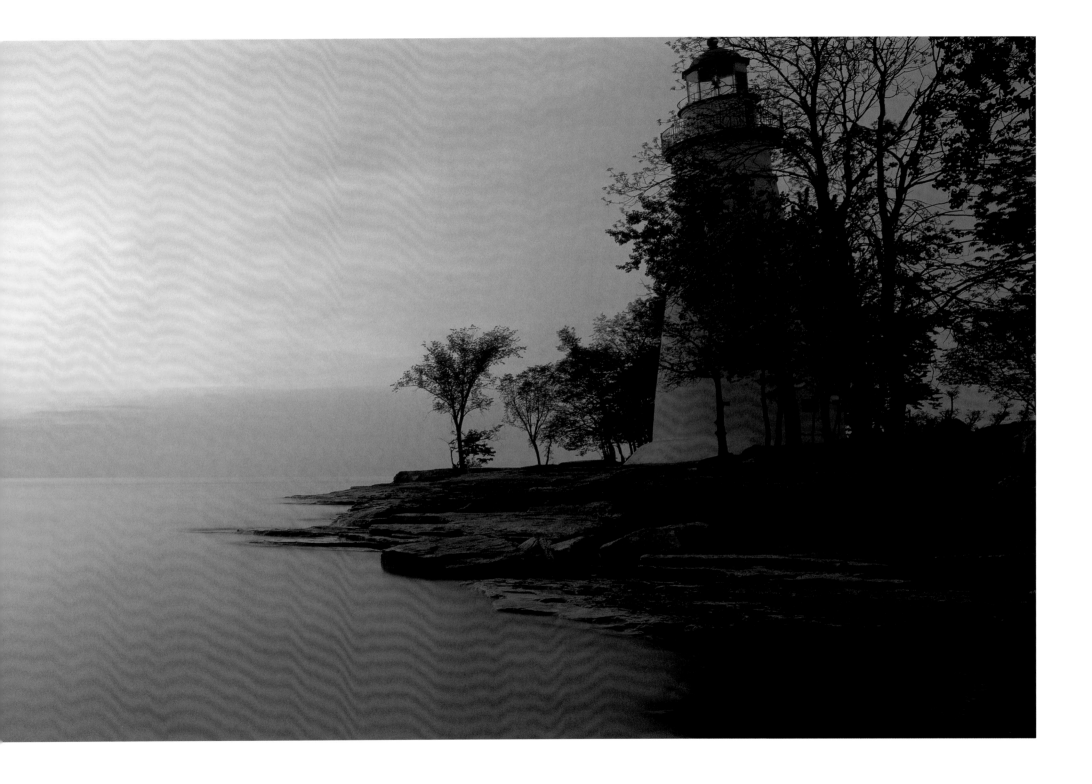

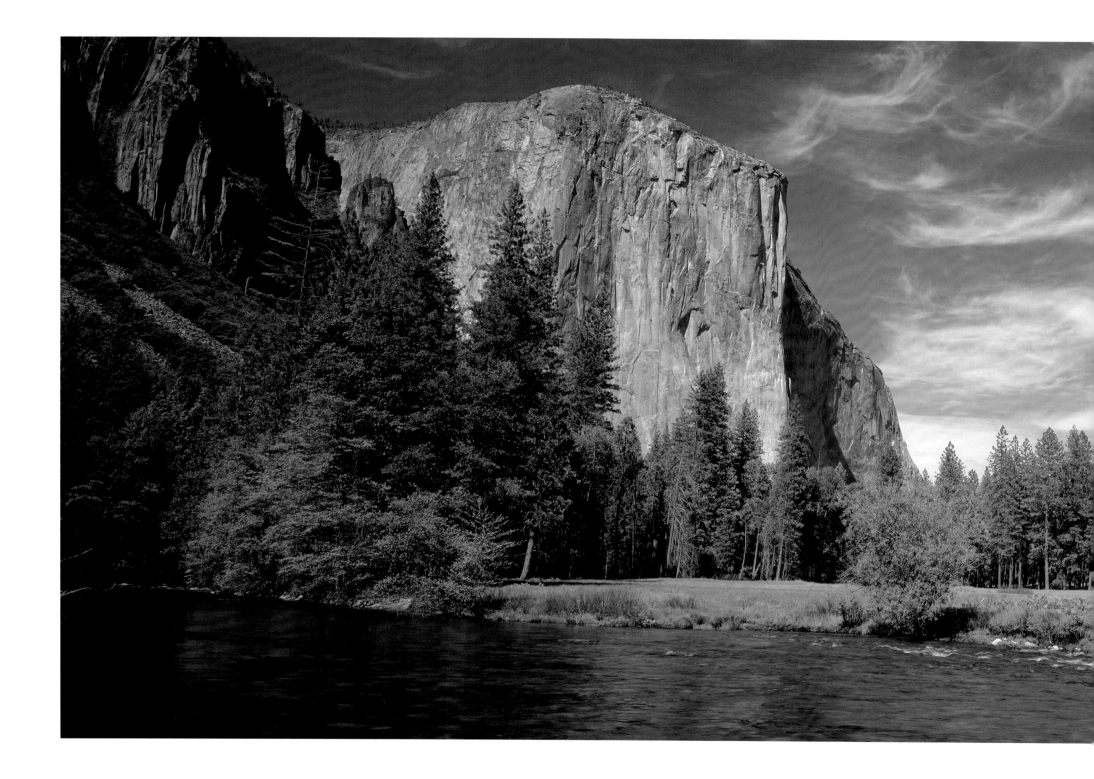

Bridal Veil Falls, Yosemite Valley, California

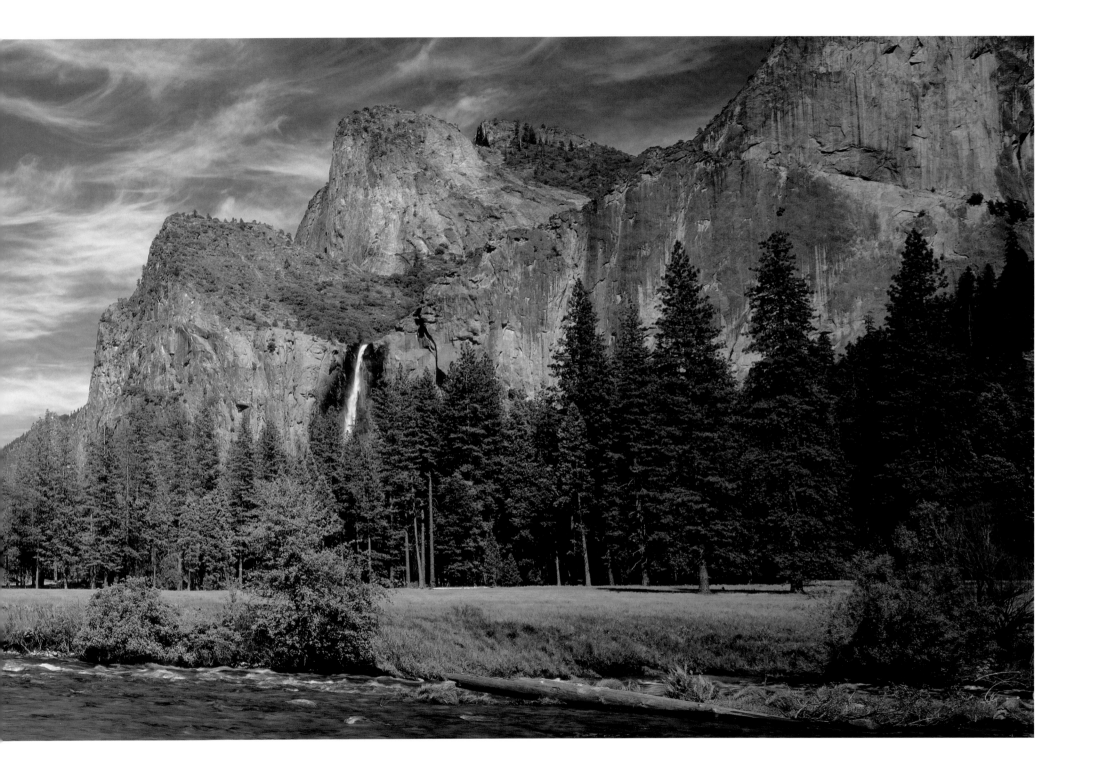

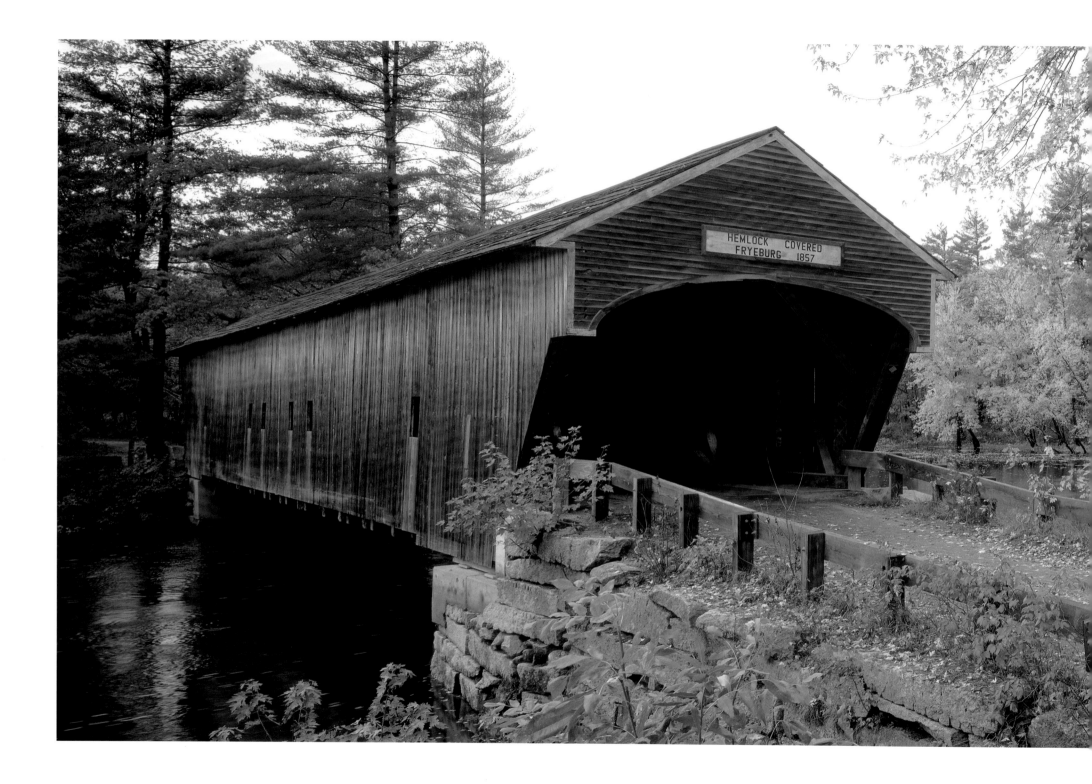

The sign on the bridge reads:

HEMLOCK COVERED
FRYEBURG 1857

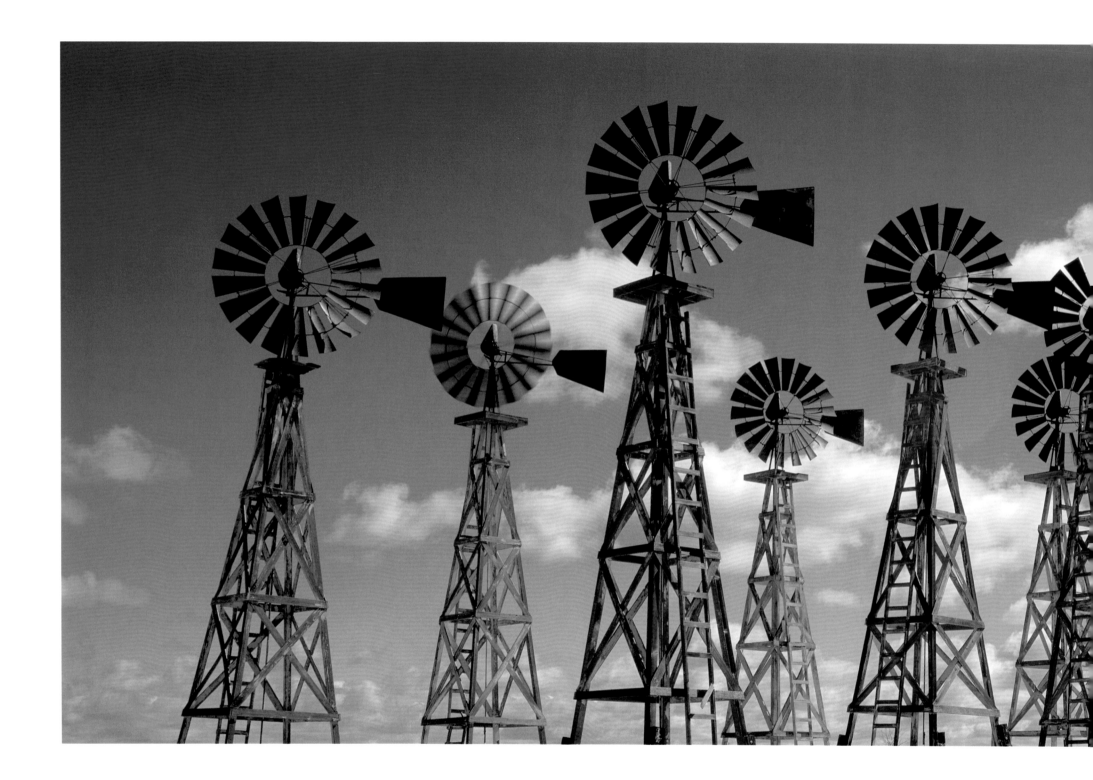

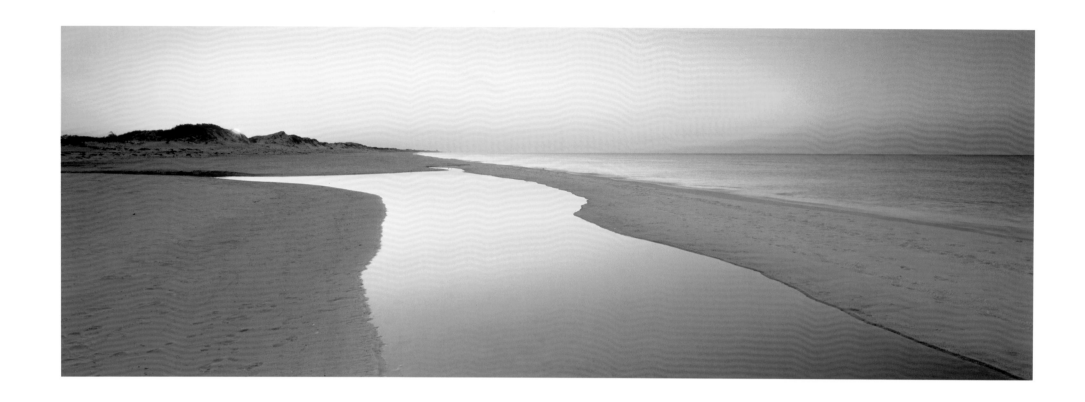

As the sun rises, it warms our soul and strengthens us
with hope for a new day.

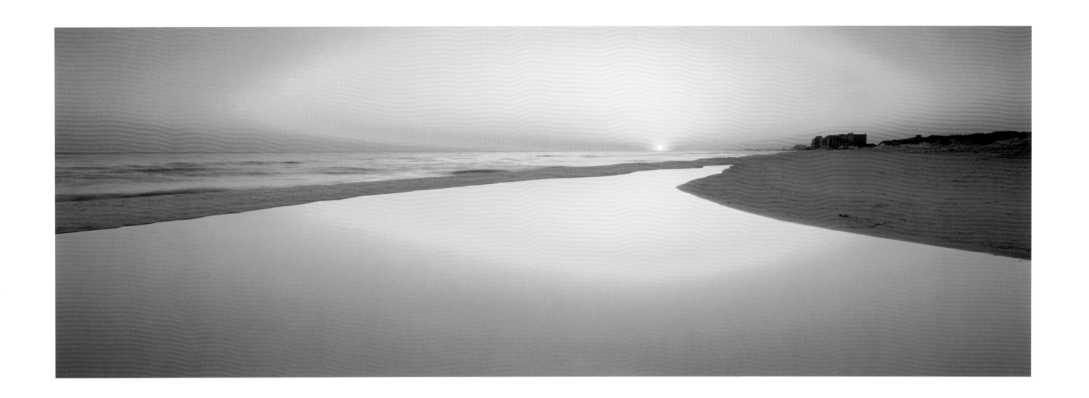

When day is done and we have done our best,
it's up to God to do the rest.

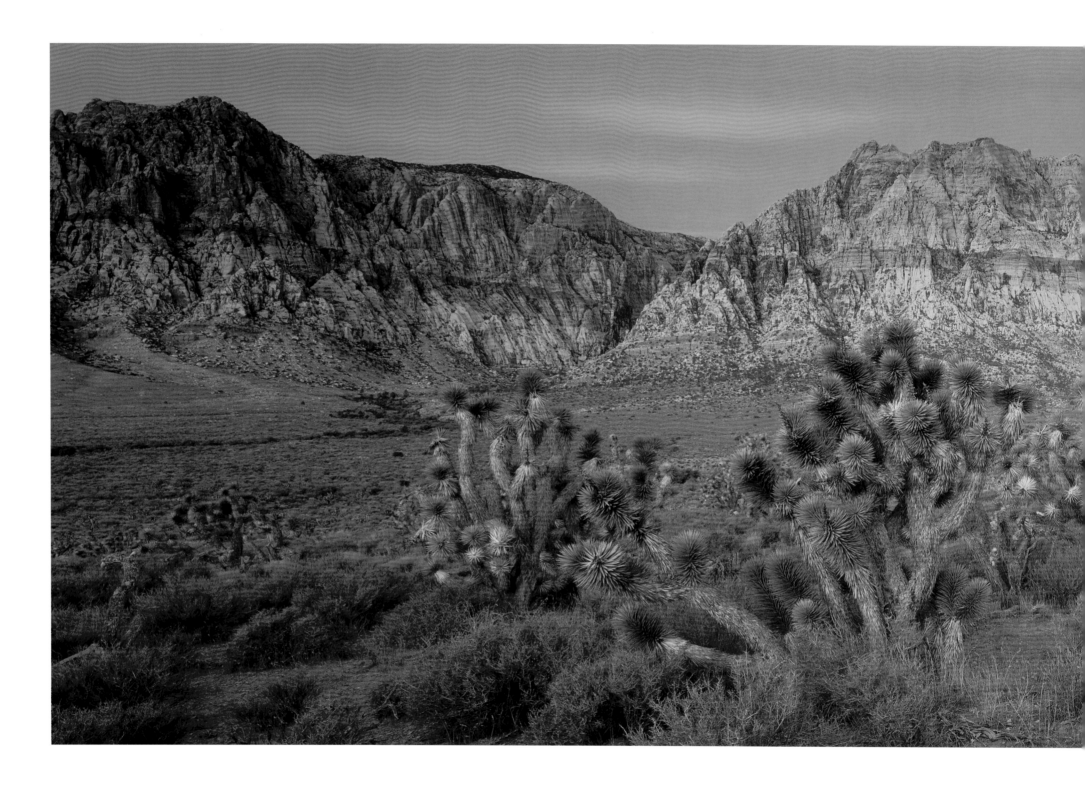

Desert near Red Rock Canyon, Nevada

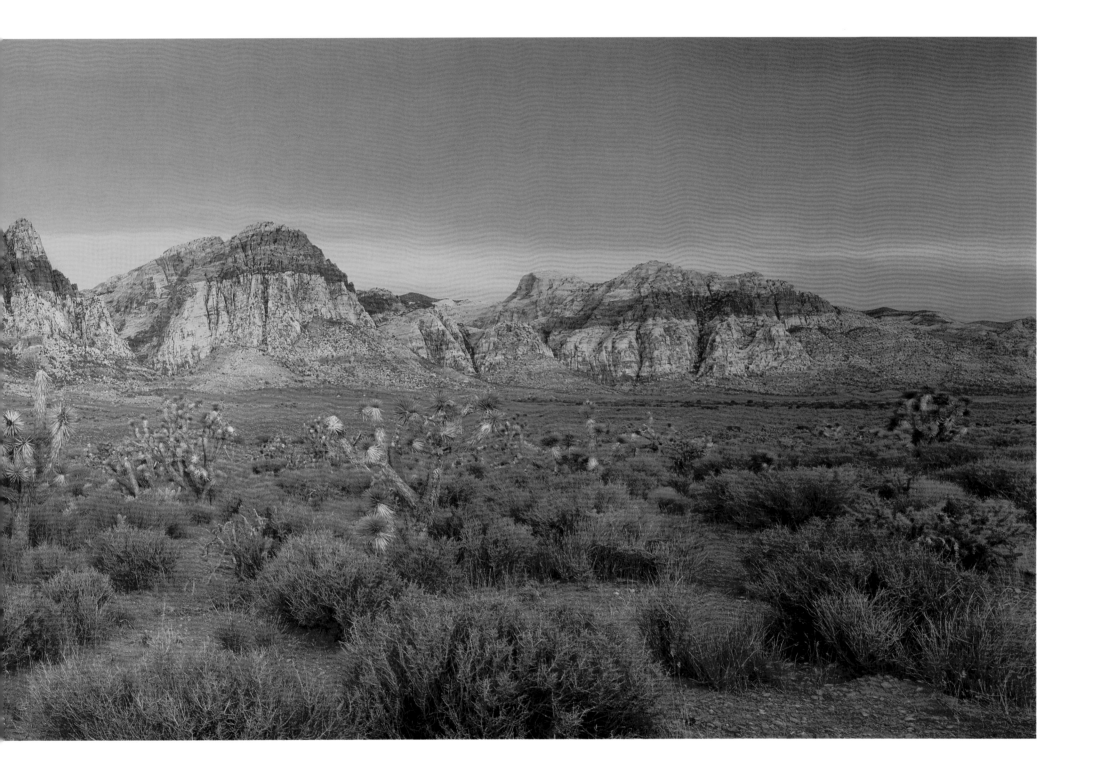

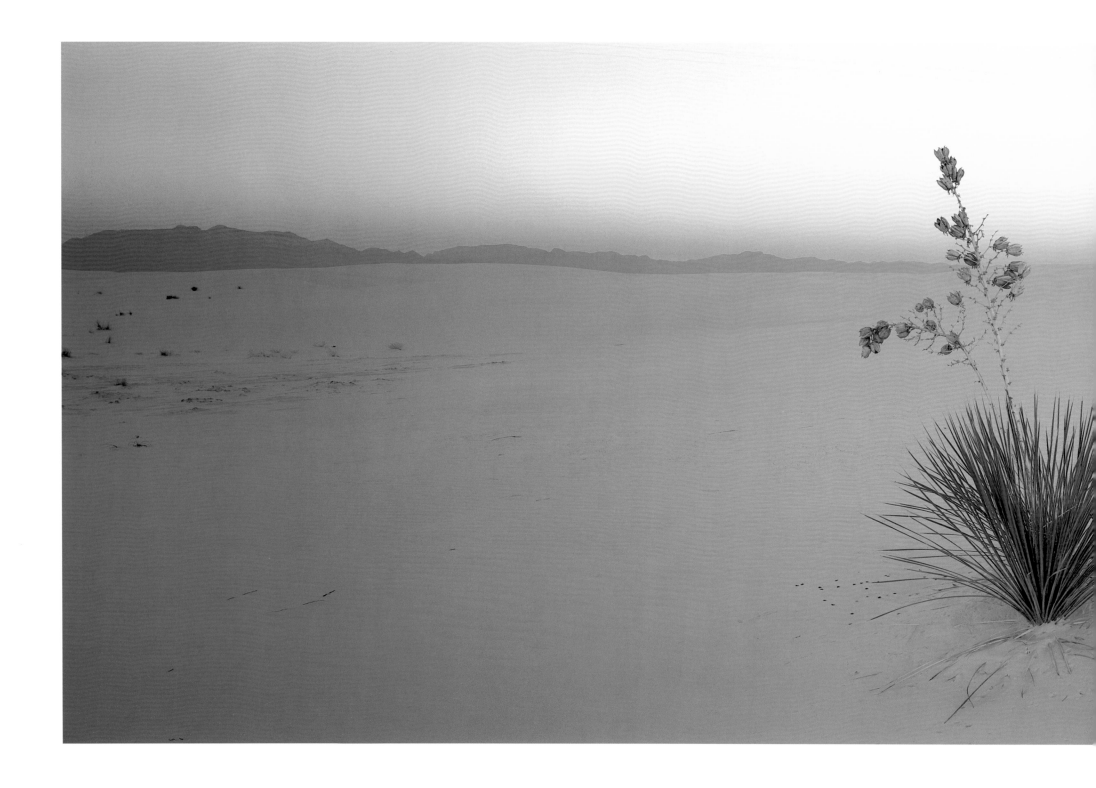

White Sands National Monument, New Mexico

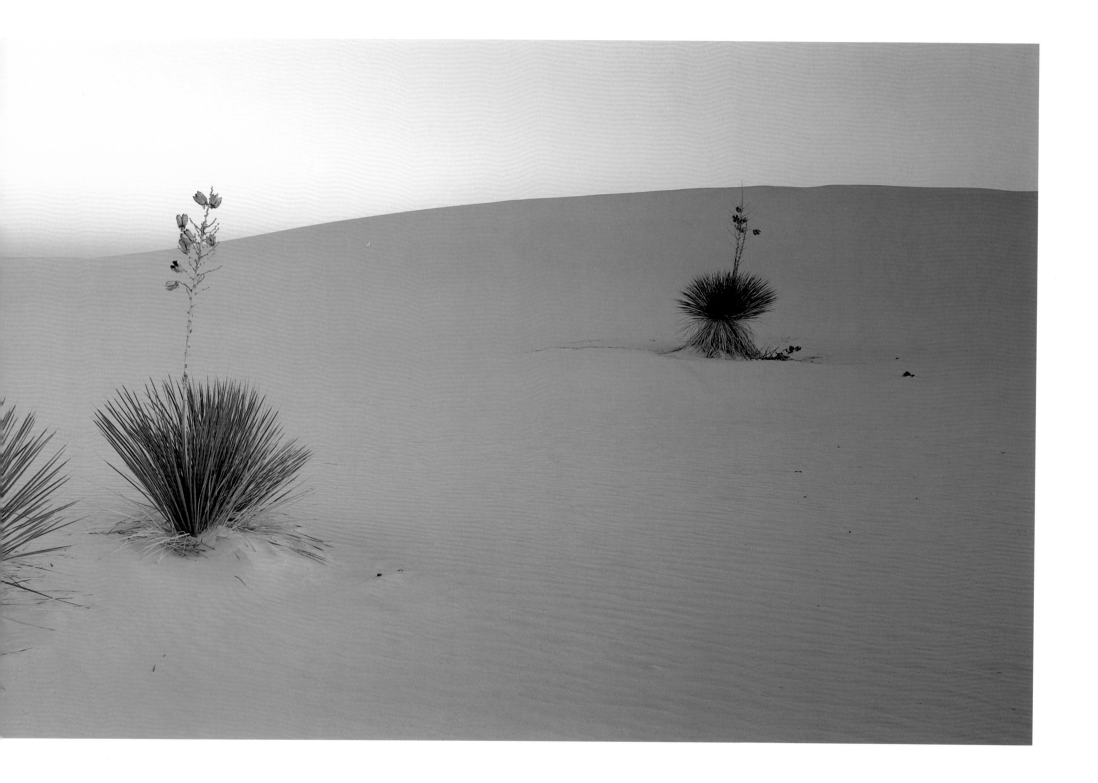

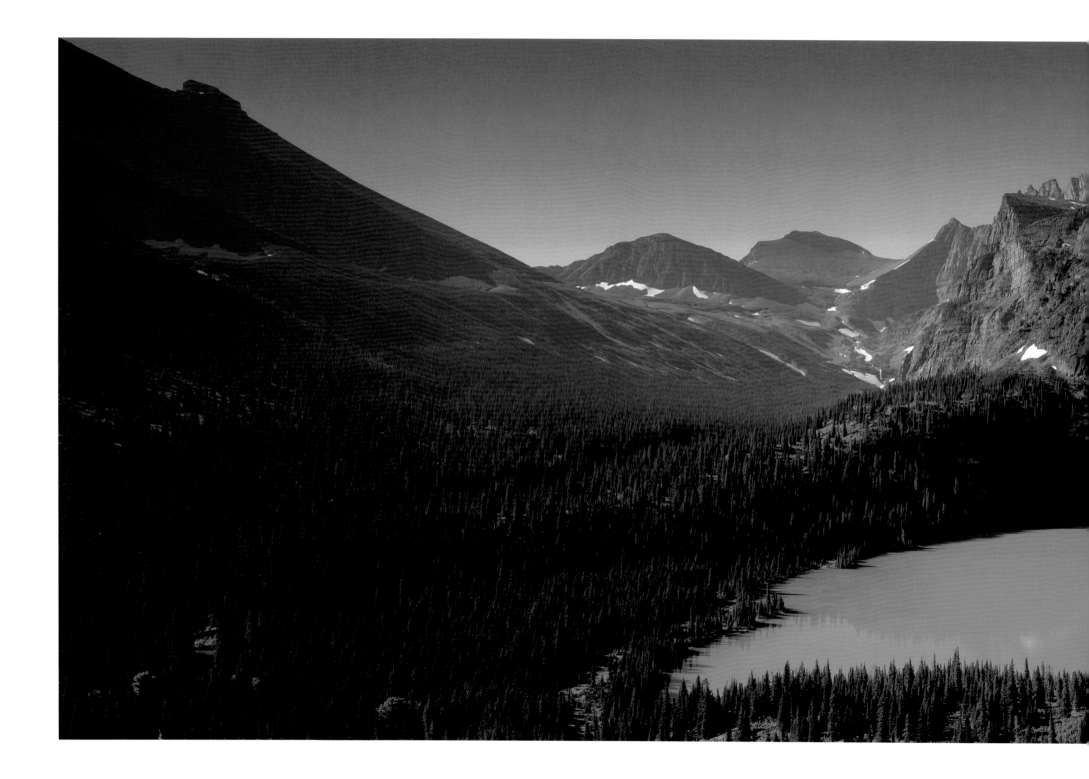

Grinnel Lake, Glacier National Park, Montana

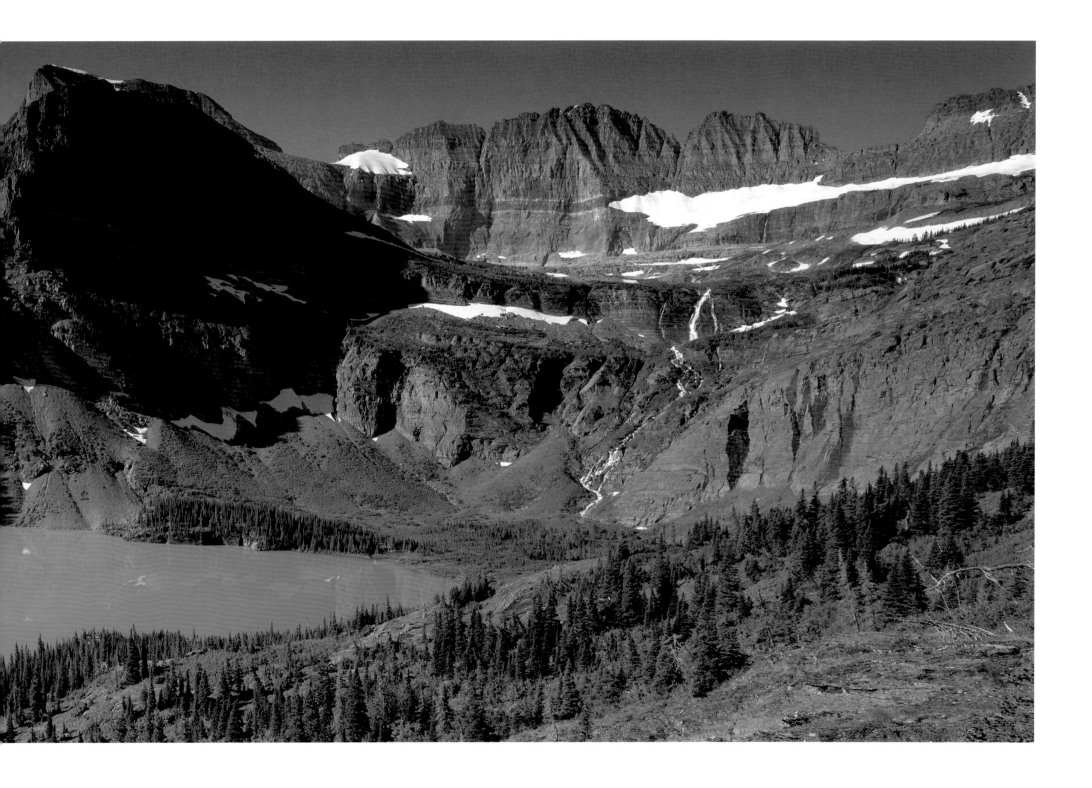

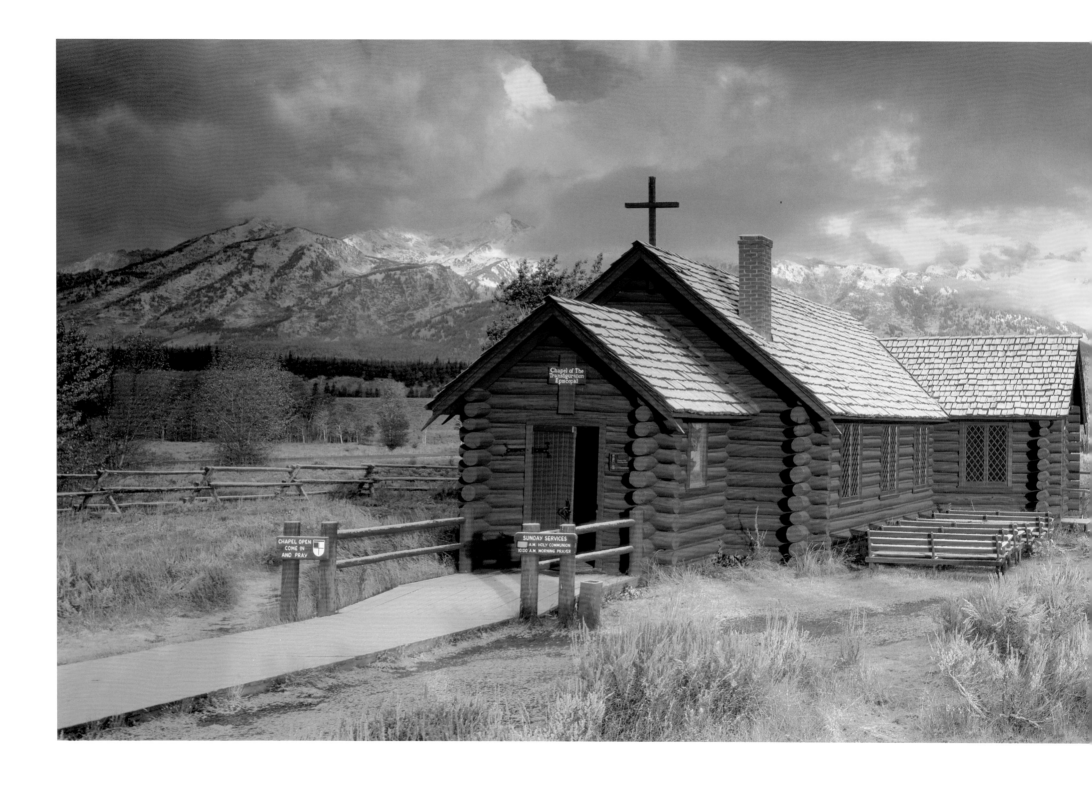

Chapel of the Transfiguration, Grand Tetons, Wyoming

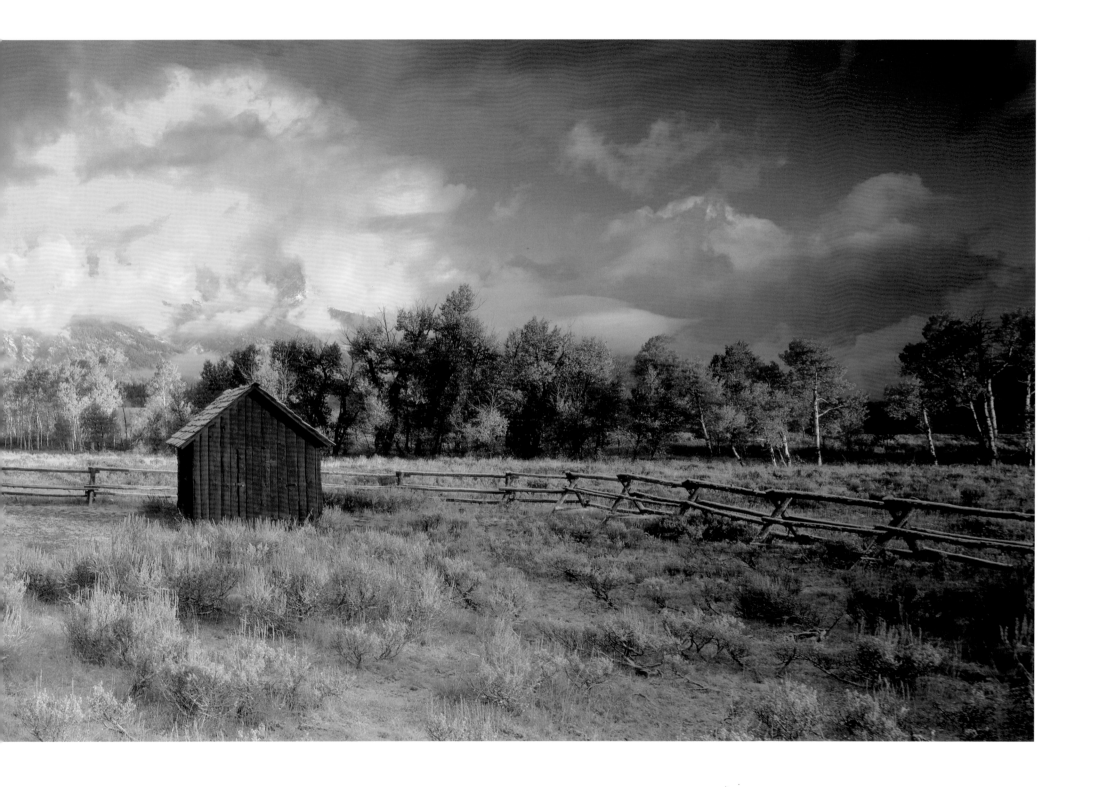

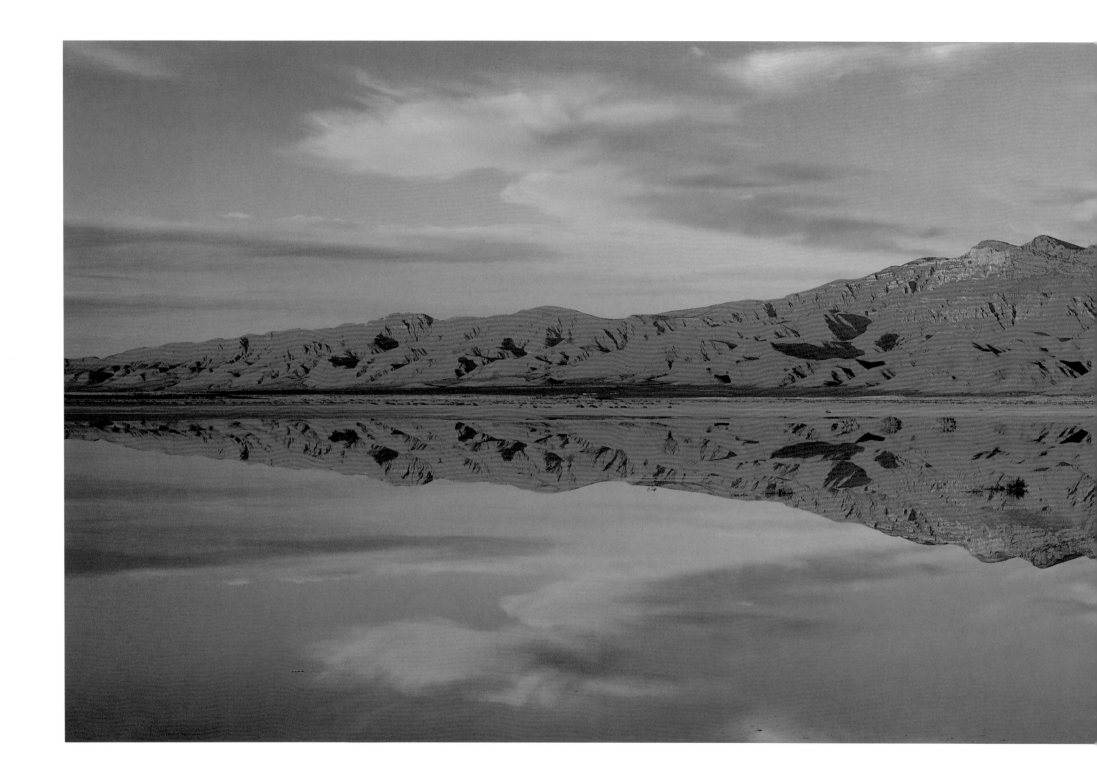

Salt Flat, Guadalupe Mountains, Texas

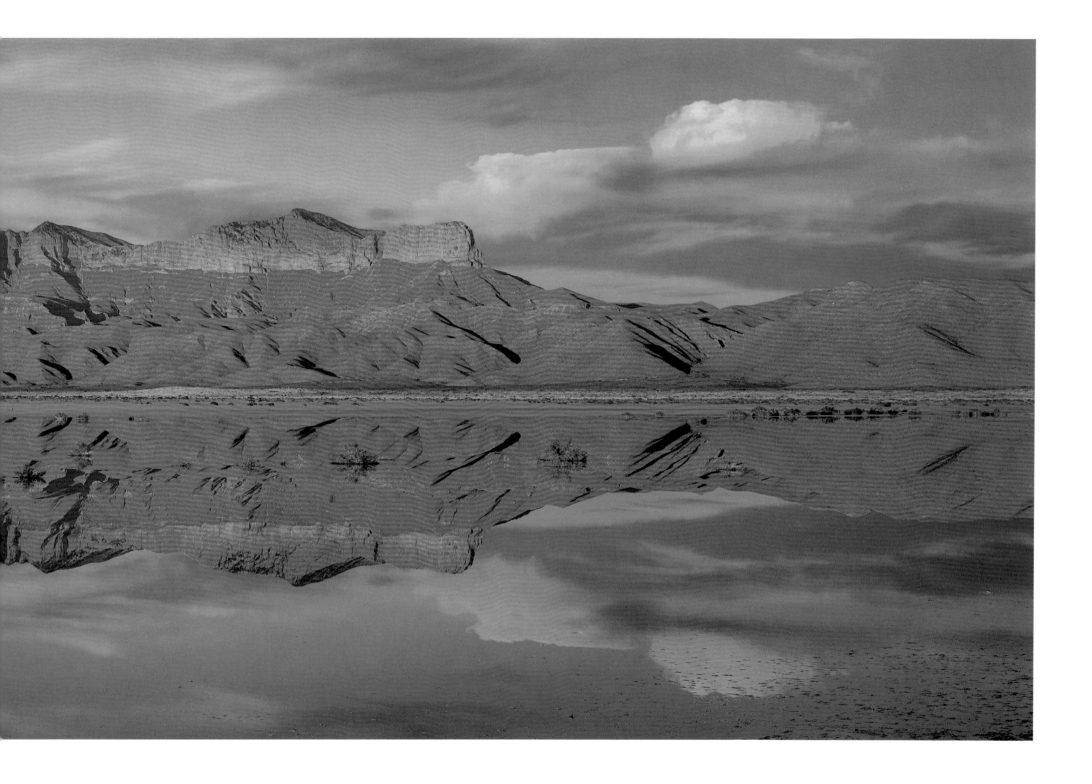

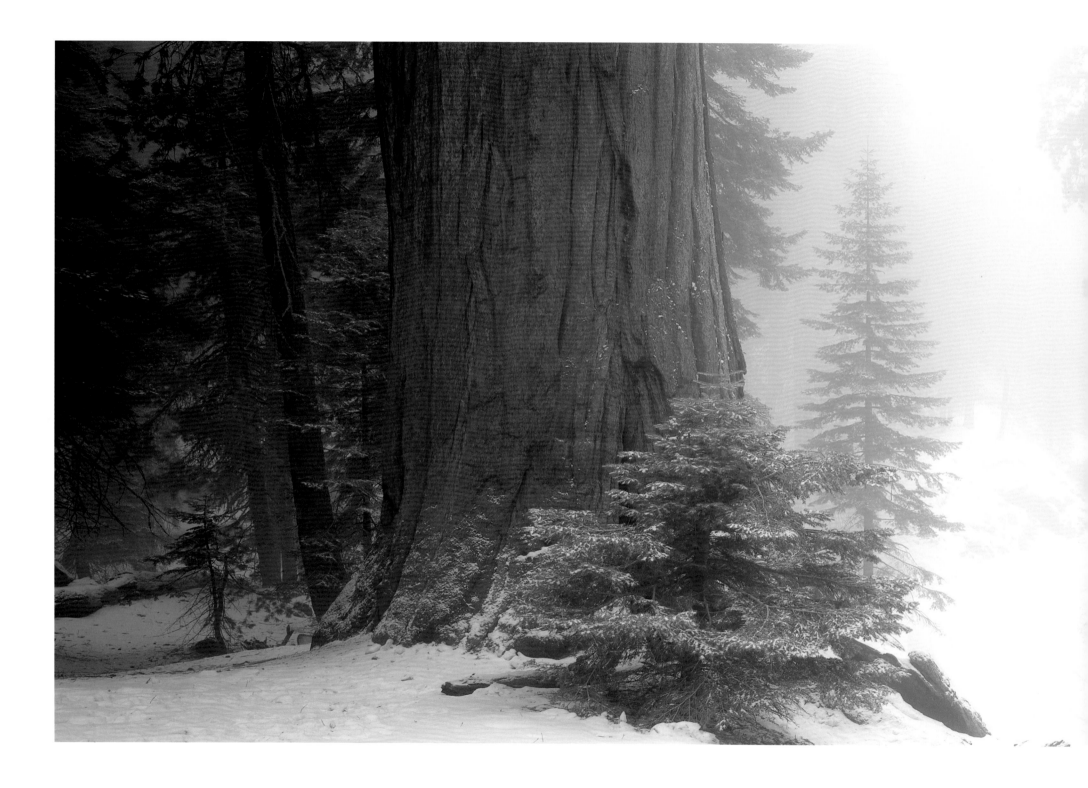

Sequoia Forest, California

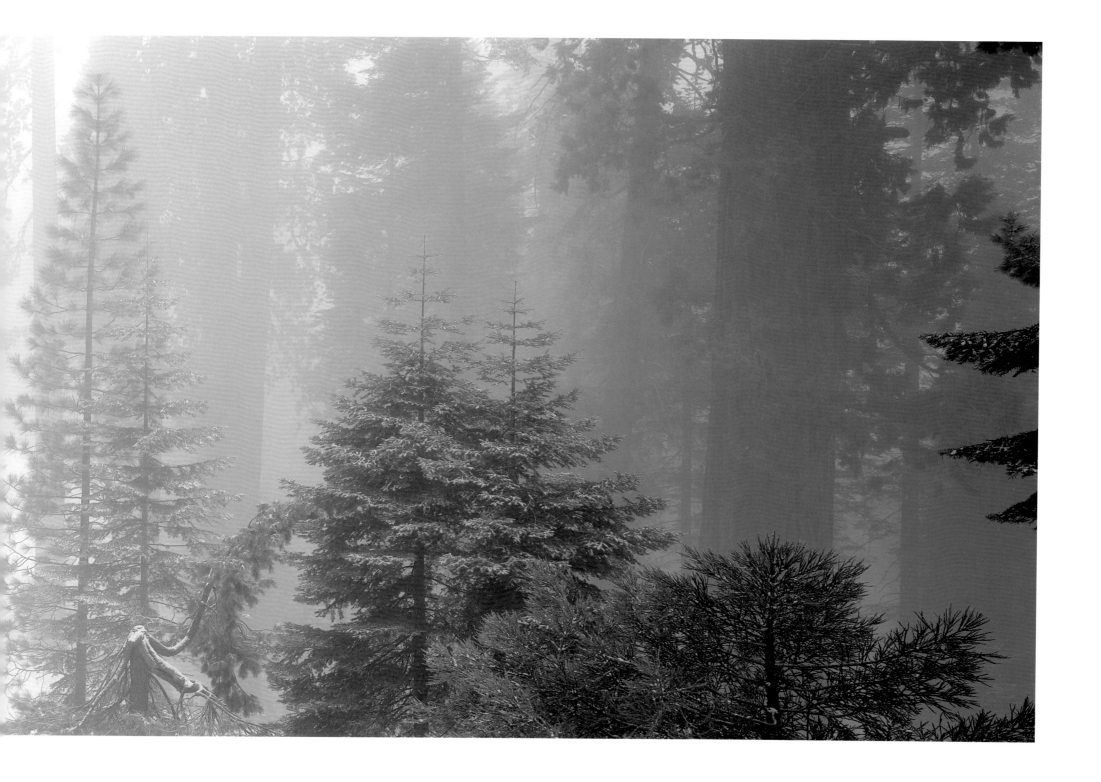

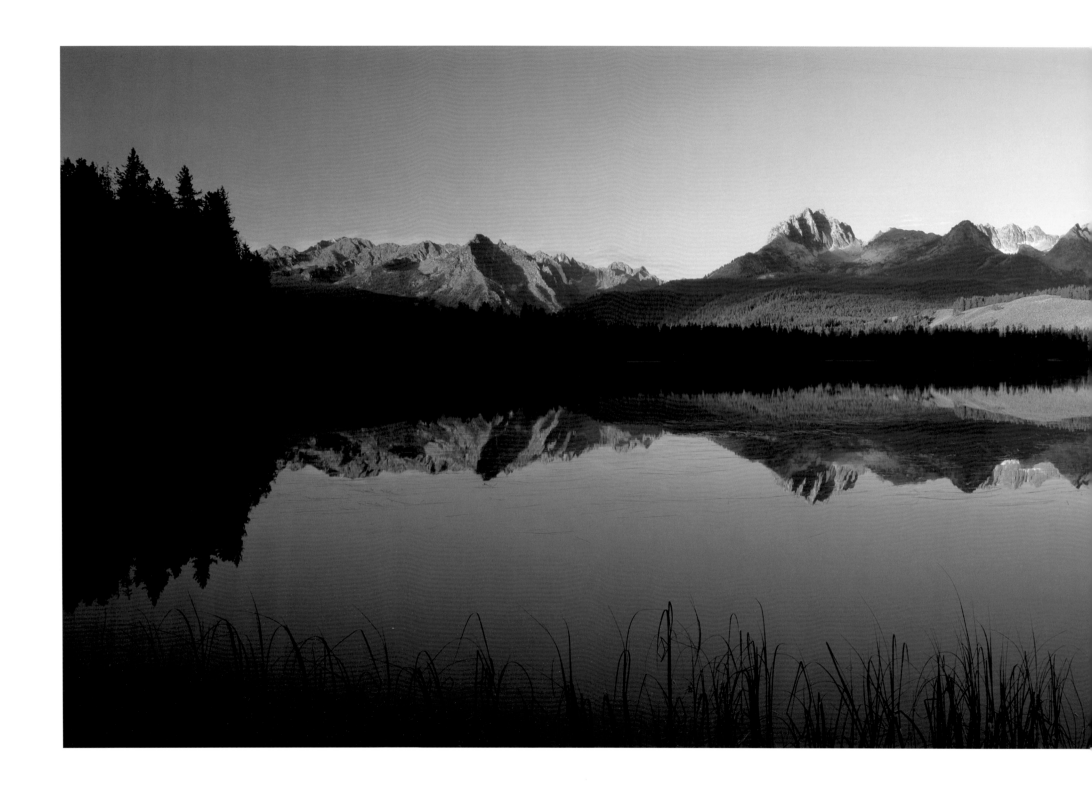

Little Redfish Lake, Stanley, Idaho

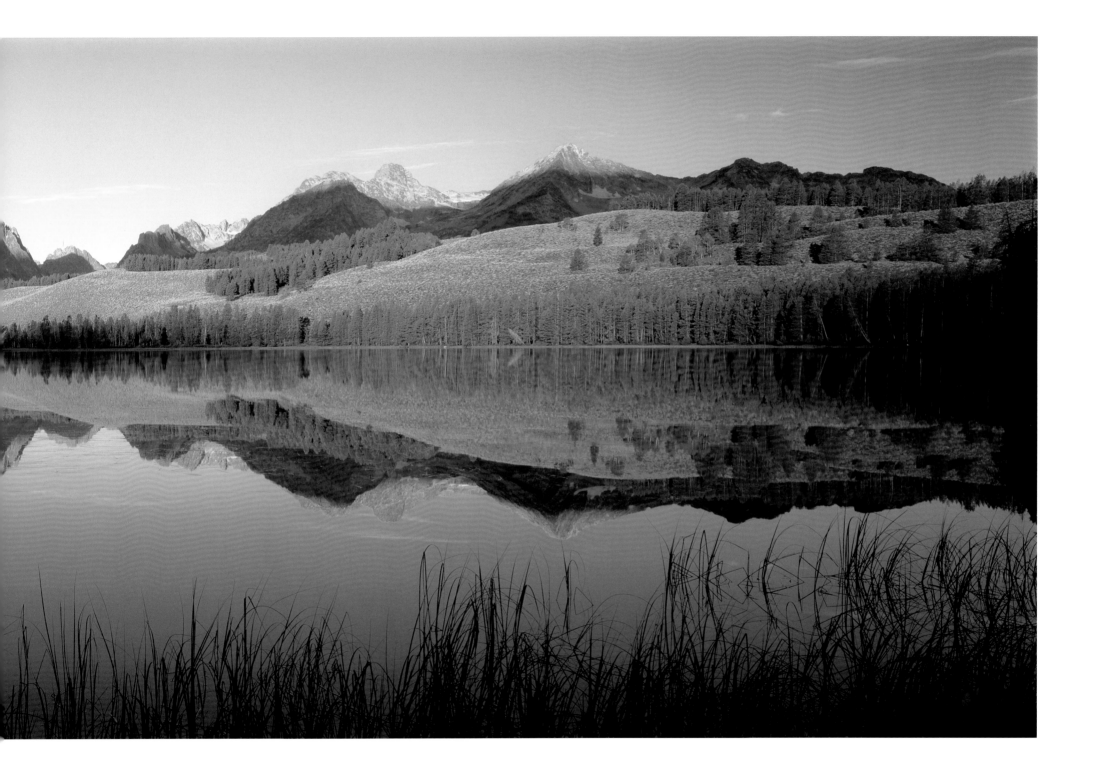

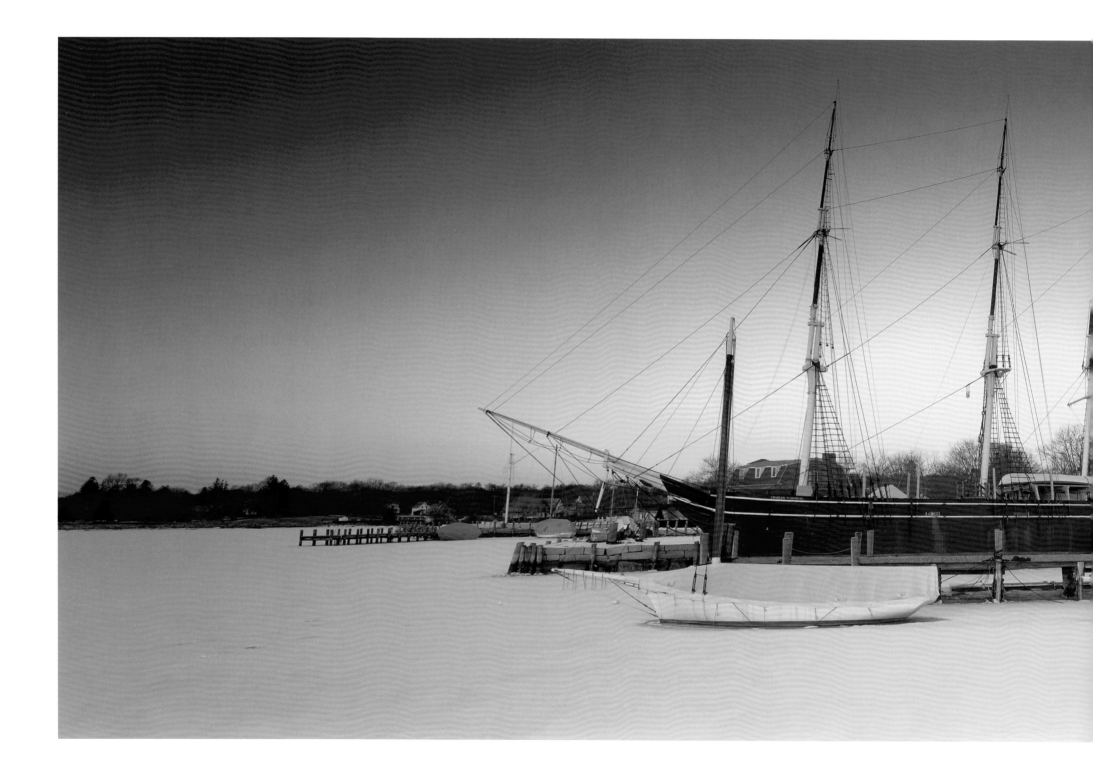

Sunset, Old Mystic Seaport, Connecticut

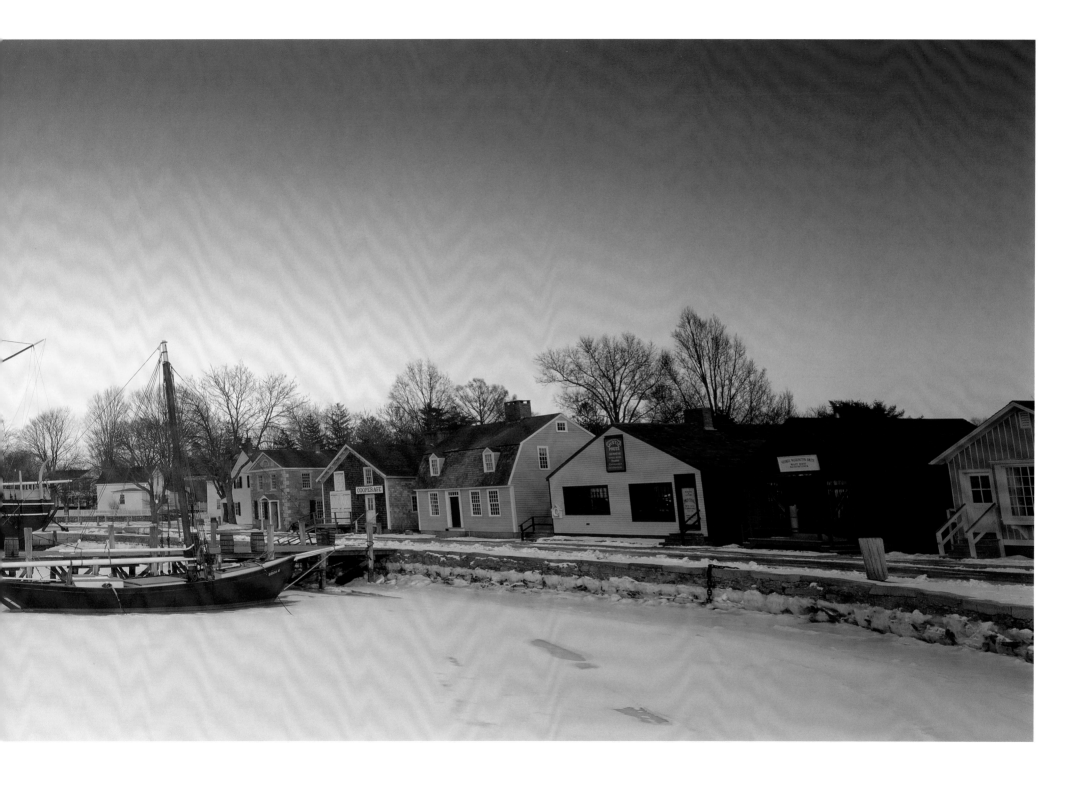

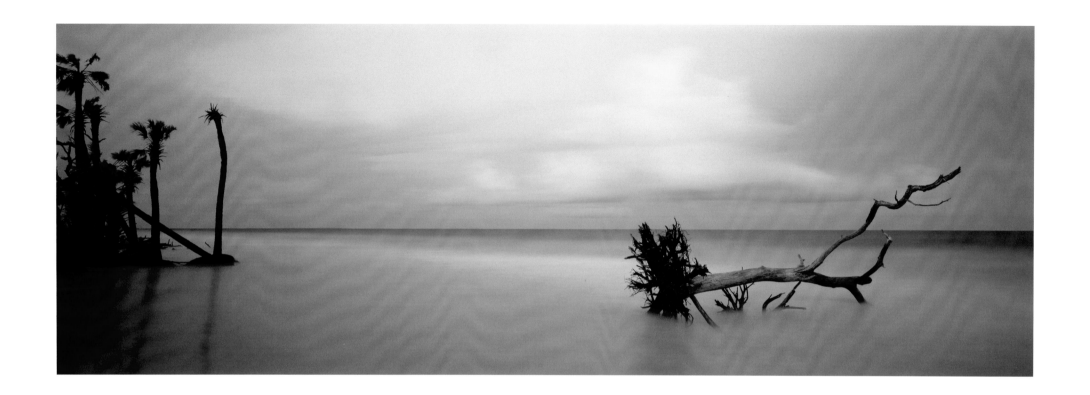

The semi-tropical vegetation of Hunting Island State
Park does its best to resist the relentlessly
encroaching seas at North Beach. The more firmly
rooted the trees are, the longer they will stand.

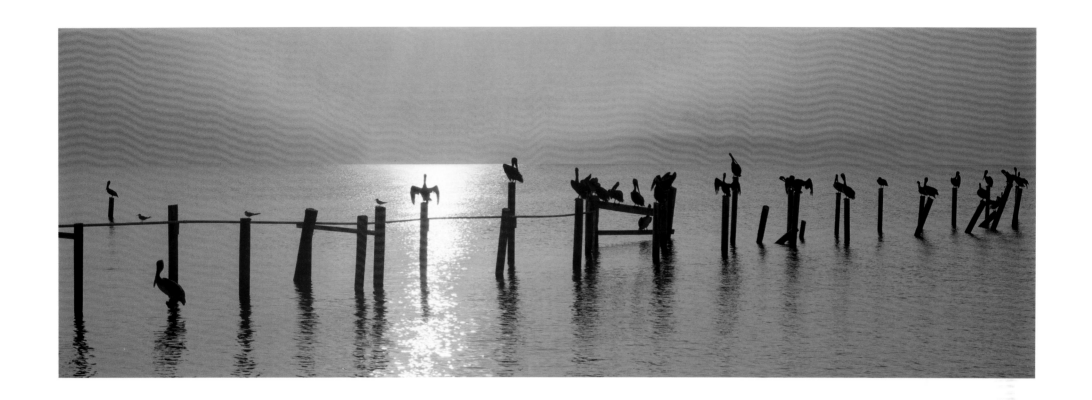

A wonderful bird is the pelican – its beak can hold more than its belly can! Here at Heron Bay the pelicans await the returning fishermen – and any morsels they might glean during the cleaning of the catch.

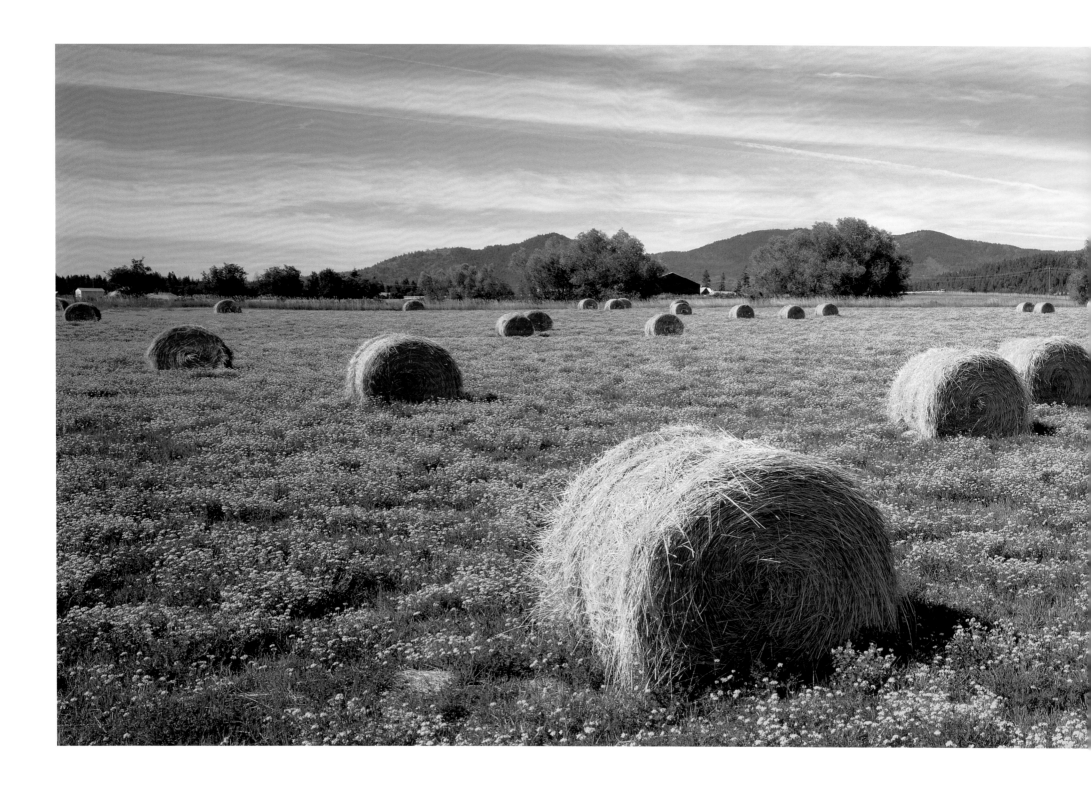

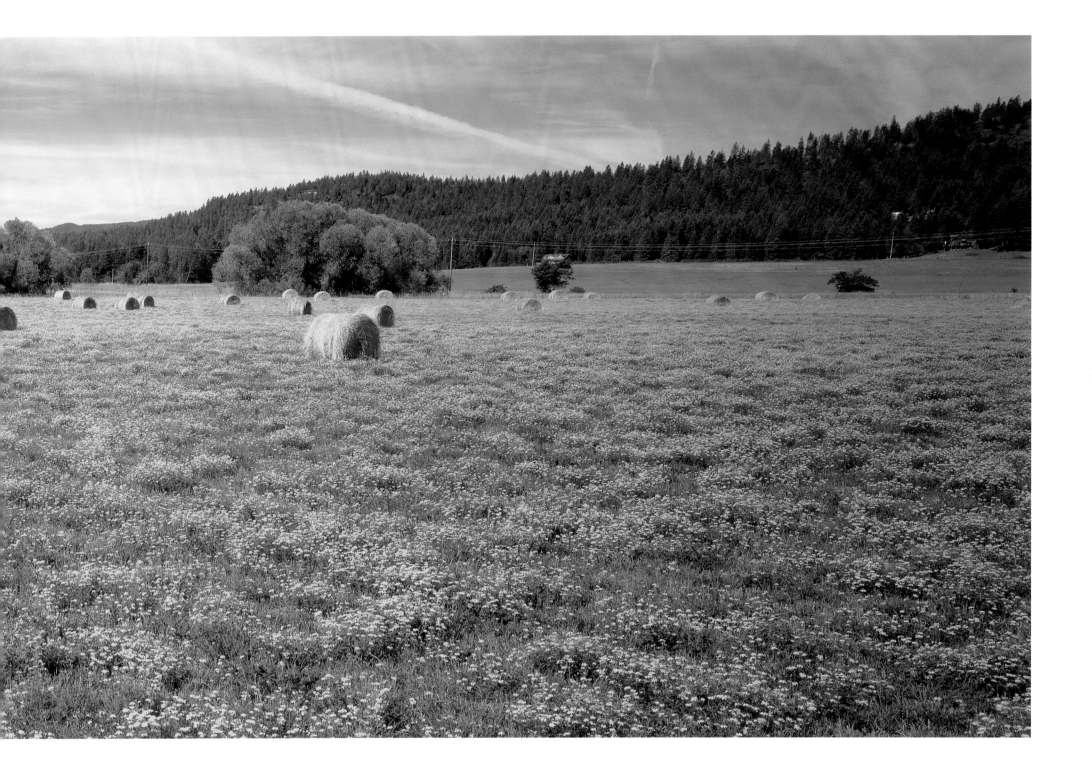

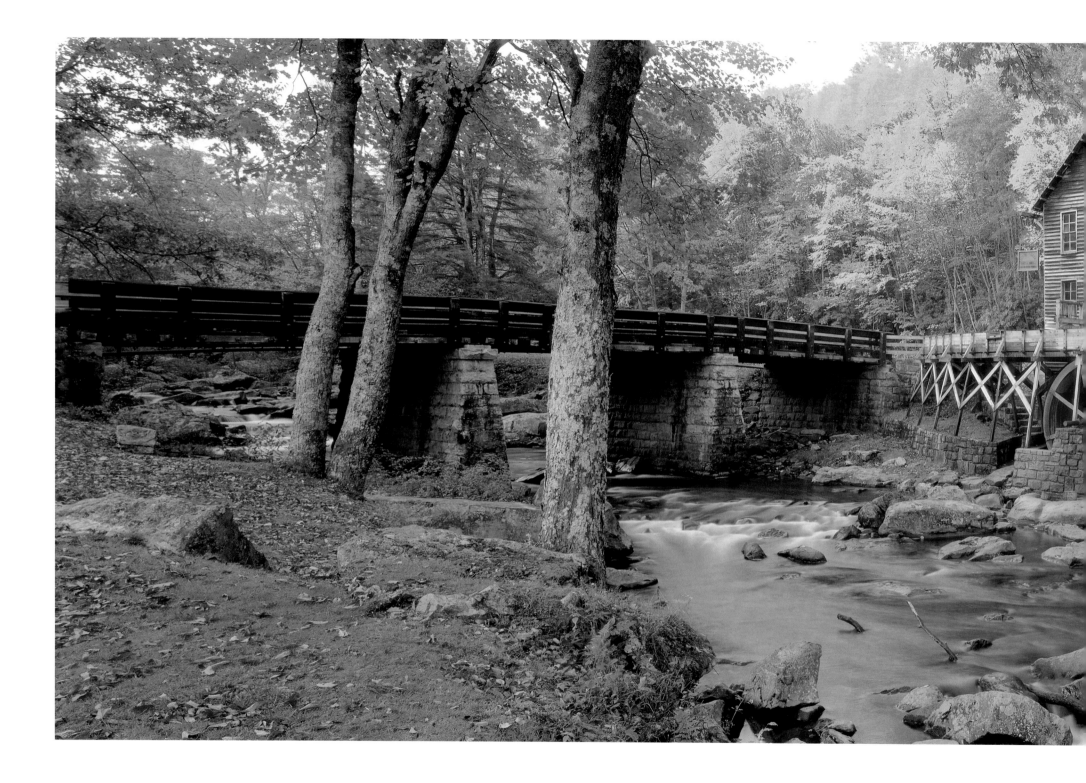

Glade Creek Grist Mill, Babcock State Park, West Virginia

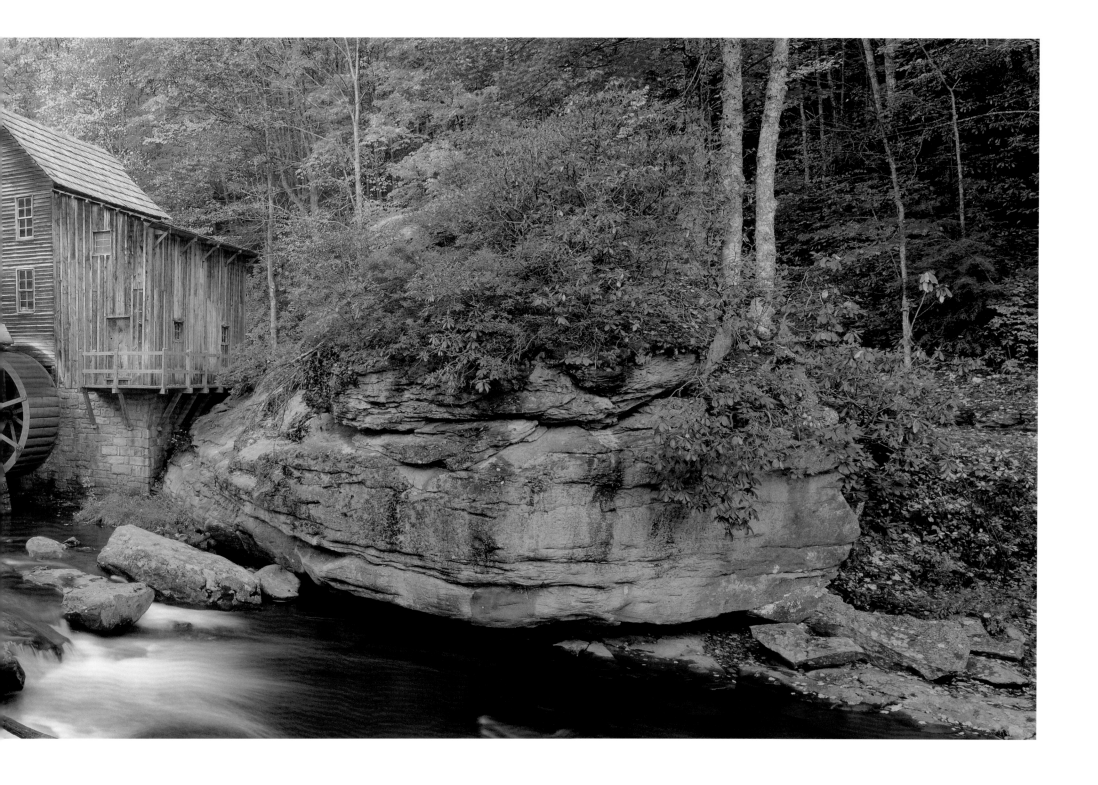

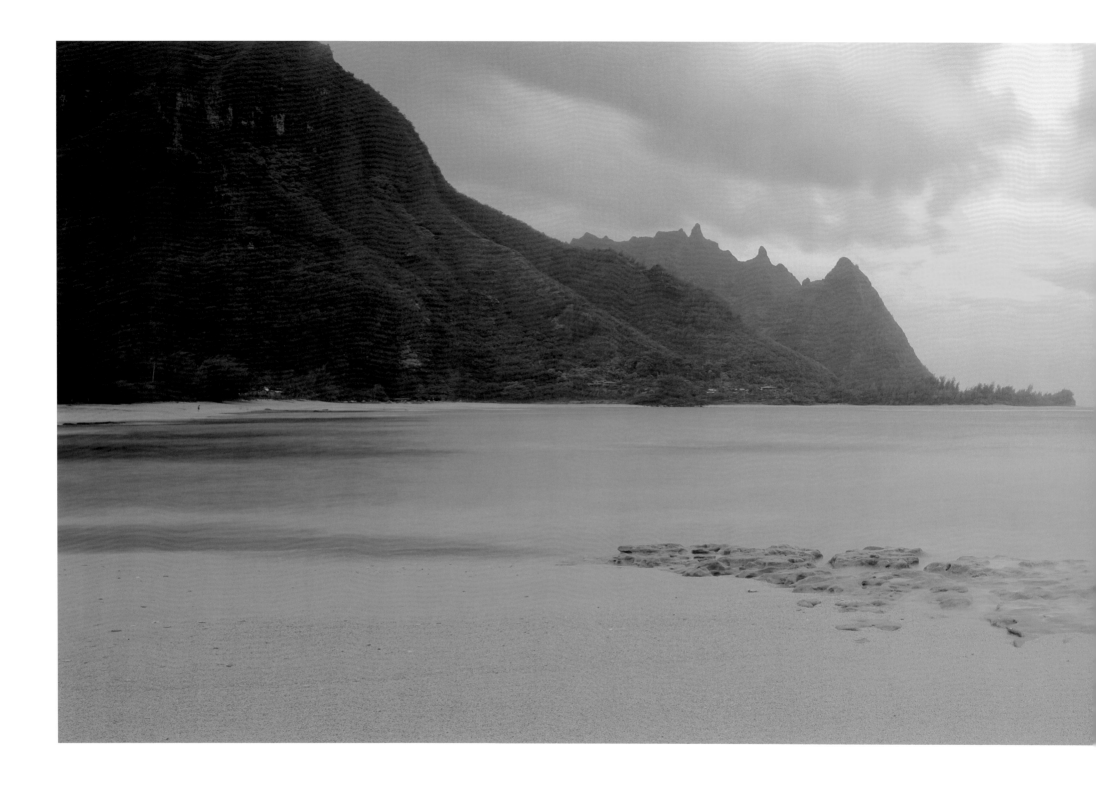

Bali Hai, Kauai, Hawaii

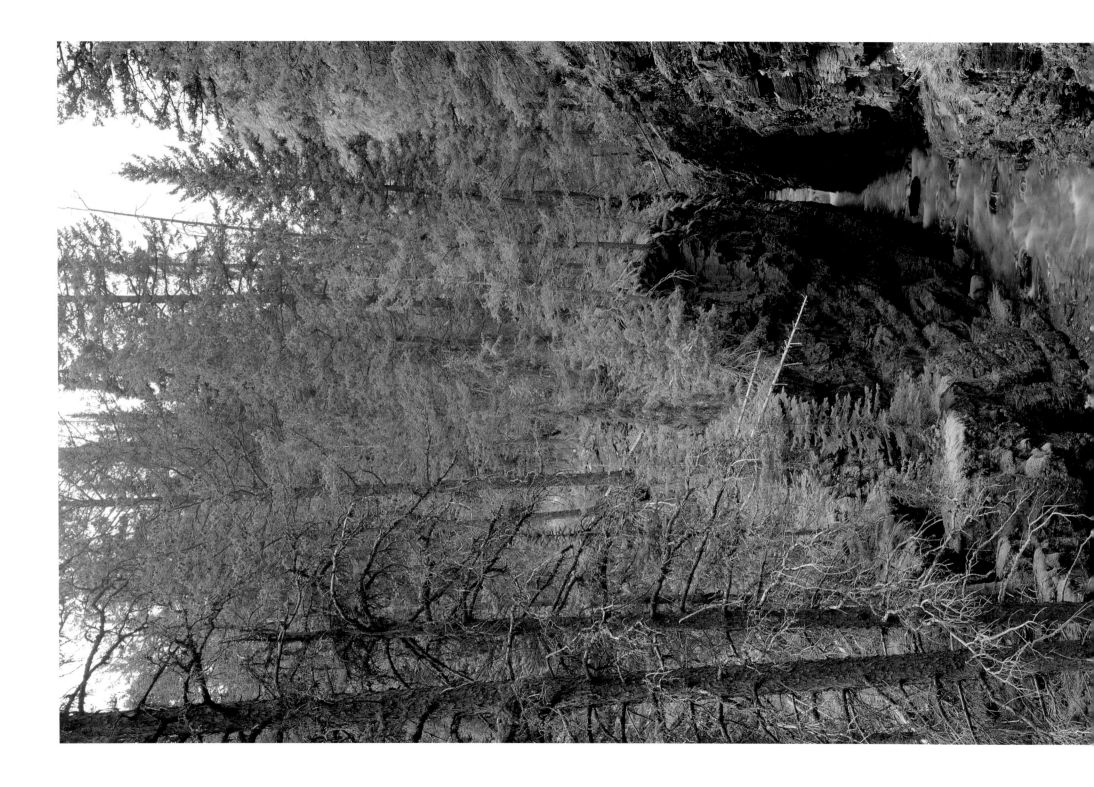

Sundrift Gorge, Glacier National Park, Montana

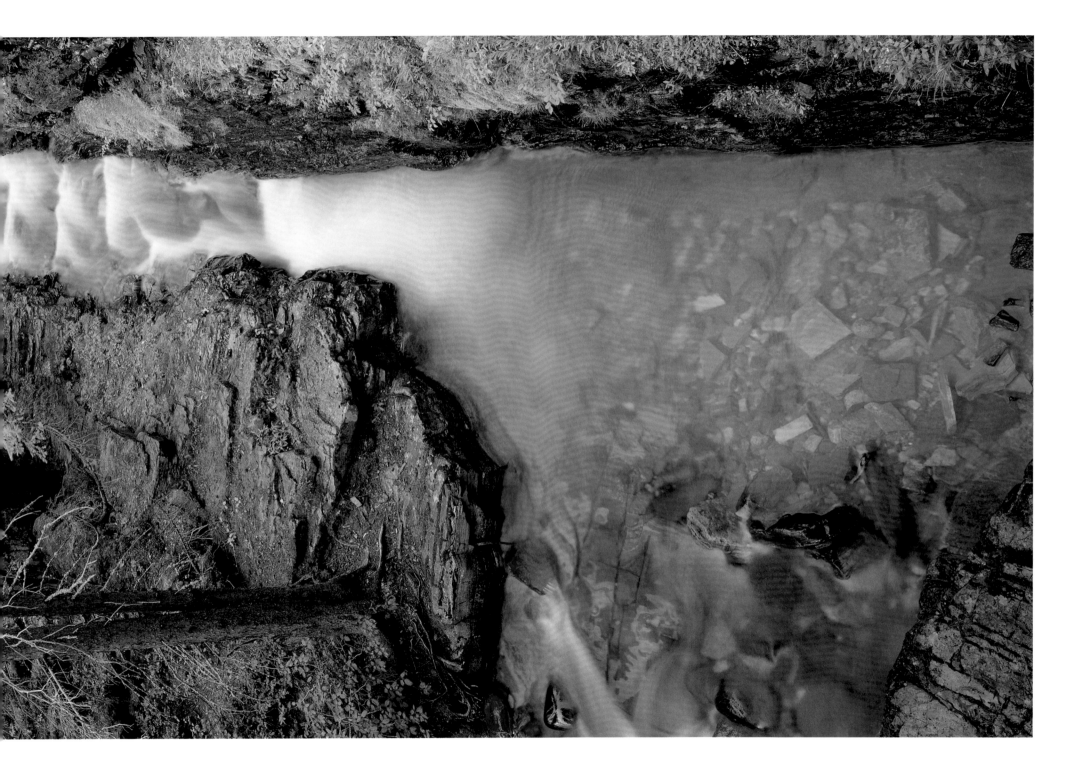

Small groves of trees clinging to the sides of towering sand cliffs are dwarfed by the gigantic proportions of Grand Sable Dunes. Pastel hues from the twilight sky are reflected in the world's largest freshwater lake as it laps the foundations of these 300-foot sand-hills.

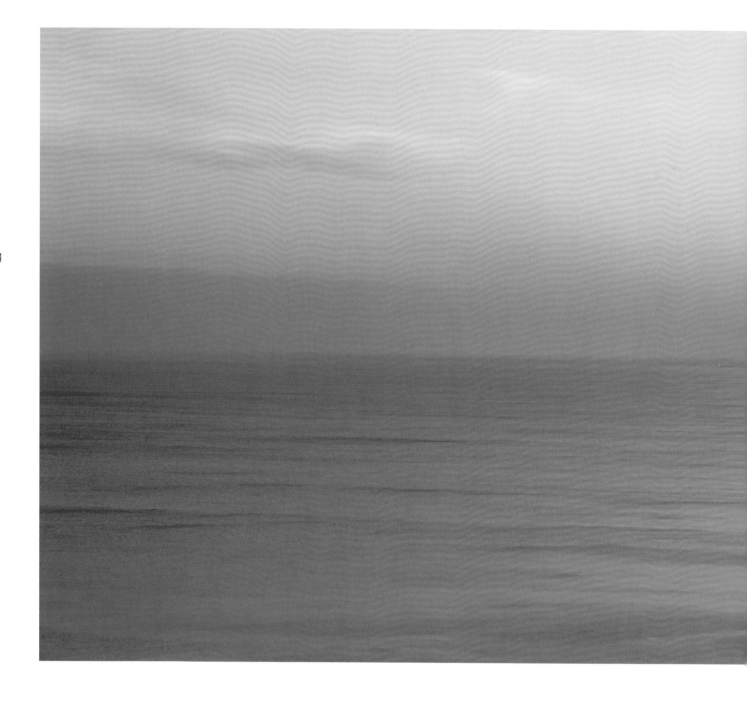

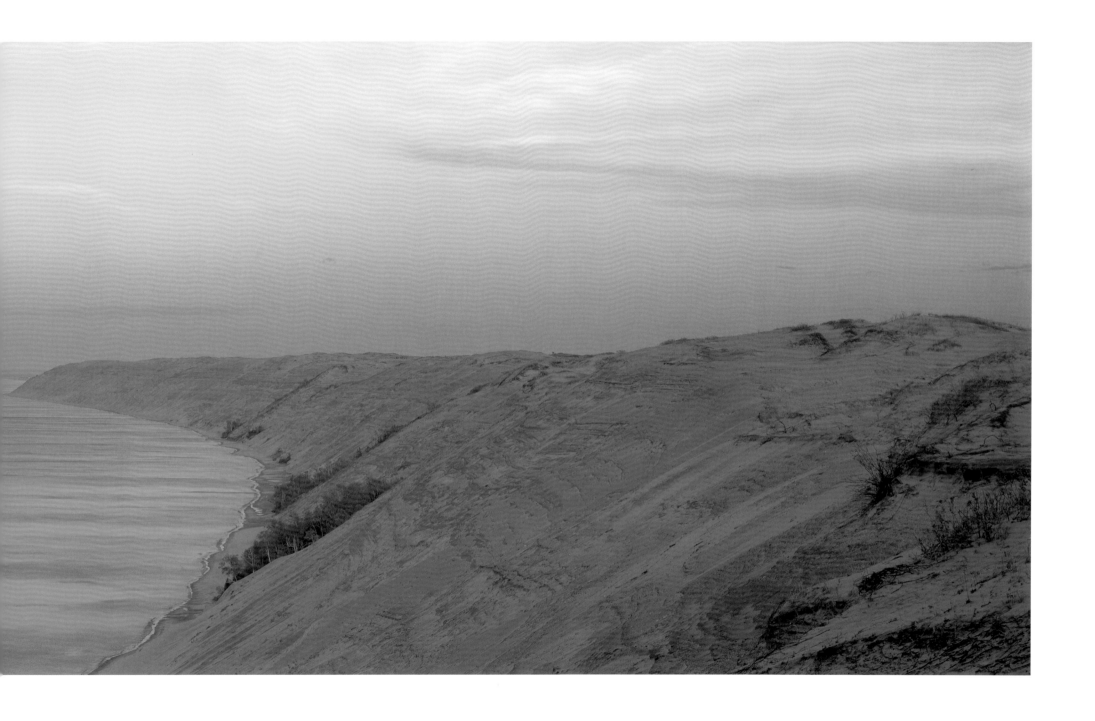

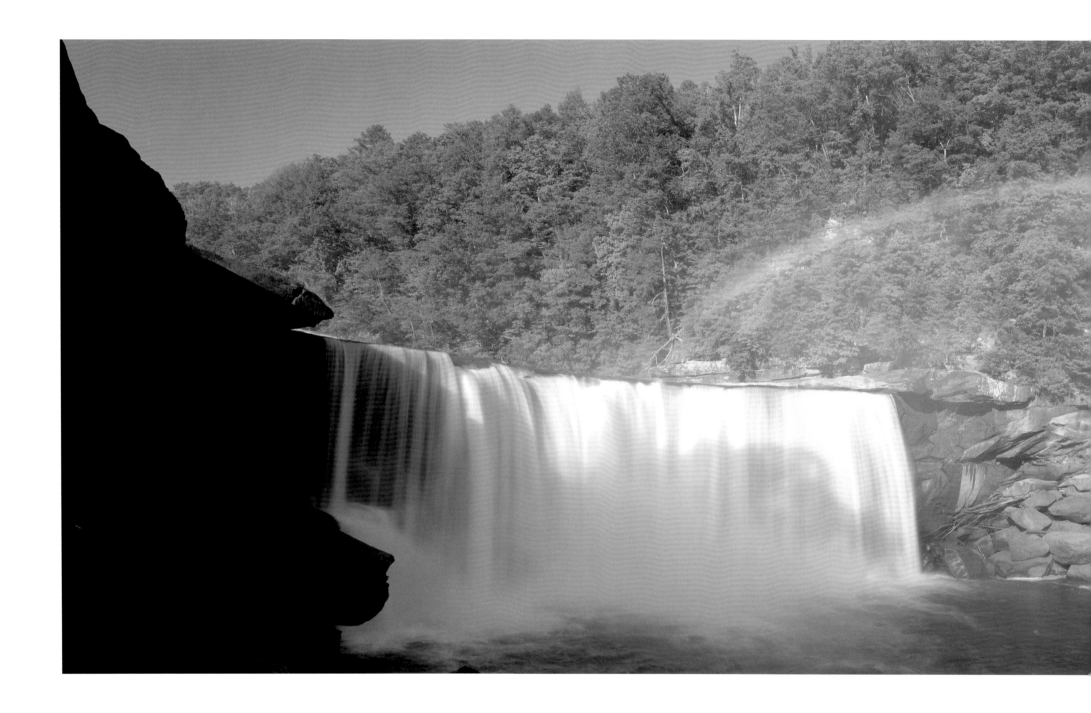

Sometimes we envisage how things should be and are disappointed when they don't work out. I had gone to Cumberland Falls for a beautiful sunrise. It never happened. I could have been impatient and left, but I relaxed and waited. Conditions changed and I was rewarded with this shot. Moods and emotions are ever changing. None will last forever. They are like the weather that comes and goes in a pattern beyond our control. Patience and a positive attitude help us live in the here and now and appreciate every moment.

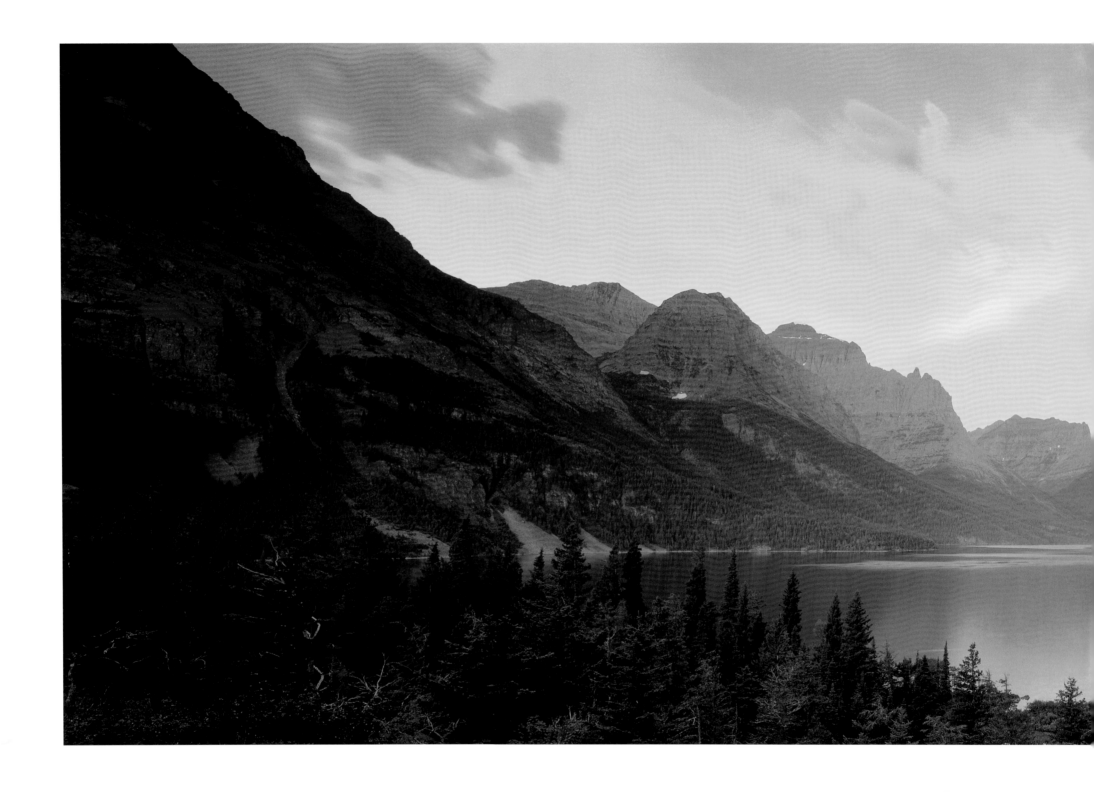

St. Mary Lake, Glacier National Park, Montana

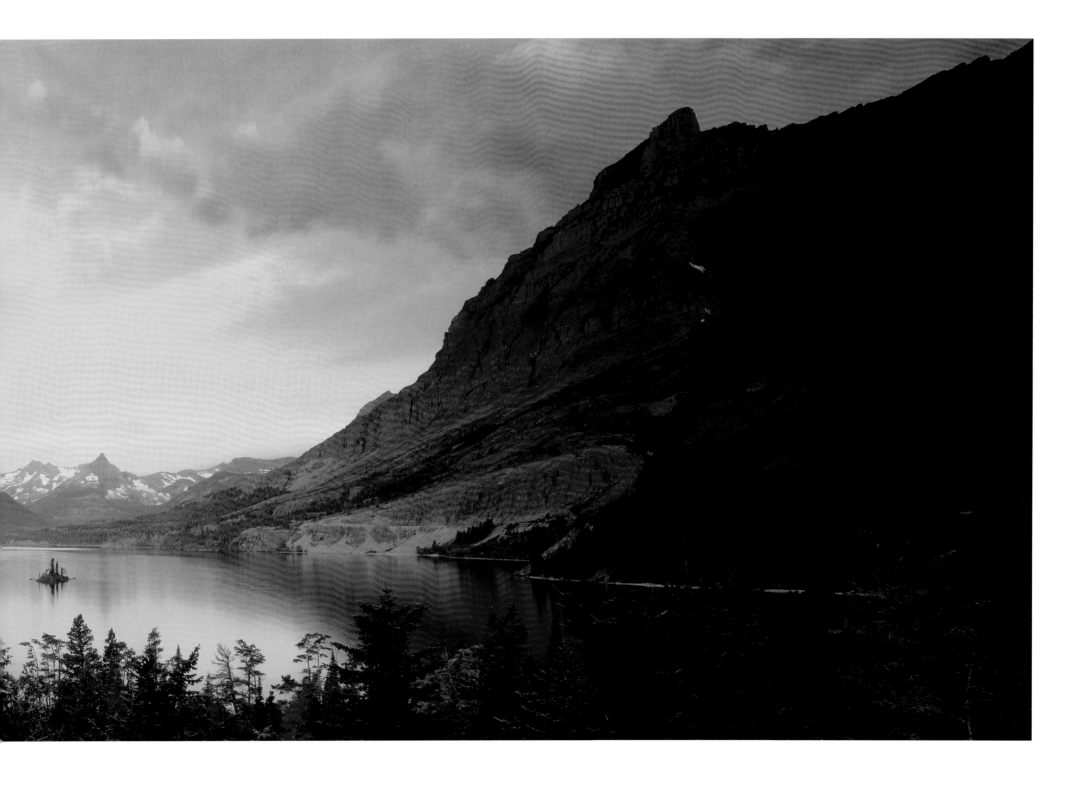

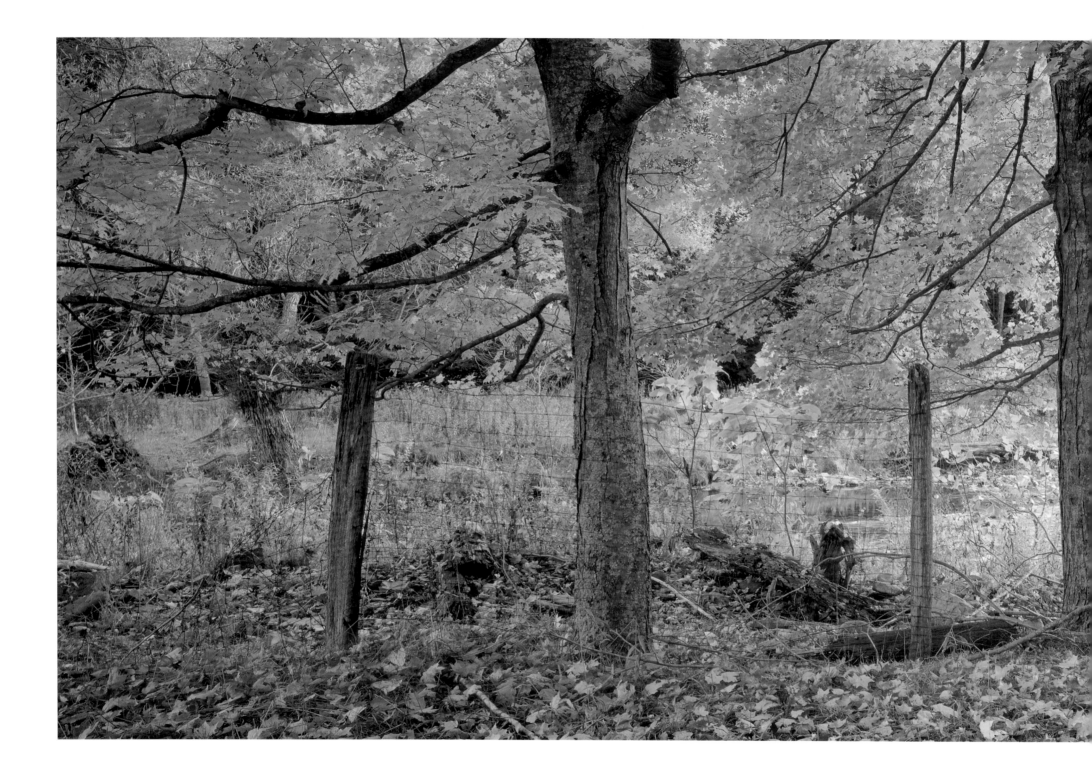

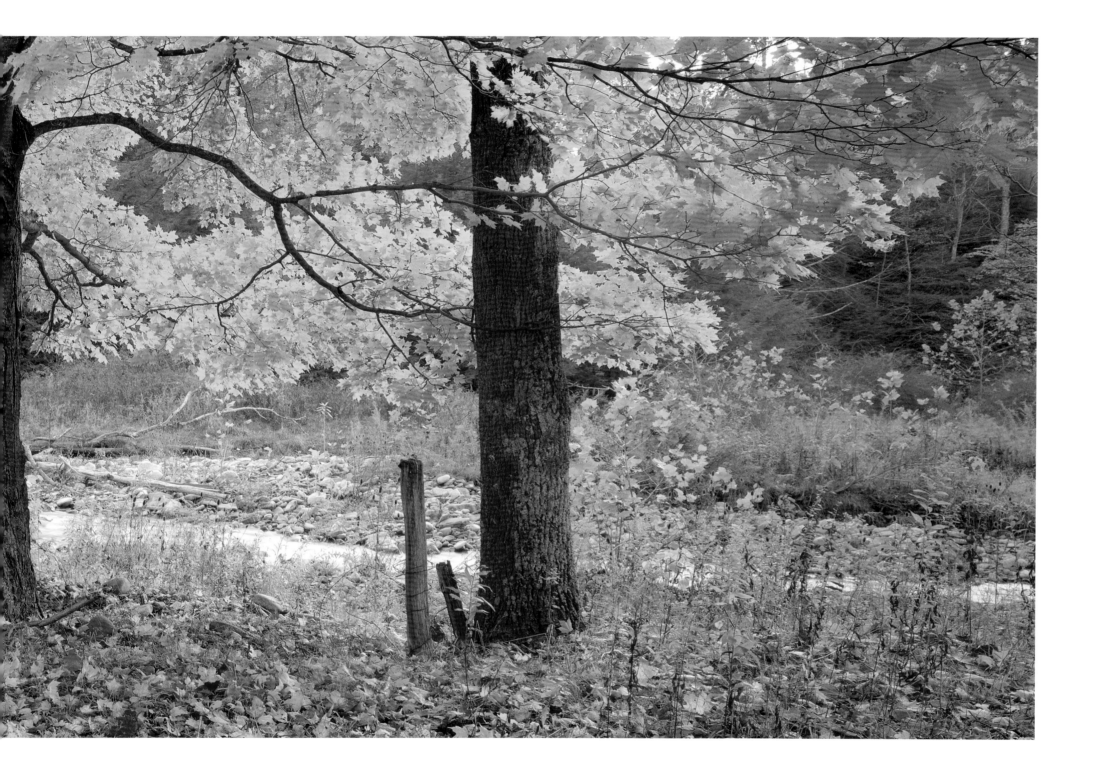

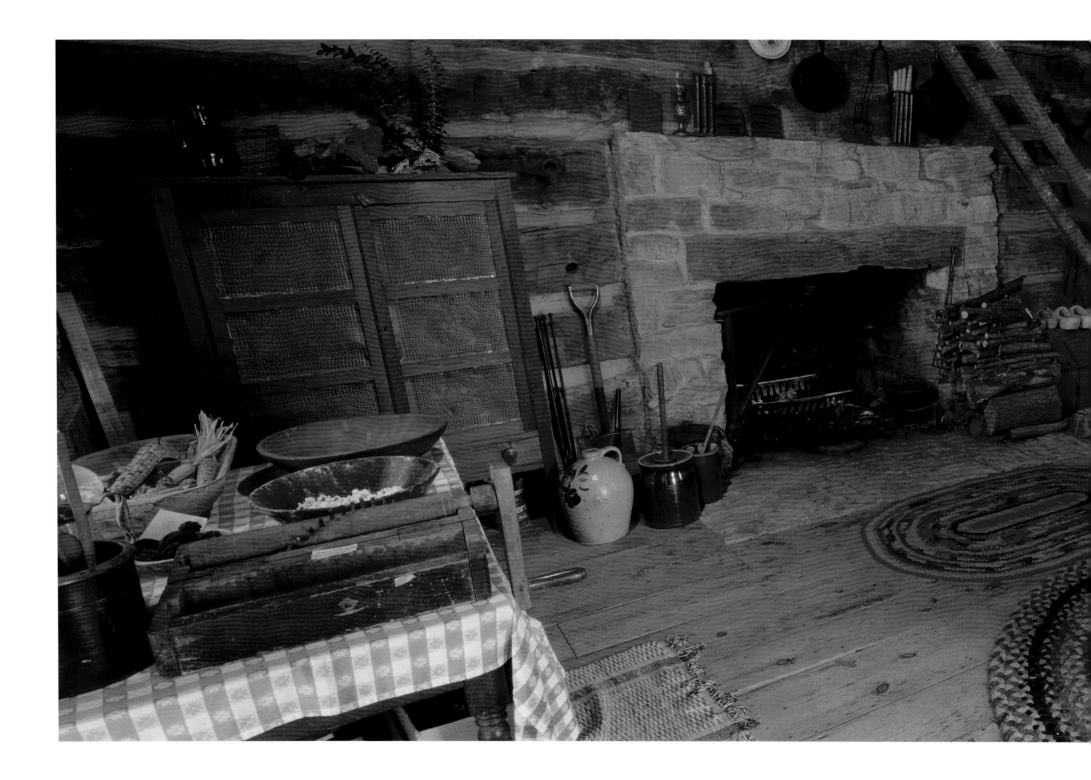

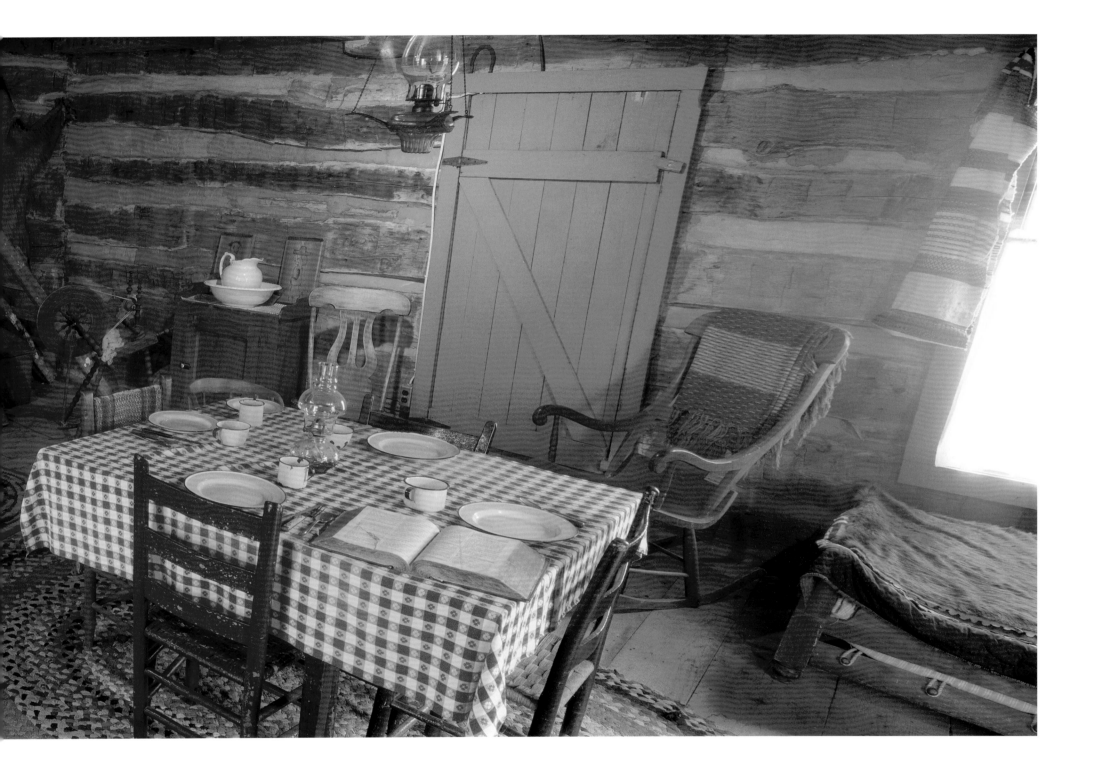

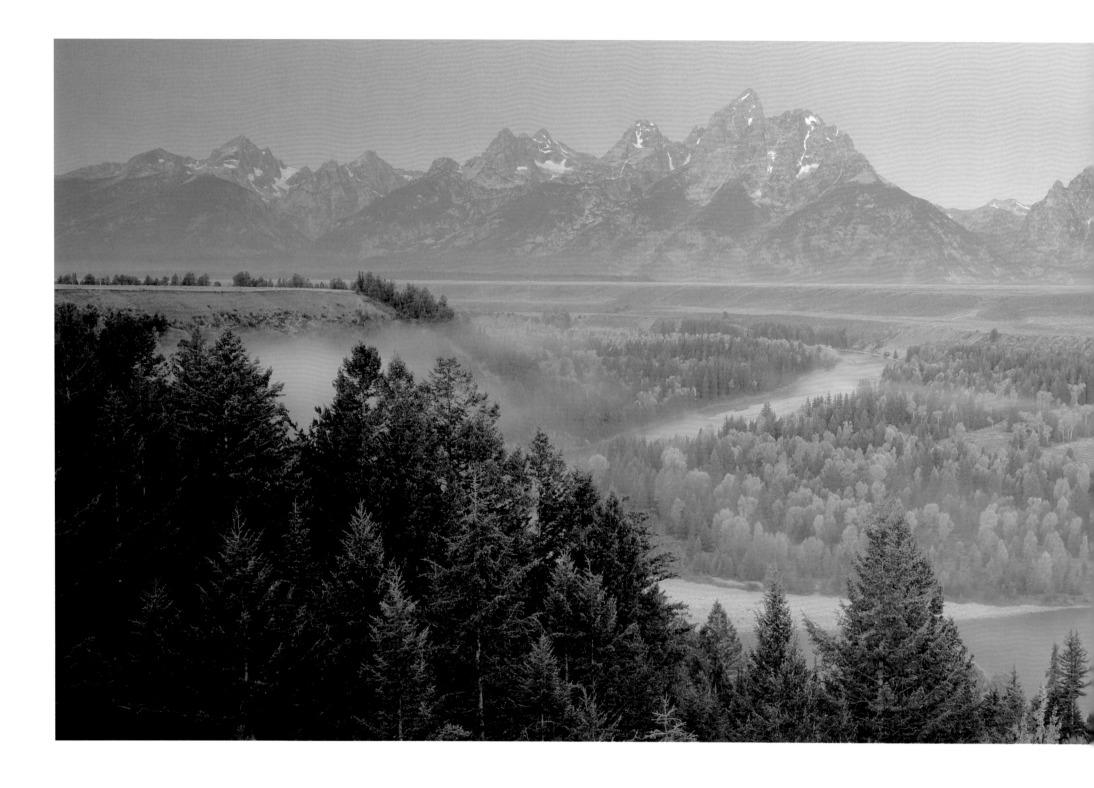

Snake River, Grand Teton National Park, Wyoming

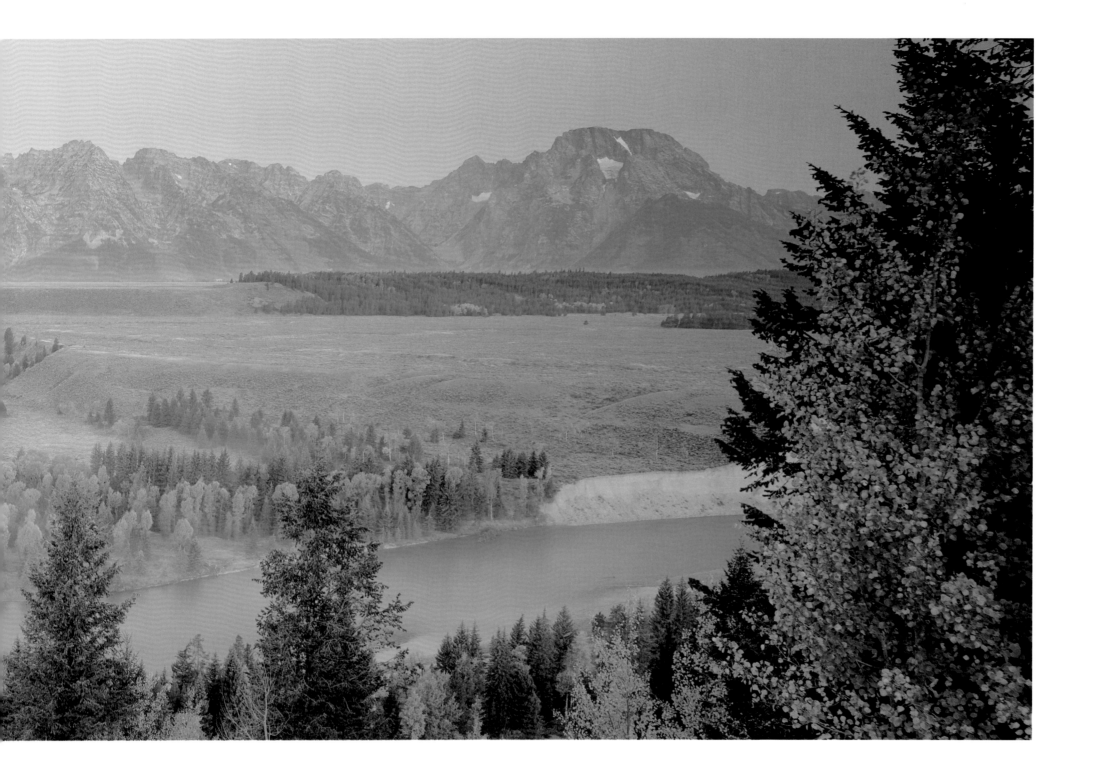

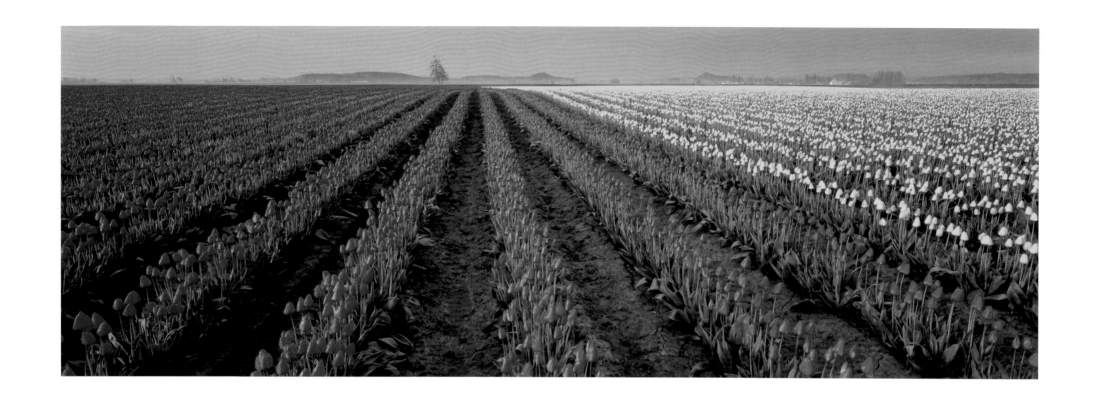

Let it shine

This field of vibrant flowers adorning the canvas of Skagit Valley in Washington State transforms the area into a masterpiece of bold brush strokes. Here we see the field in all its glory without considering the seasons the pasture has had to endure to bring forth such abundant life. While photographing there I happened to see some unused plows off to the side of the paddock. The implements had great character developed by aging and rust, but apart from looking good they served no real purpose. Later that afternoon I passed another freshly plowed field. The plow responsible for that fine job sat proudly in the furrows, its shining discs like mirrors reflecting the sun.

I began to ponder the difference between the abandoned, rusty plow and the recently used one. The only reason those discs shone so brightly was that they had been polished by all the hard ground they had broken through. The smoother the surface of a disc, the easier the job becomes, until there is only minimal friction which acts as a burnishing agent for a radiant shine.

In life we have choices. We can be like a disused plow, sitting by the wayside and watching others' fields bloom – full of potential but not wanting to attach to the tractor of life and dig in deep. Or we can be like a burnished plow, constantly applying ourselves to the field of our dreams – not seeing the journey as abrasive, but as polishing, so that our lives may shine. Although it can be difficult to develop a new pasture, when the ground is broken and cultivated the field is fertile ground for our dream seeds to be planted. They may lay dormant for a time, but in due season those seeds will break forth into the sunshine. If we allow the challenges of our lives to polish us for the tasks ahead, then one day we will reap a great harvest.

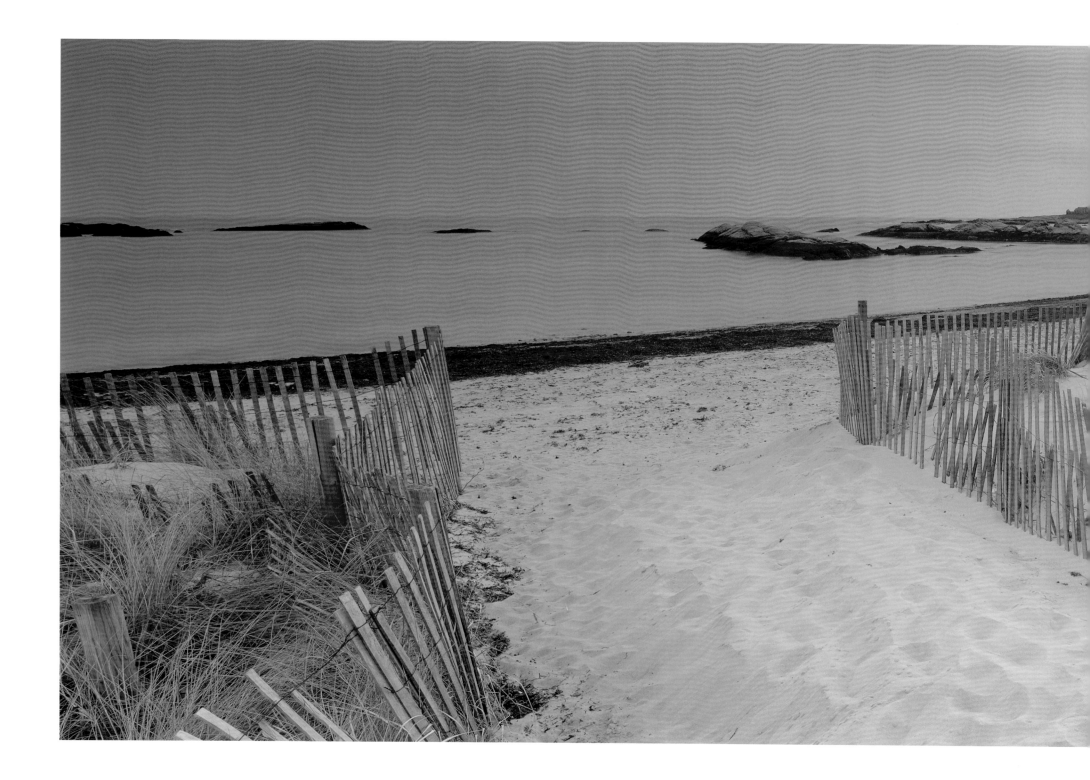

Gooseberry Beach, Newport, Rhode Island

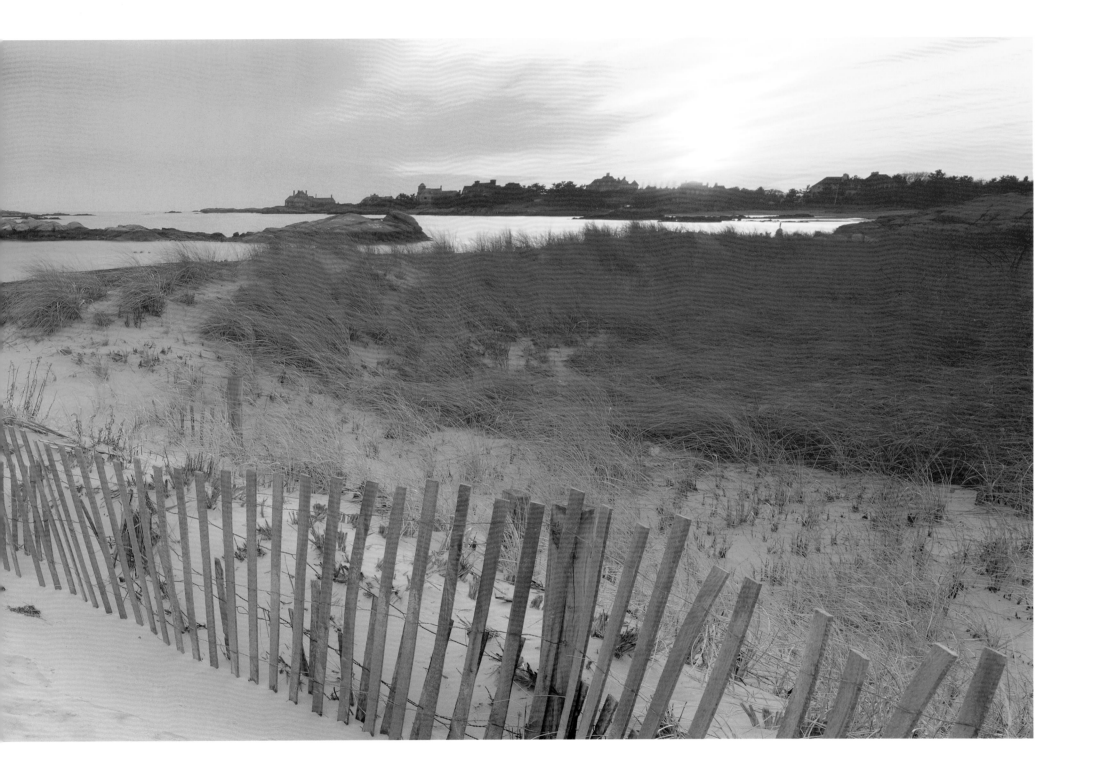

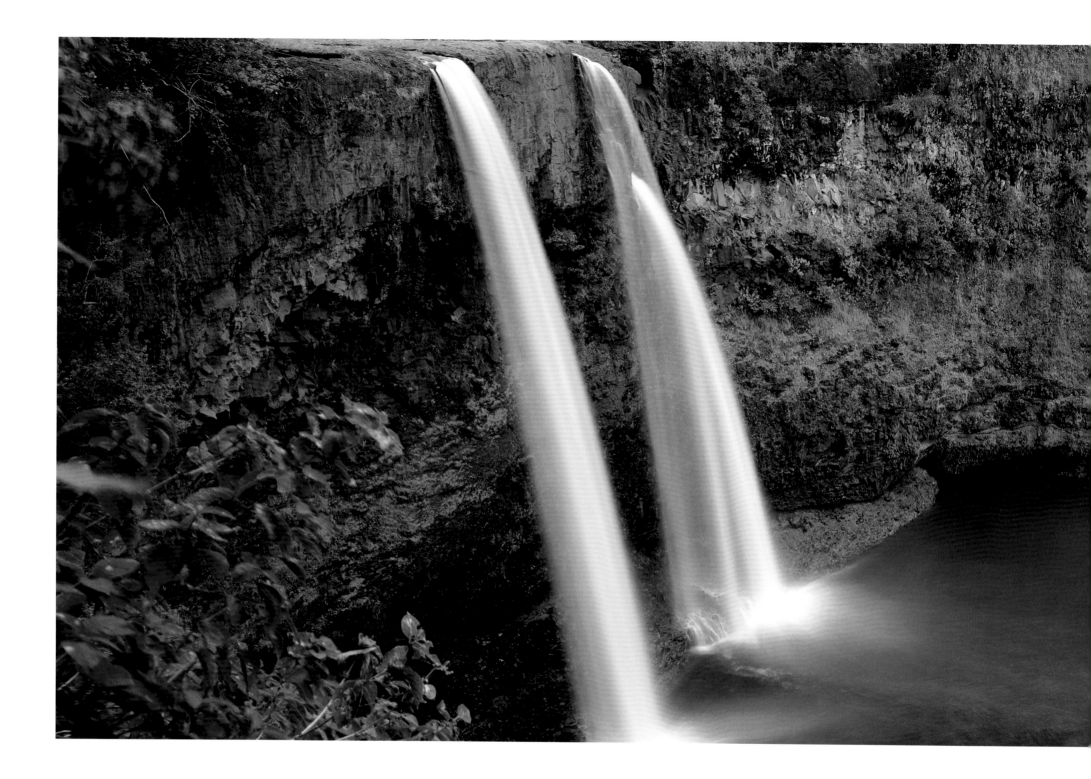

Wailua Falls, Kauai, Hawaii

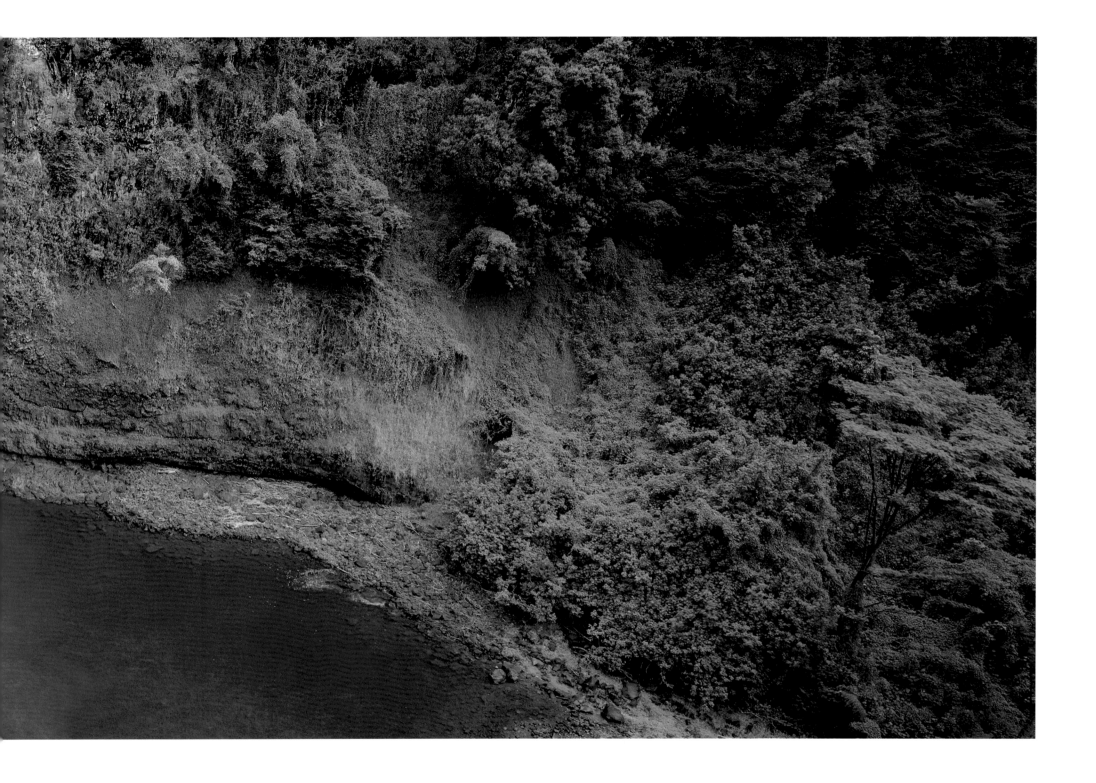

Forming a border between Mexico and Texas, the Rio Grande flows wildly and erratically before finally emptying into the Gulf of Mexico. At Big Bend, the river makes a complete U-turn. The massive canyon – eroded over thousands of years as if by the action of a relentless gravity-powered belt sander – proves that even mountains are no match for the power of persistence.

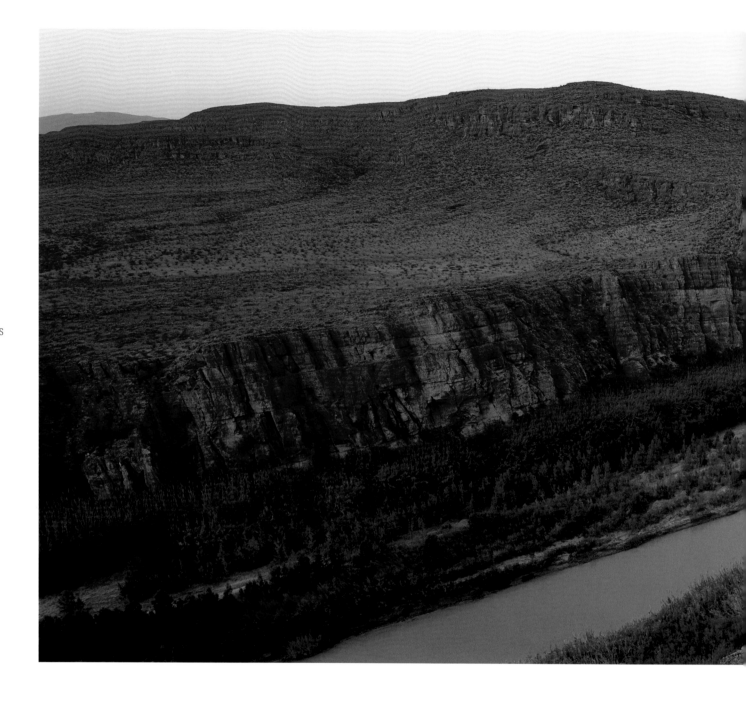

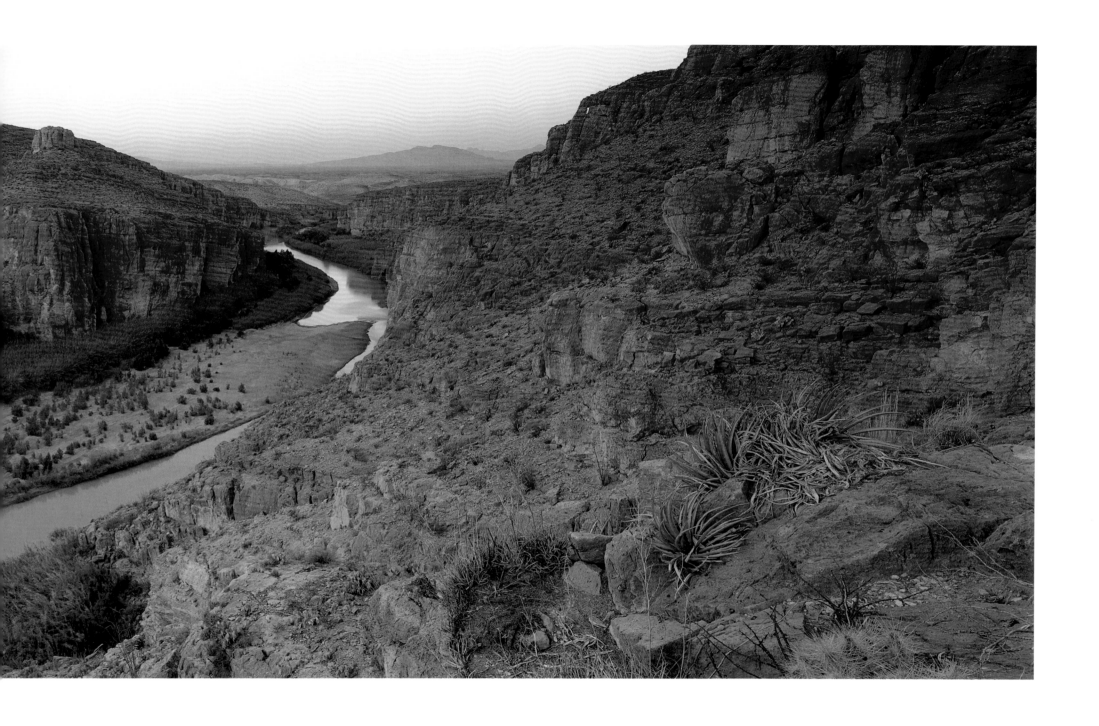

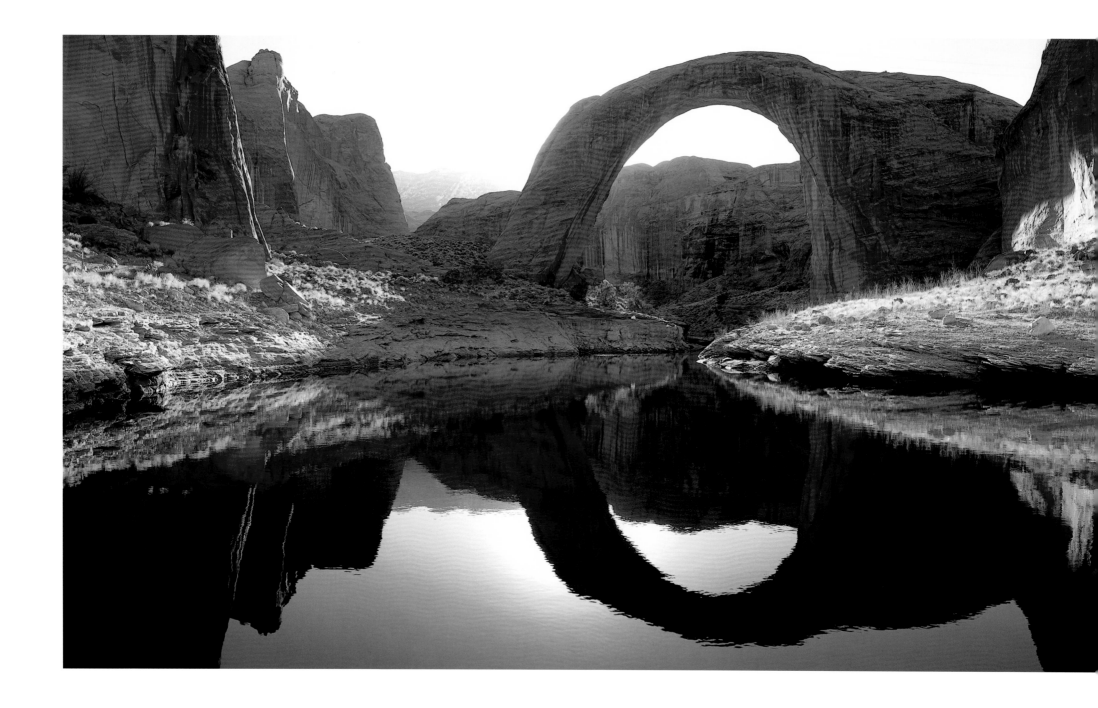

Rainbow Bridge, Lake Powell, Utah

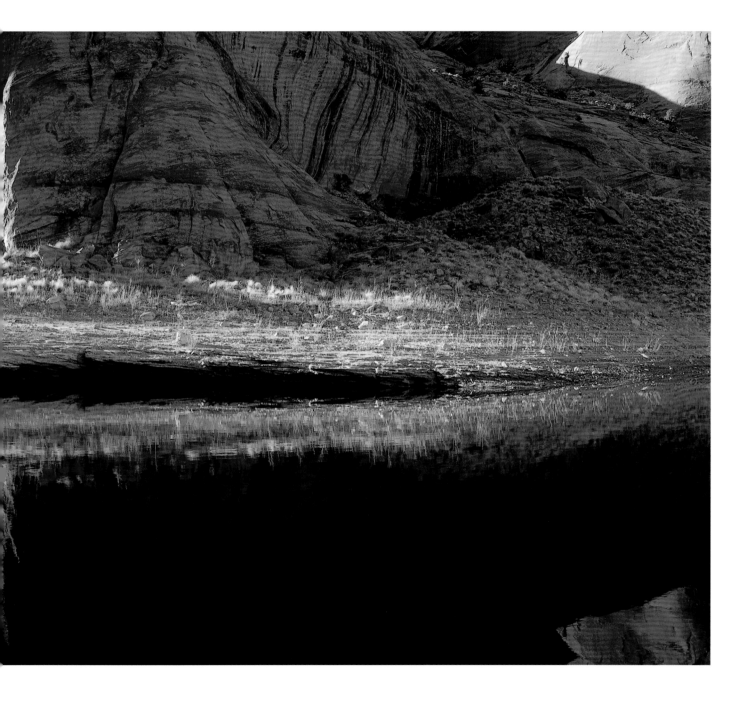

Rainbow Bridge is the world's largest natural bridge. The Navajo people call it Nonnezoshi, which means 'rainbow turned to stone'. They have great sensitivity to the spiritual realm and to them it's a place of spiritual significance. To me it's a spectacular example of God's handiwork and I could feel the Spirit of God strongly in this place.

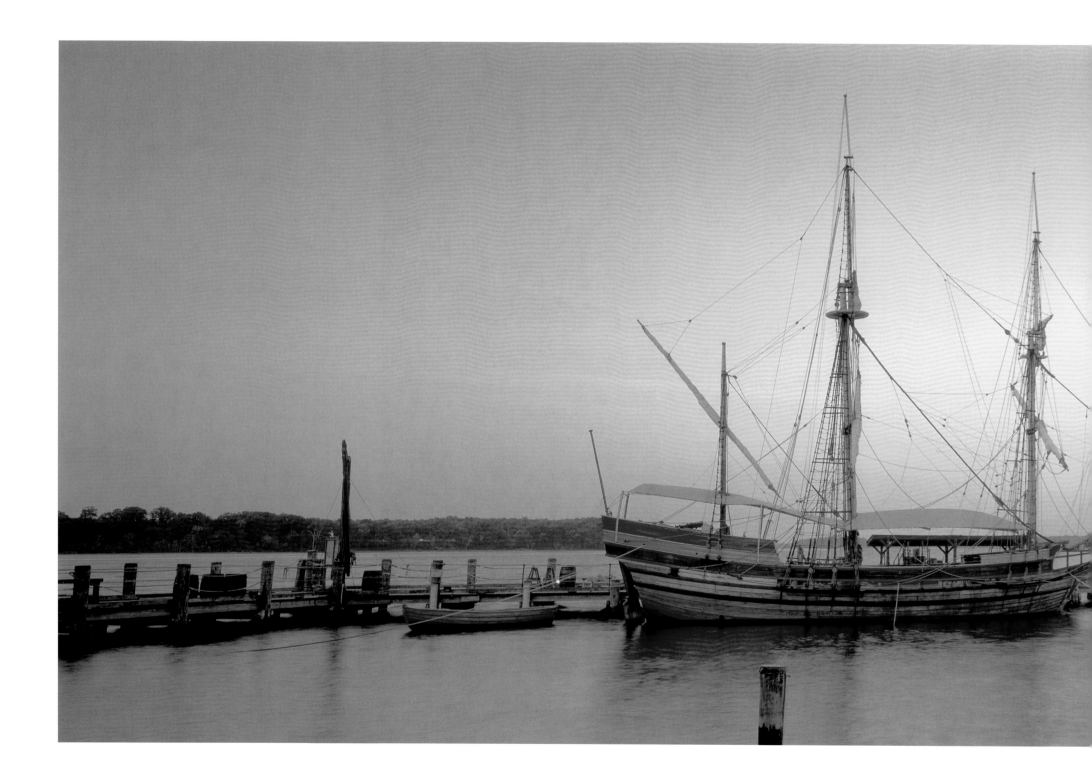

Maryland Dove, St. Mary, Maryland

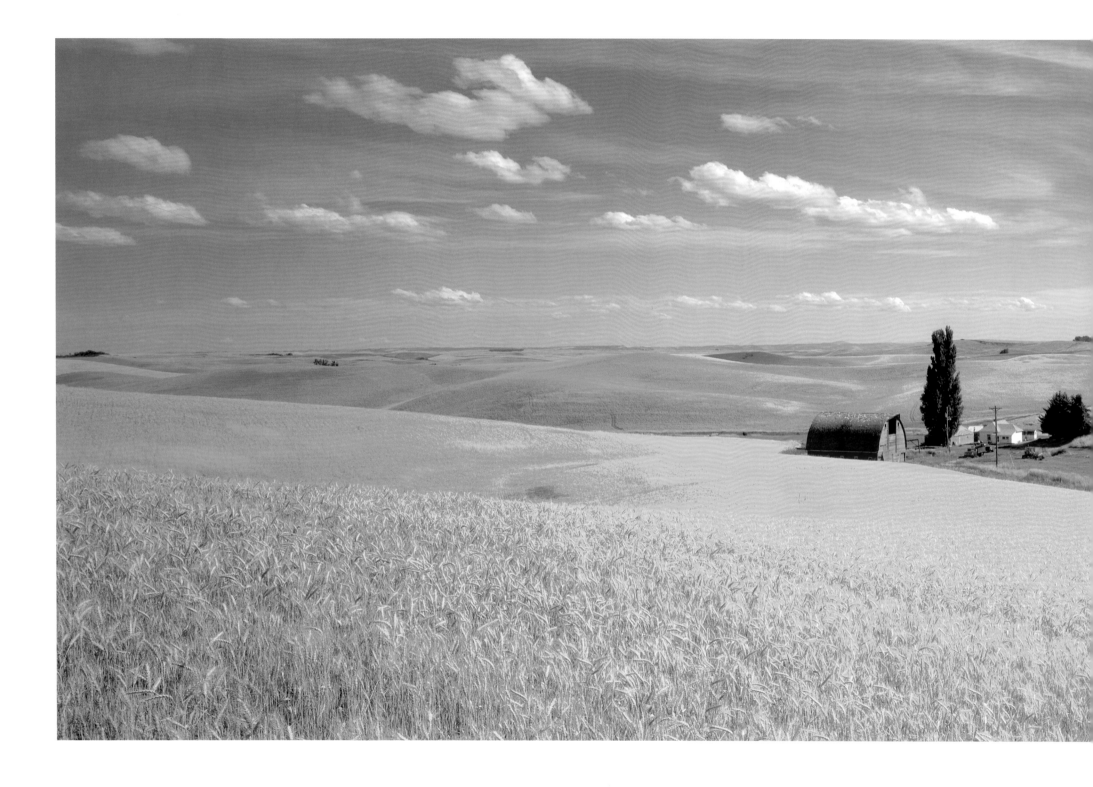

Wheat Fields, Blaine, Idaho

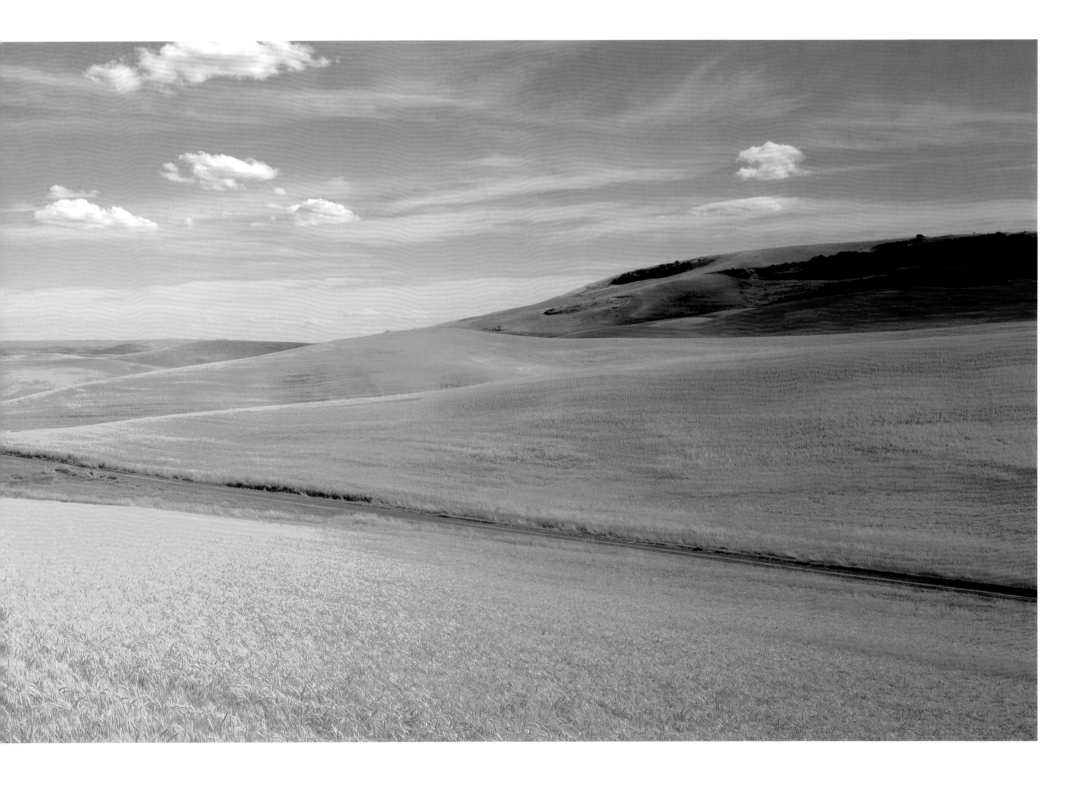

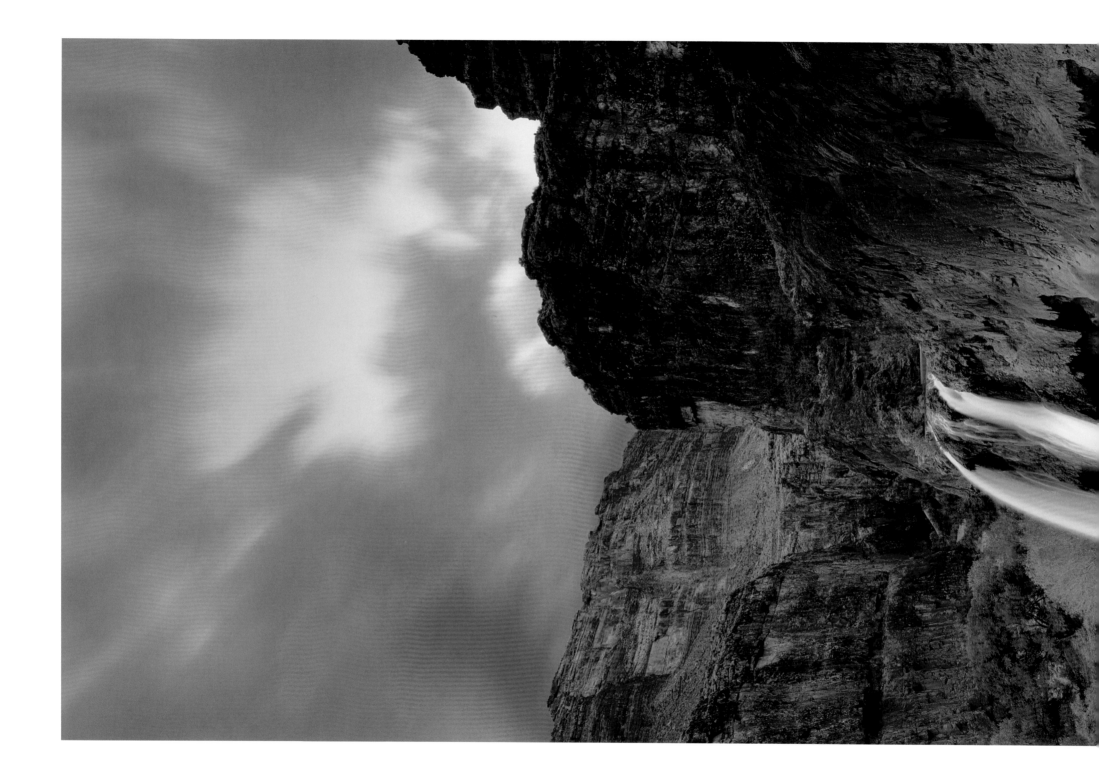

Havasu Falls, Grand Canyon, Arizona

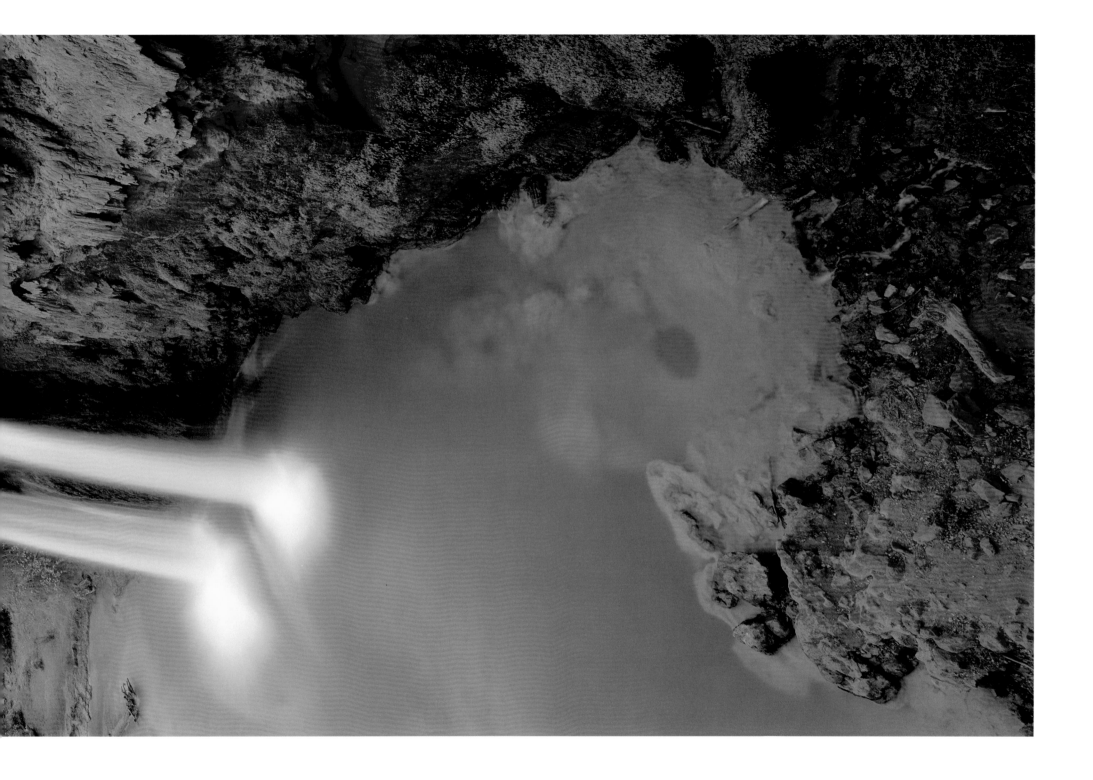

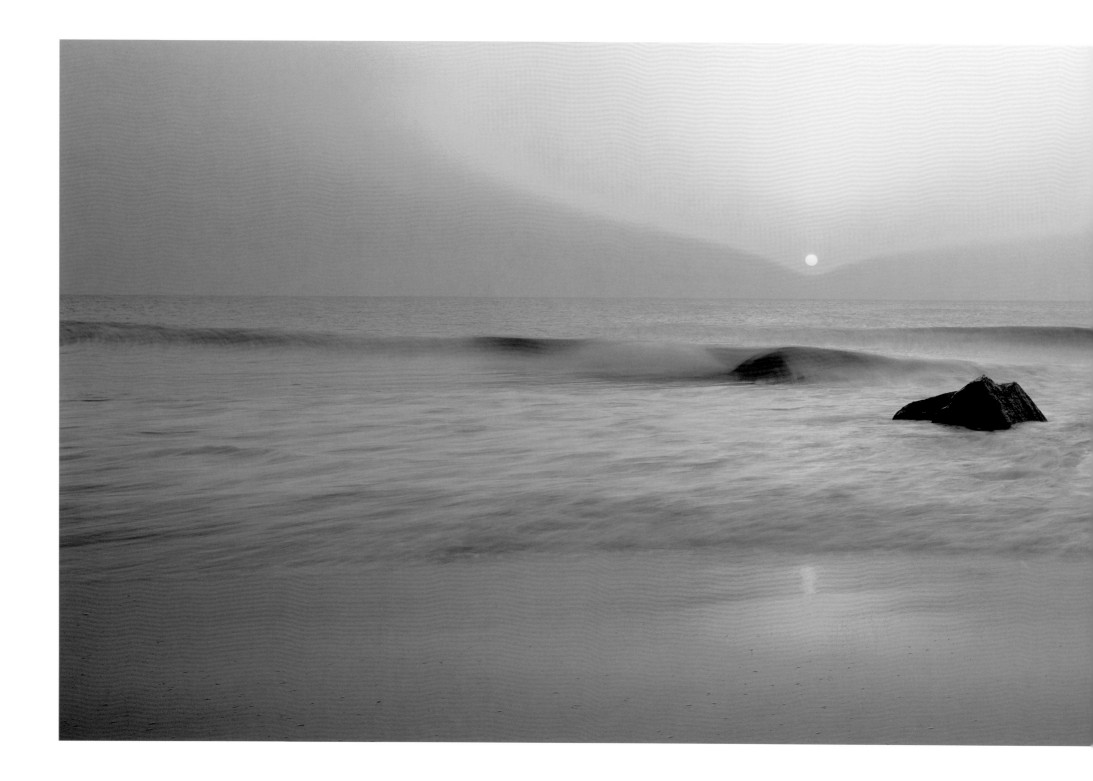

Sunrise, Bethany Beach, Delaware

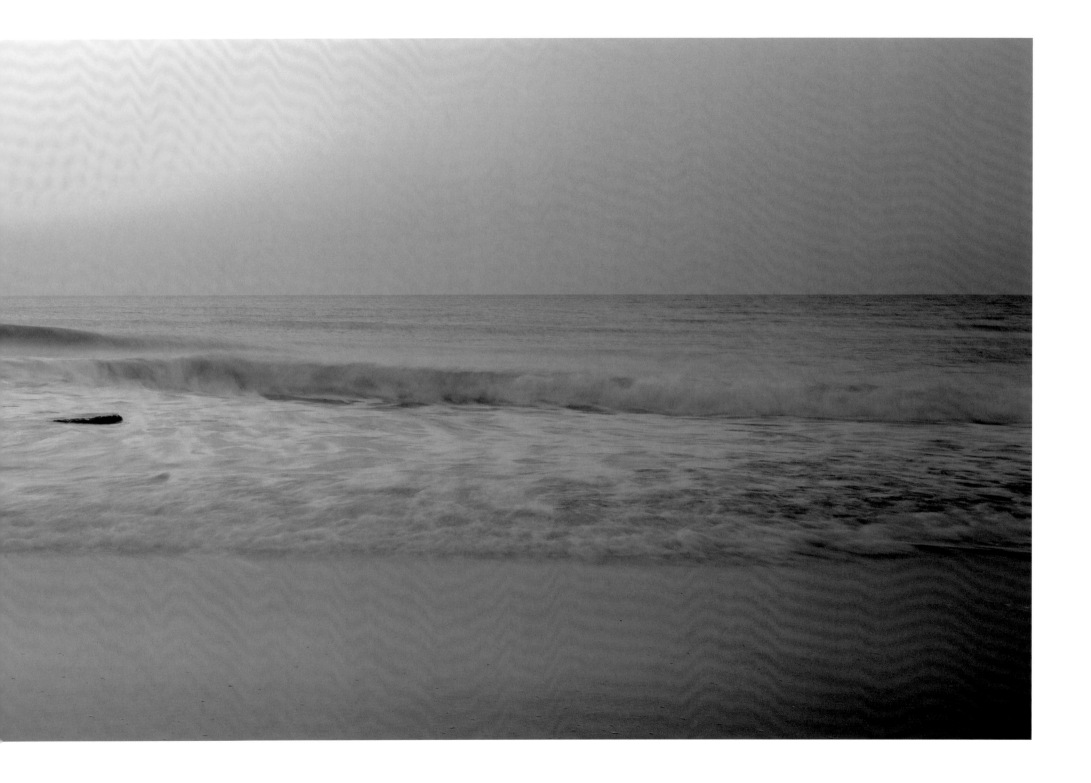

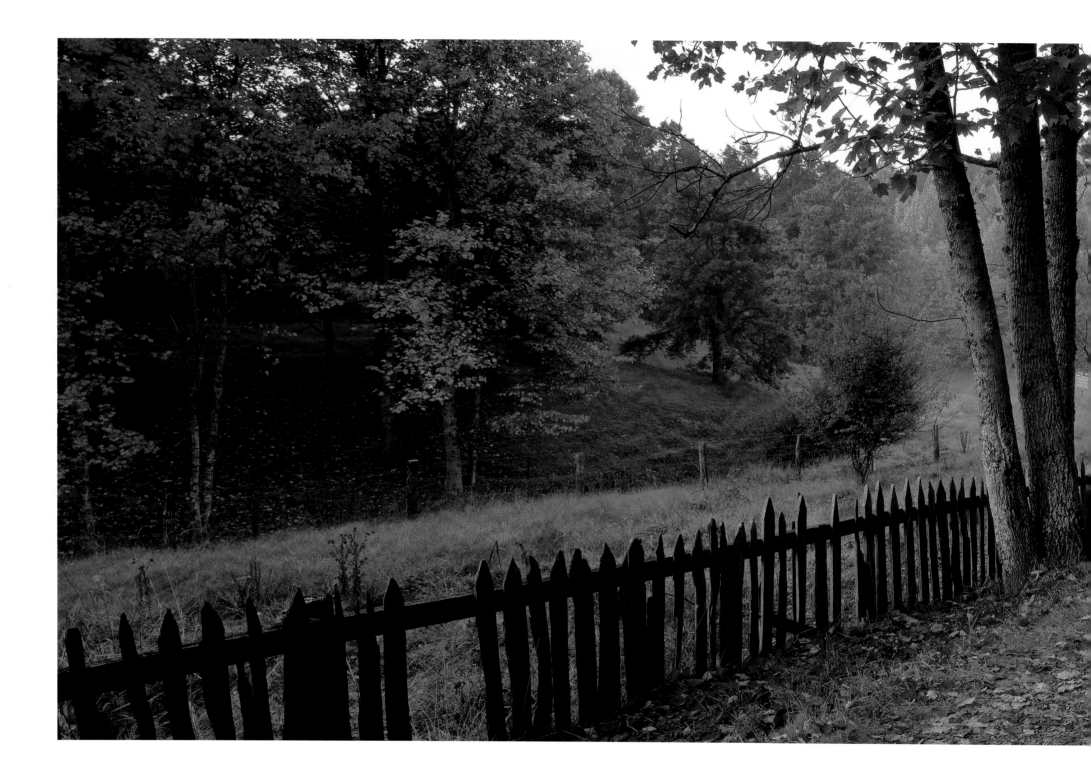

Pioneer Farm, Twin Falls State Park, West Virginia

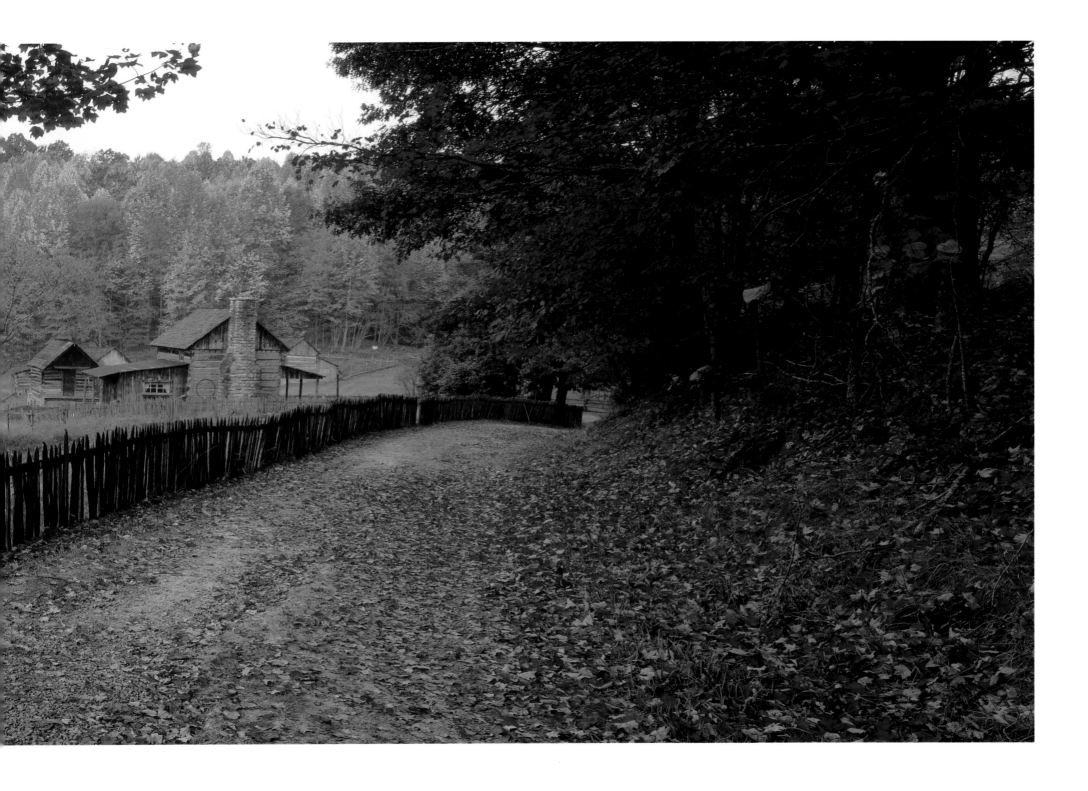

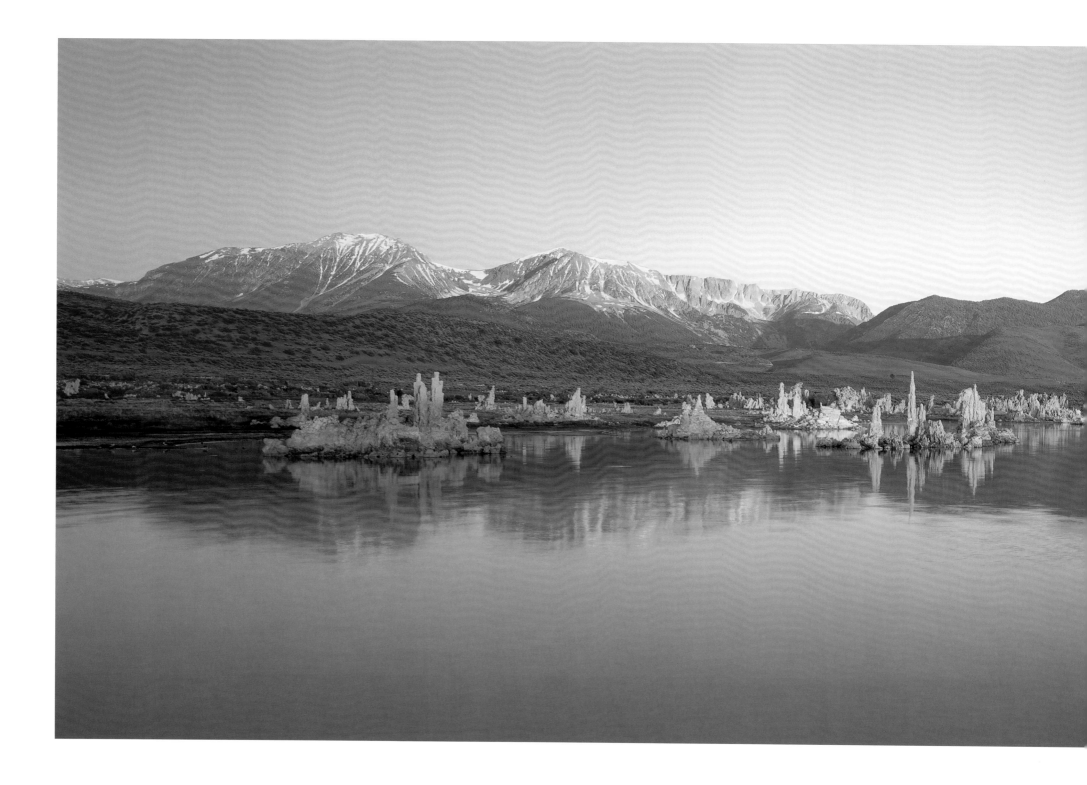

Mono Lake, Lee Vining, California

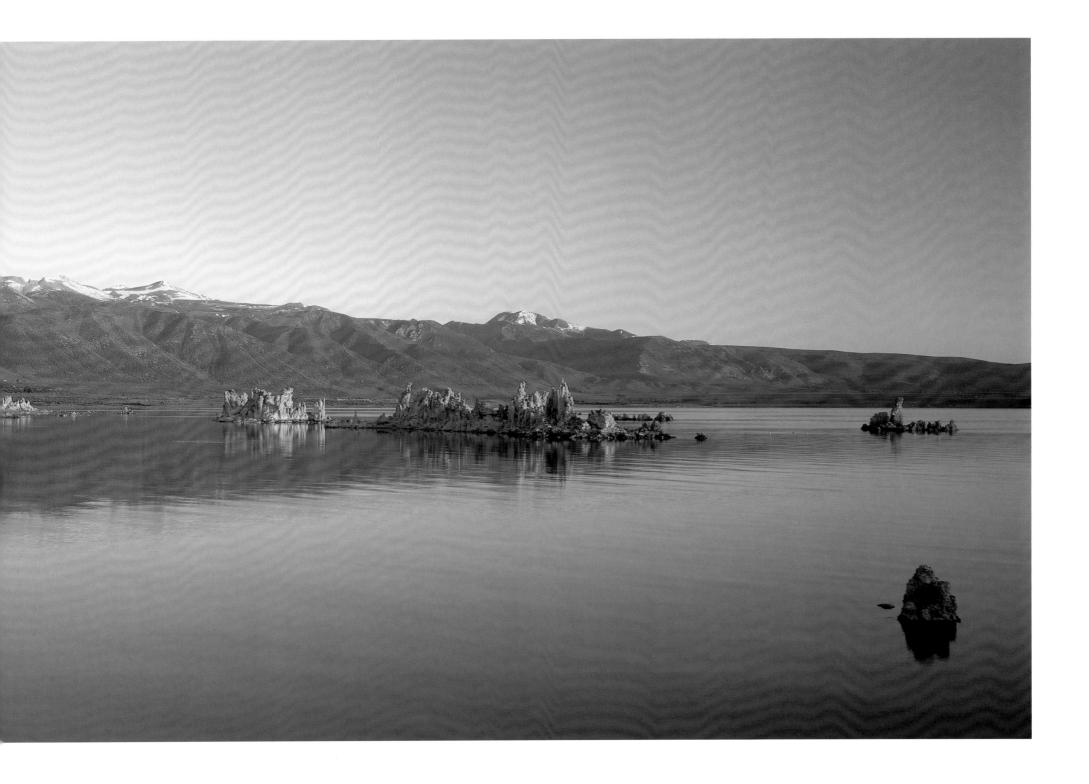

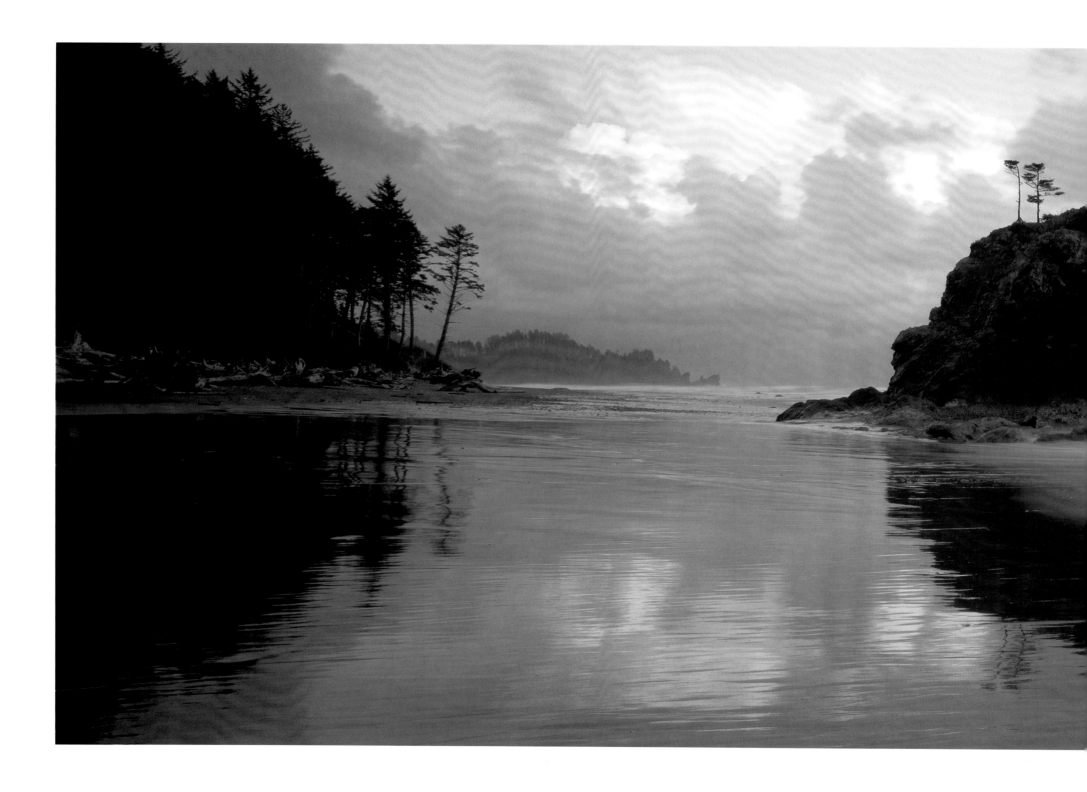

Second Beach, Olympic National Park, Washington

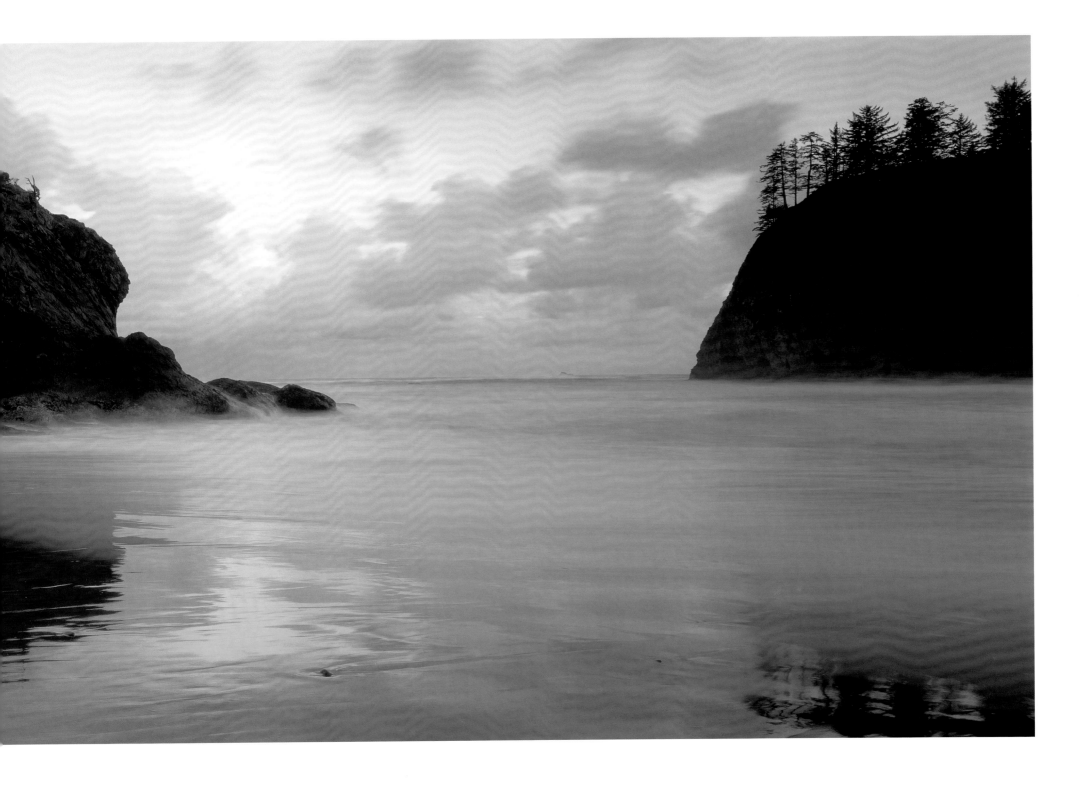

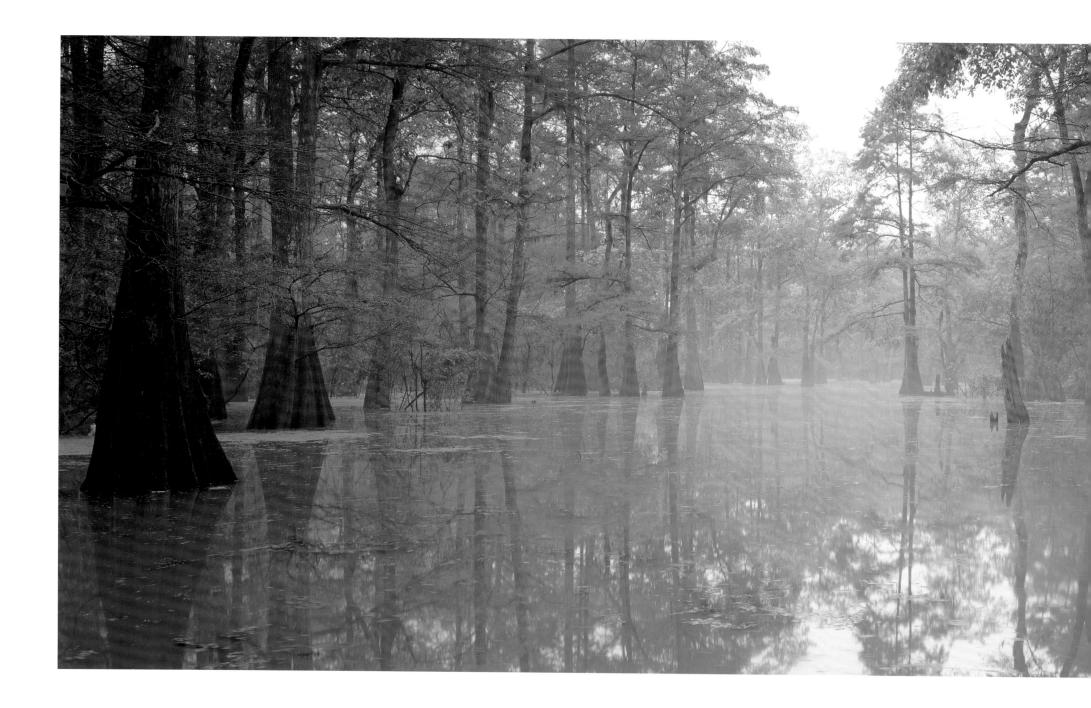

Atchafalaya Swamp, Louisiana

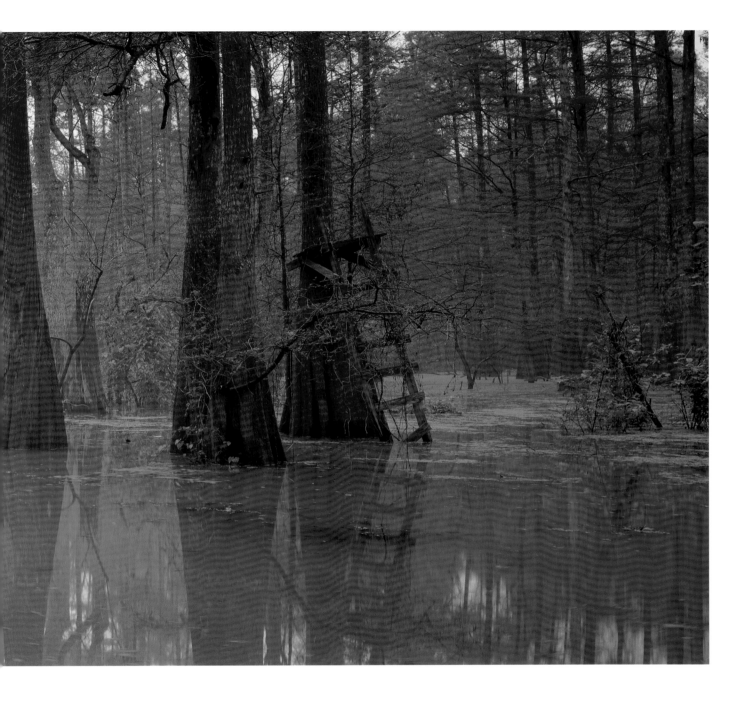

It's well before sunrise as we start our adventure into the bayou. Our guide has taken us through a maze of channels – too many twists and turns for me to have any idea where we are. As the light begins to penetrate the swamp, ghostly trees take form like menacing giants with outstretched arms. An old abandoned hunting platform makes me wonder what happened to the hunter. Strange noises – slithering and gurgling – greet the day. The swamp is alive and well.

Beautiful Vermont – here in its autumn glory. Every season has a beauty of its own. How boring life would be without seasons, for it is the contrast that gives texture to our lives. Autumn removes the old growth. Winter is a time of rest. Spring brings forth new life, and summer is a time for rejoicing.

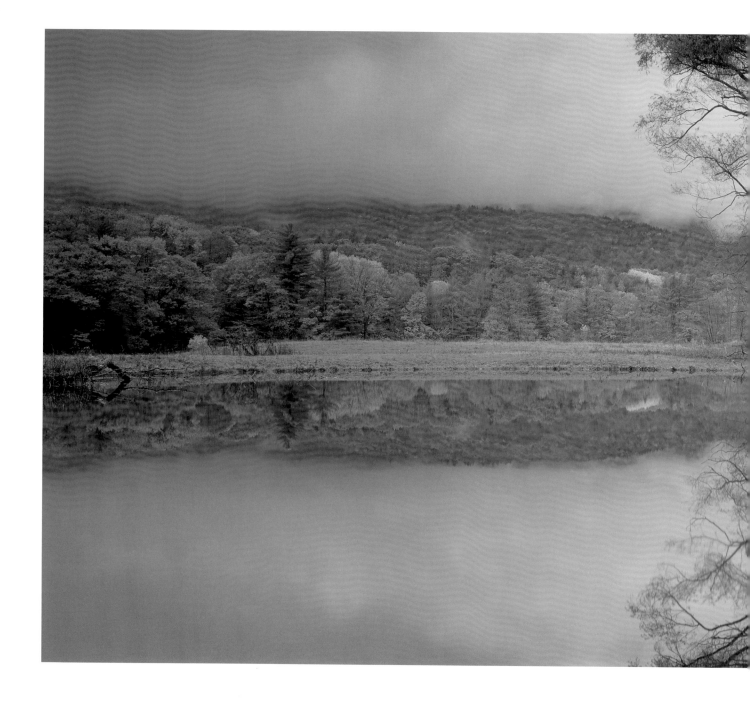

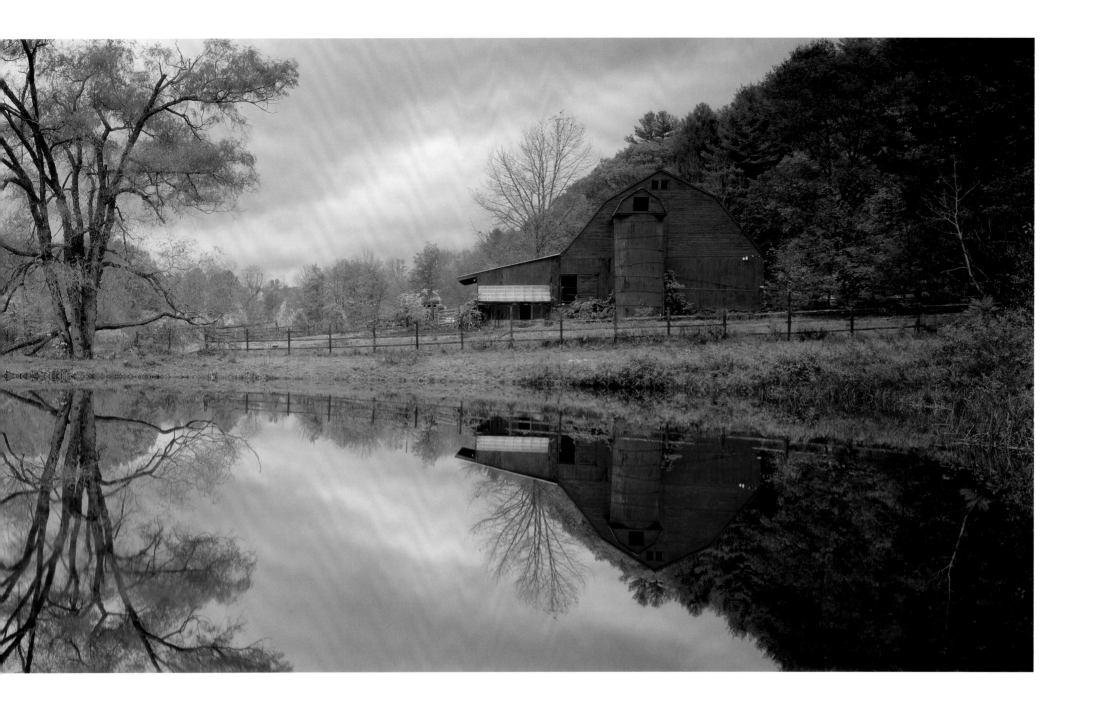

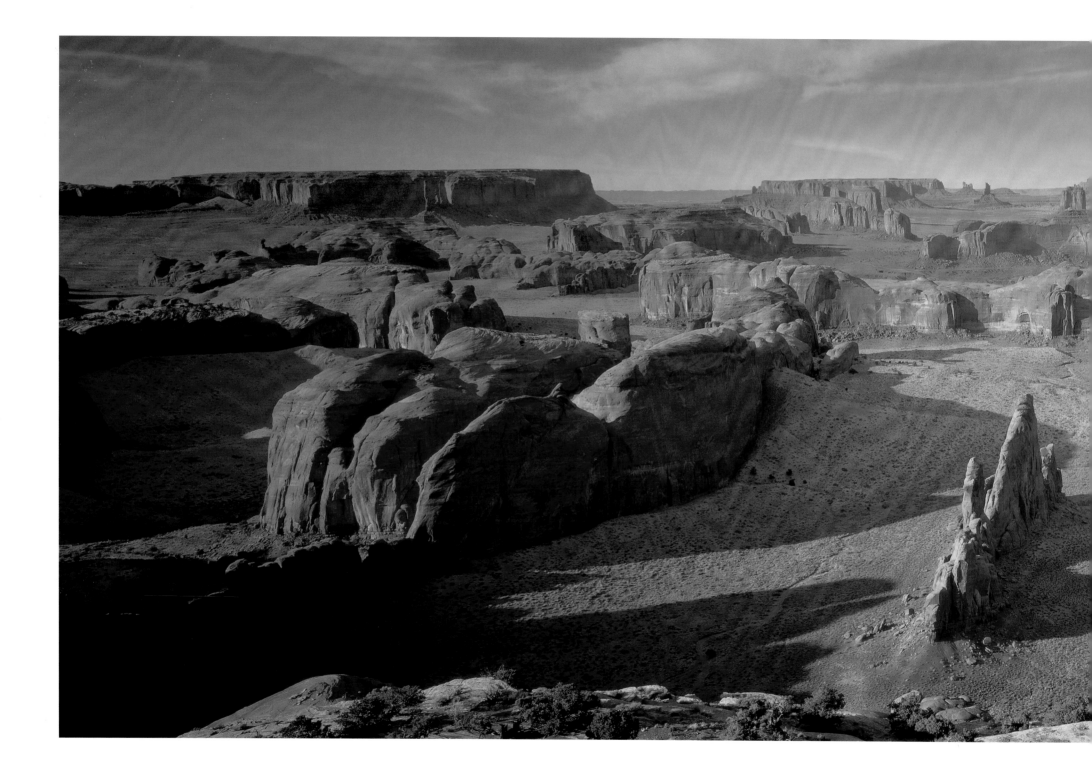

View from Hunts Mesa, Monument Valley, Arizona

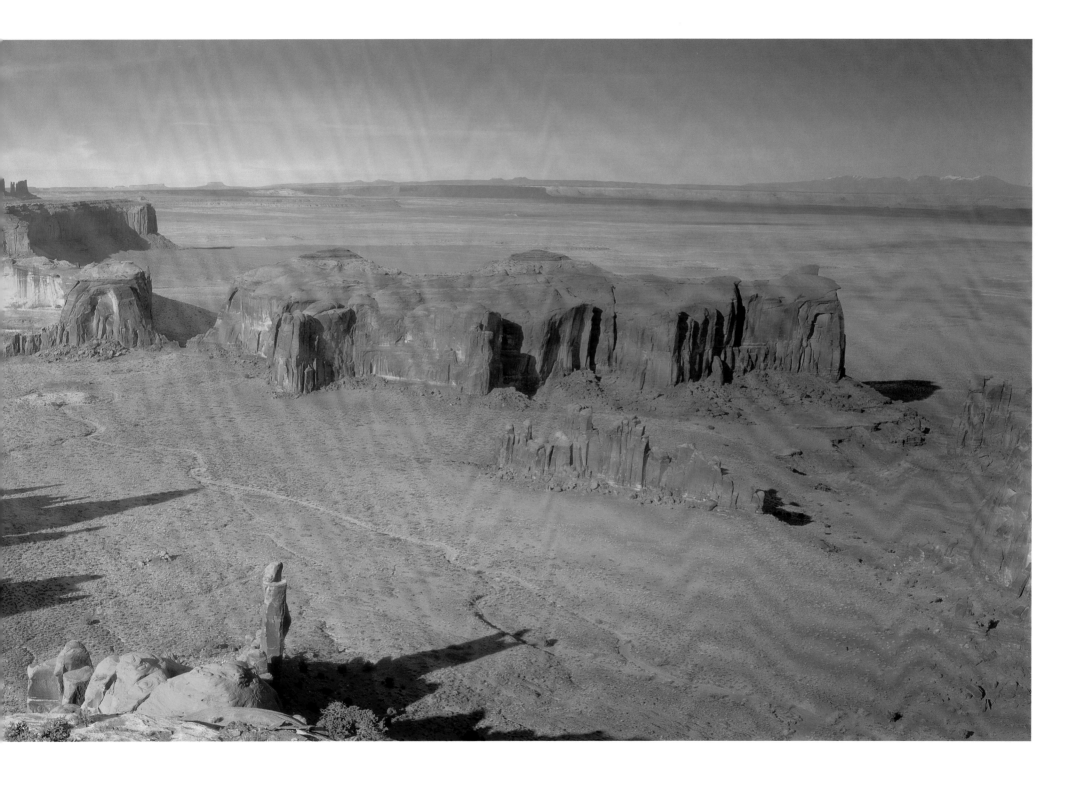

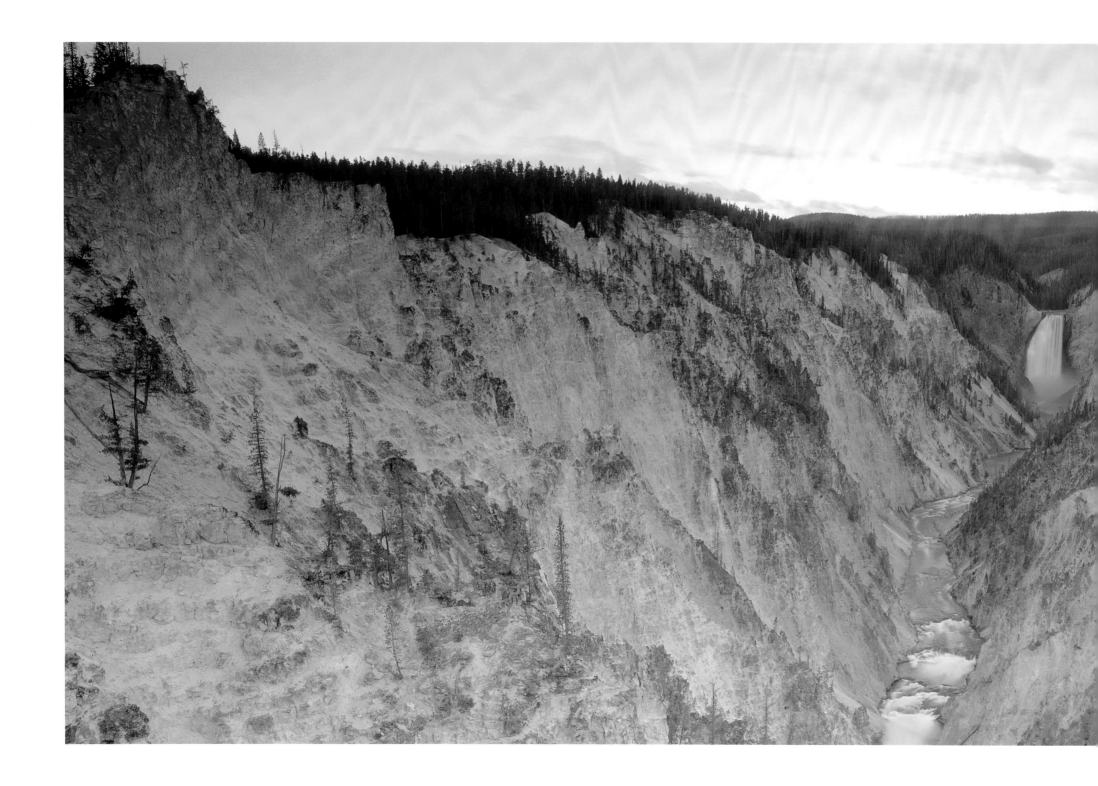

Lower Falls, Grand Canyon of the Yellowstone, Wyoming

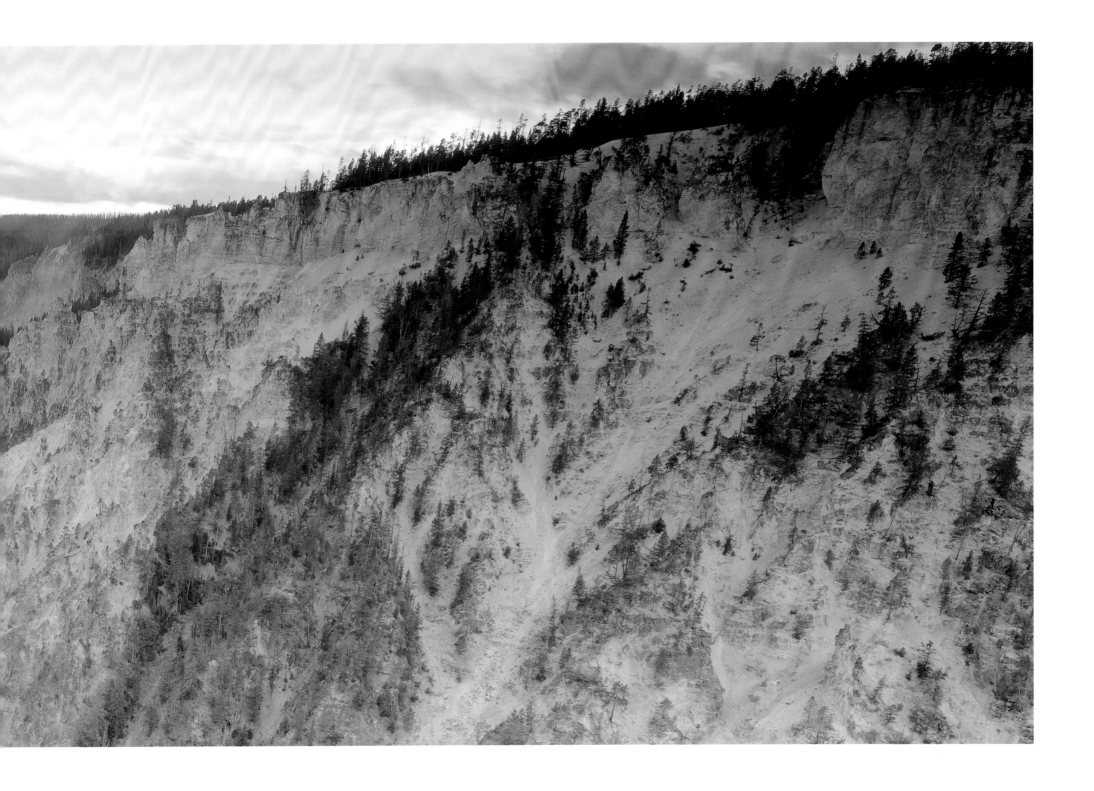

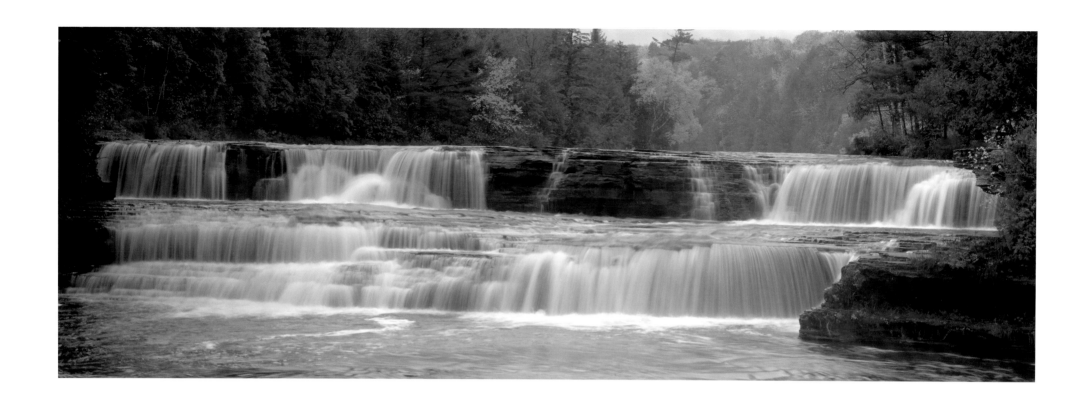

"Love and faithfulness meet together;
righteousness and peace kiss each other.
Faithfulness springs forth from the earth,
and righteousness looks down from heaven.
The Lord will indeed give what is good,
and our land will yield its harvest."

PSALM 85:10-12

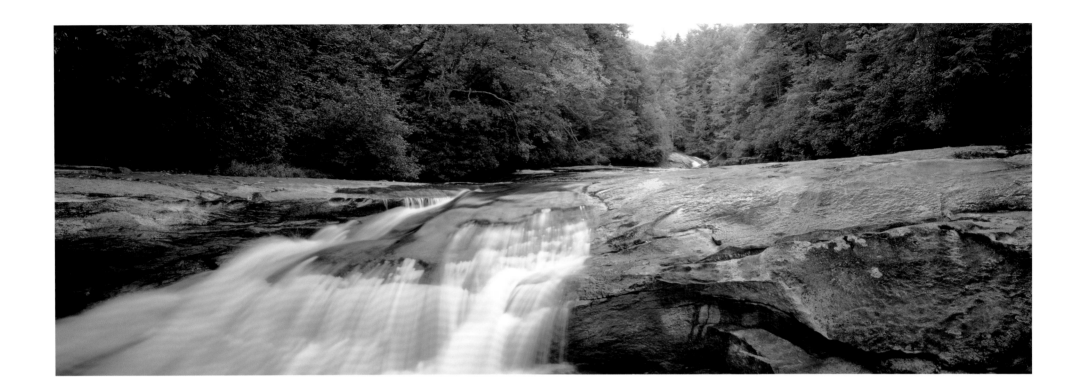

"The Lord bless you and keep you;
the Lord make His face shine upon you,
and be gracious to you;
the Lord lift up His countenance upon you,
and give you peace."

NUMBERS 6:24-26

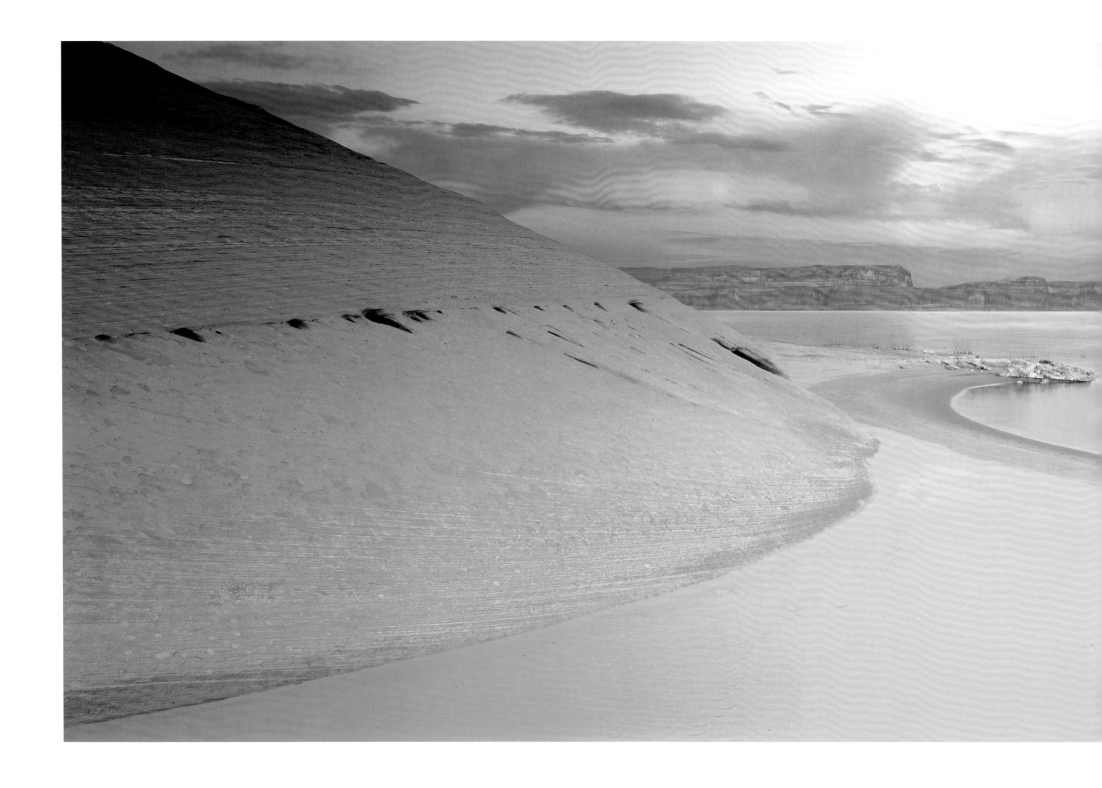

Padre Bay, Lake Powell, Utah

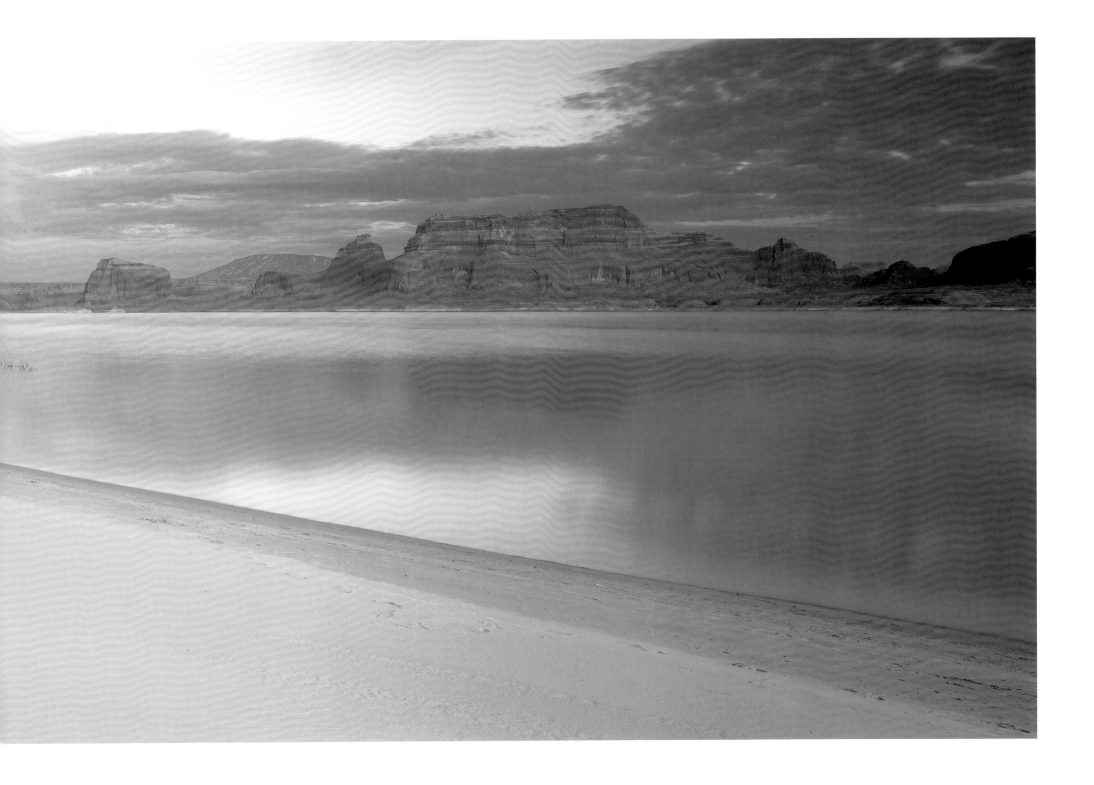

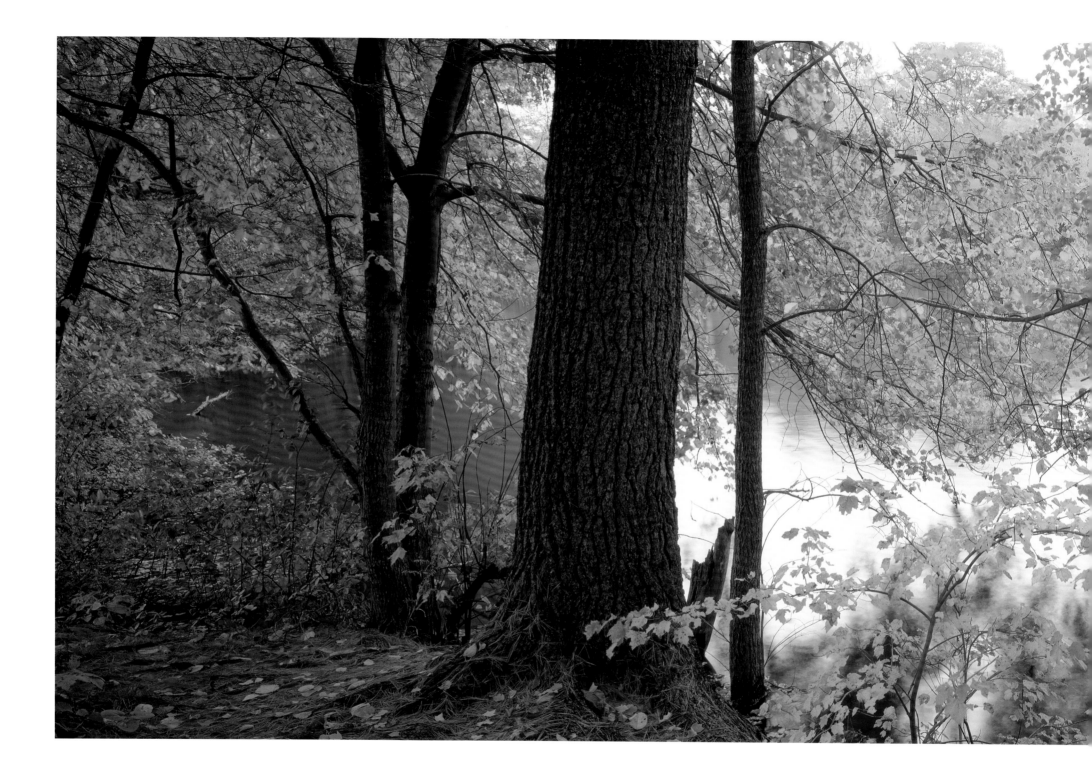

Fall Tranquility, Massachusetts

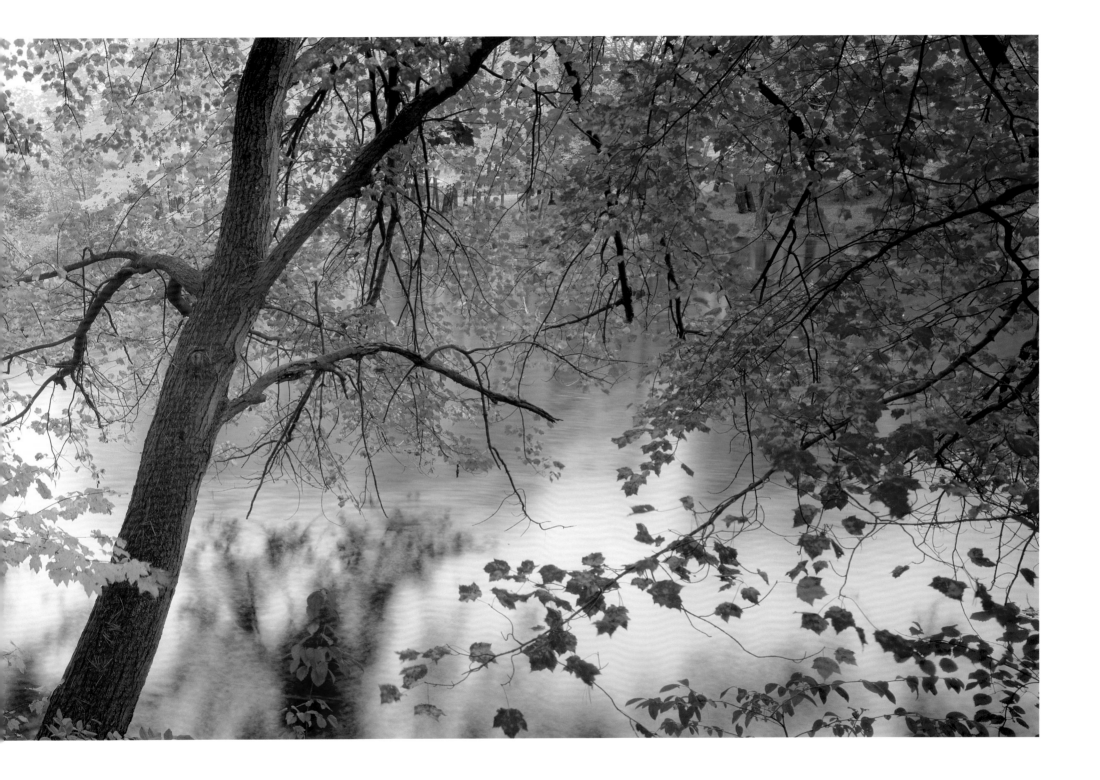

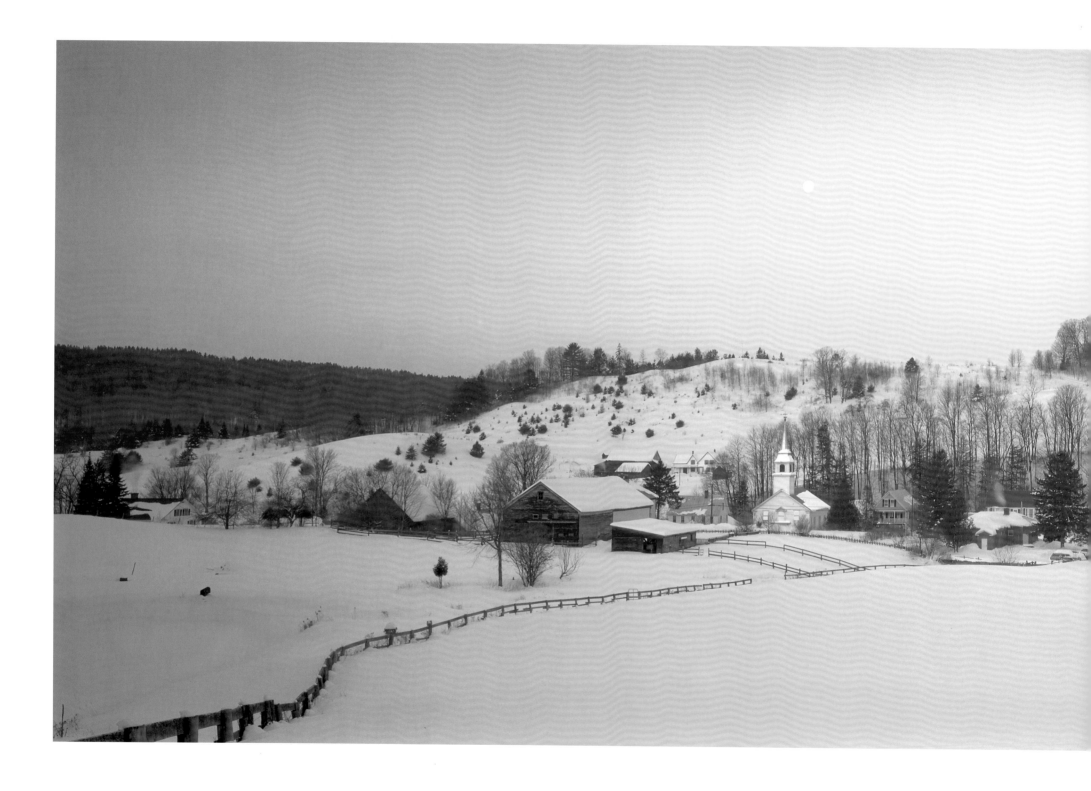

Full Moon, East Corinth, Vermont

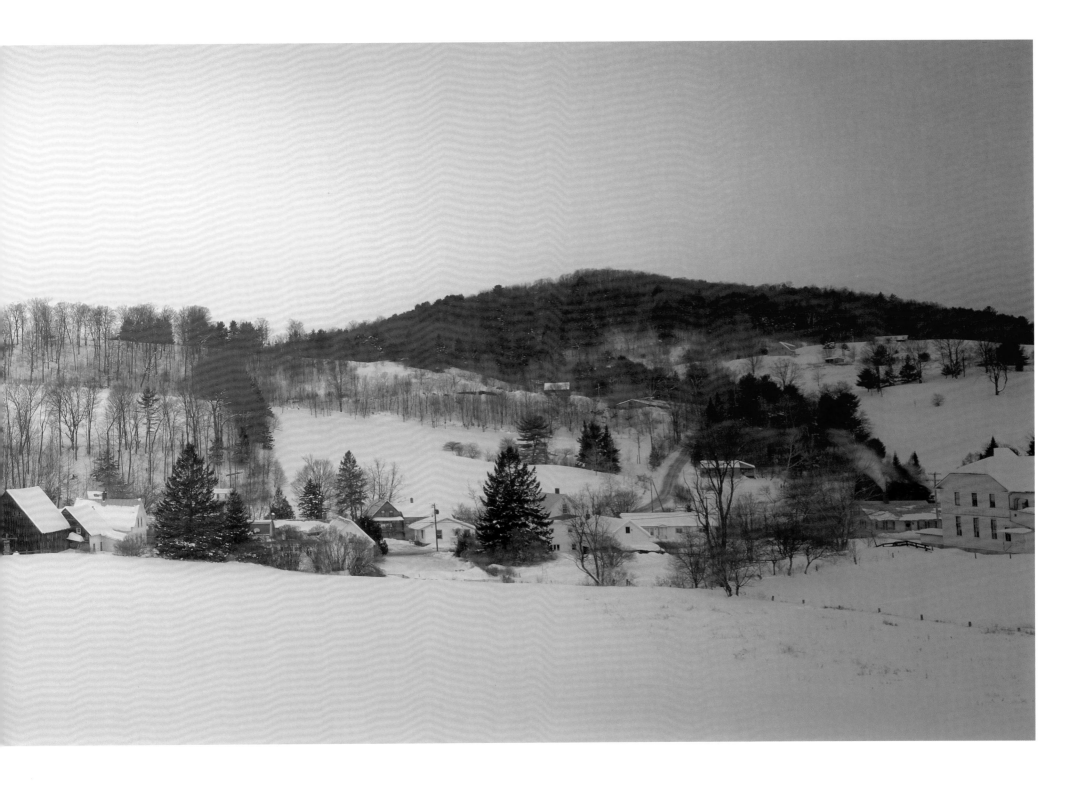

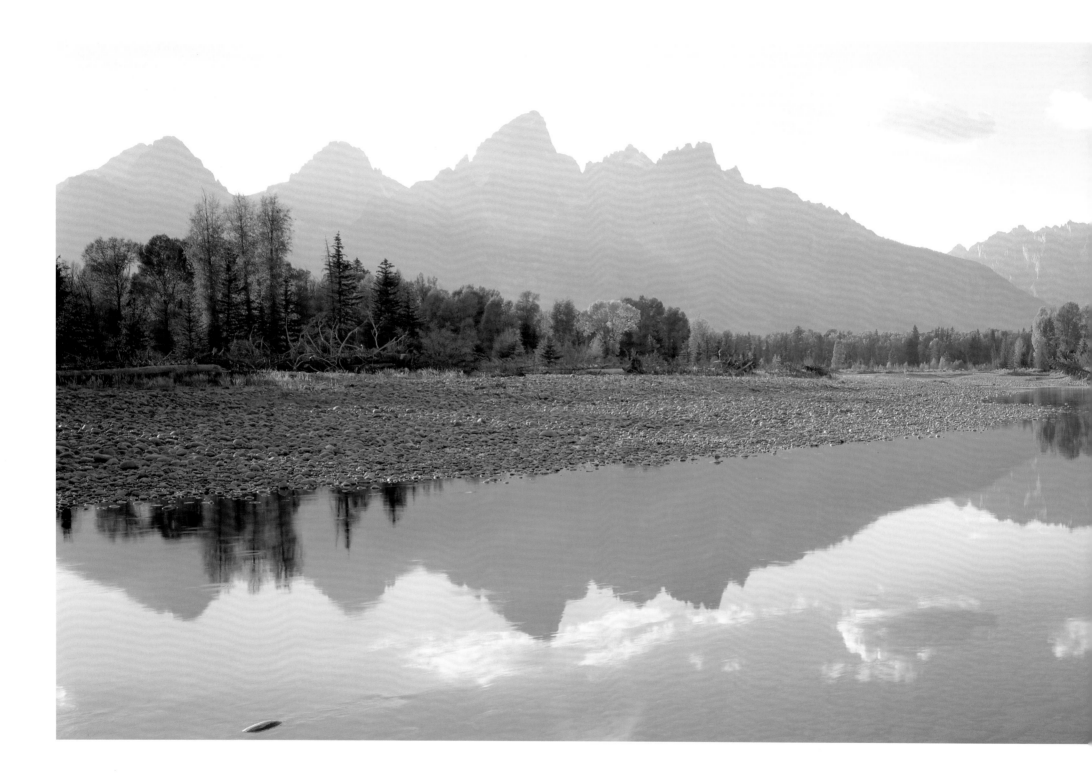

Schwabachers Landing, Grand Teton National Park, Wyoming

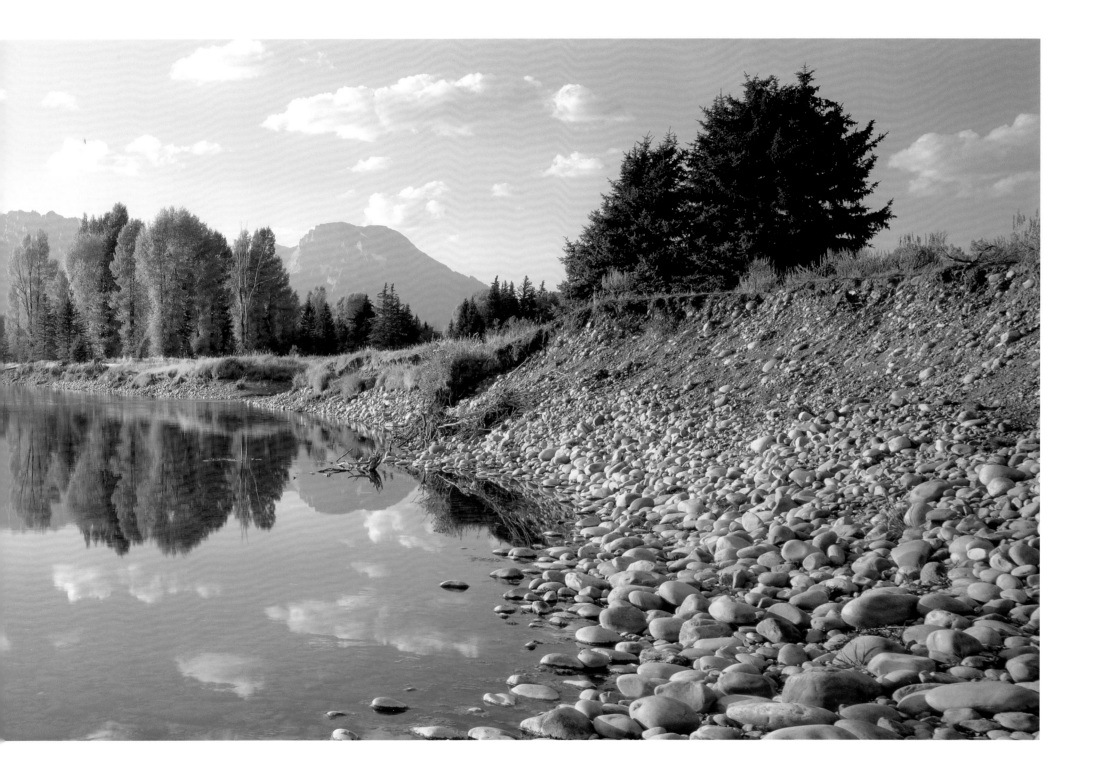

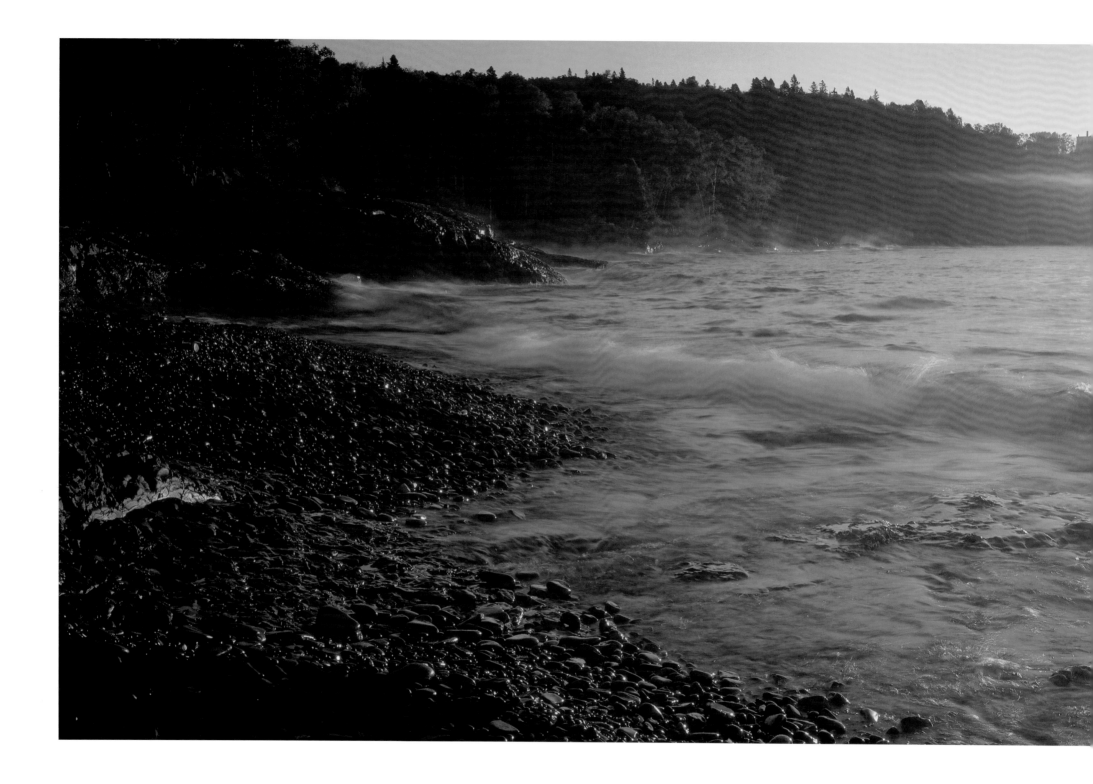

Split Rock Lighthouse, Lake Superior, Minnesota

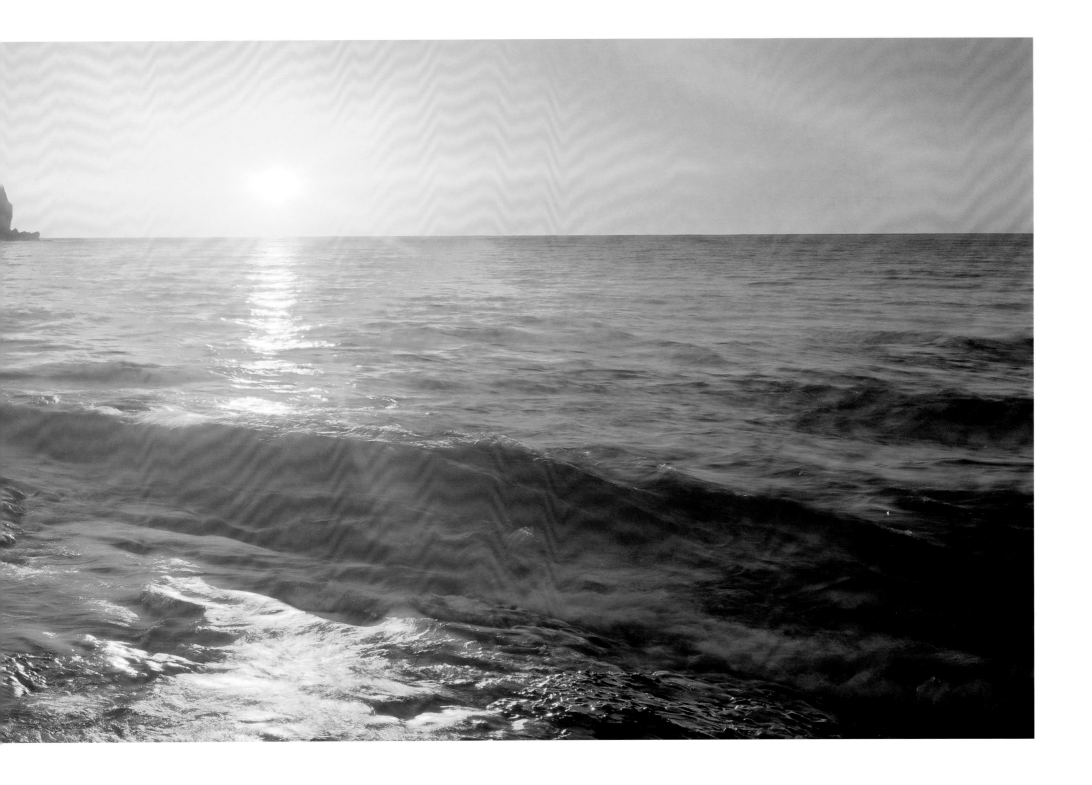

Photographer's Notes

Although people often contact me asking for photographic advice, I do not generally presume to tell anyone how to take photographs. I believe we all see differently and that is what gives each of us our unique style. When we follow our minds we are limited to our own understanding, but when we follow our hearts we see the bigger picture. Having said that, there are a few tips I can pass on.

BREAK THE RULES

The bottom line is: there are no rules. If an image works, it works; if it doesn't, it doesn't. At one of my exhibitions, a person with a doctorate in photography was looking at one of my shots and I could see she was puzzled. I asked if I could help. "I can't believe this!" she replied. "This guy has the horizon in the middle. It should be one-third sky, two-thirds foreground. But this really works!" The person didn't know I was the photographer, so I simply replied, "Isn't it lucky he doesn't know the rules, or this shot may never have happened."

There's only one essential: make sure you have film in your camera – although I once met a photographer who sometimes left the film out. He wanted to enjoy the privileged position of being a photographer without being disappointed with the results!

STOP TALKING AND START TAKING

One of the hardest parts of photography is getting out of bed. Just stick a film in your camera and get on with it. If you are going to eat an elephant, the way to do it is one bite at a time. If you sit back and look at how big the elephant is, you'll never finish the 'tusk' at hand! If you have a dream to shoot a book on America, you can think of the immensity of the country and be so overwhelmed that you never begin. Or you can pick somewhere to start and attack it one bite at a time. If you persevere, you'll reach your goal.

LOOKING PAST THE 'I'

Often the biggest thing blocking the light is our own shadow. We can get so locked into what we want to achieve or why we have gone to a particular area that we miss the very thing we are there for.

I believe there is a force at work much bigger than you or I. The key is to tap into the Creator's power rather than your own technical understanding, which by comparison is very limited. This is a hard pill for many to swallow (especially 'techno-heads') because people love to be in control. Personally, I would rather be out of control. I'm just an average photographer with a great God.

Photo by John Shephard

I have definitely not perfected this area of relinquishing control, but I'm working on it. It's exciting! How small we are and how big He is.

USING WHAT YOU HAVE

If you are not using what you already have, you won't use what you think you need. Many people think they need a better camera to take photos, and it certainly is nice to have a great camera. But the way to get it is by using the one you have now.

I started taking photos on my Dad's old Praktica, and my first book, *The Last Frontier*, was shot using second hand Widelux cameras that only cost $250. Talk about equipment with limitations – only three shutter speeds and constant breakdowns – but they did the job. The best understanding of your equipment comes from using it.

The technical aspects of a shot are secondary to capturing the spirit of a moment. Some years ago, at my sister's bidding, I judged a junior school photo competition. Some of the work was good; some was average. But there was one landscape shot which was just awesome. It had been taken at sunset by an 8 year old boy, using a disposable camera through the window of a bus traveling at 60 miles per hour! Against all odds, this shot really worked. It certainly humbled me.

WILD LIGHT

Light is undoubtedly one of the most important things to consider. No light, no photograph! Different light conditions suit different subjects. For example, overcast light may not work for a summer beach shot, but it is great for rainforests, especially during or after light rain.

Early morning and late afternoon is generally the best time to take photographs as the light has great warmth and softness. The mesas and buttes of Monument Valley in Arizona don't actually change color. It's the changing color temperature of the light that makes them appear so radiantly red at sunset.

One thing to be careful of is 'blue sky mentality'. Certain parts of America are blessed with lots of blue skies and this can sometimes become boring in photographs as the sky often accounts for a large part of an image. Cloudy light or wild, moody light can test your patience but when the break happens, you can get great emotion in a shot. Times of wild light are often when I speak to God asking (respectfully!) such things as, "What are you up to?" or, "Come on, give me a break – please!"

THE THIRD DIMENSION

Photography is a two dimensional medium, so we sometimes need to create the illusion of a third dimension in our photographs – especially in landscapes – to give

depth to the images. A simple way to do this is to use strong foreground interest. Another way is to use lines within the shot to draw the viewer in – a road, a fence, a curve of beach. Sometimes a good way to get better depth in a photo is to shoot from a higher vantage point. I often take shots from the top of my car or standing on my camera case.

PASSION

Passion is like an artesian well – when tapped, it brings life and energy to even the most barren desert. Passion, like attitude, is contagious and is essential for a project to succeed.

Life is an adventure, not a worry, and if you want to pursue a dream, stumbling blocks must become stepping stones. Passion is a powerful thing and when directed properly it can help bring visions to reality.

PATIENCE

Photography is like fishing. While you wait, learn the benefit of relaxing and getting into the rhythm of what is happening around you. The fruit that keeps you going is that occasional big catch – a good photo. Patience can be a difficult discipline but when we learn to be still, blessings come our way. Once I was shooting in Yosemite National Park and I waited all day for the light to be what I considered 'just right'. Throughout the day, about five other professional-looking photographers came along. Each one pulled out his mega-expensive camera, tripod, the works, waited a couple of minutes, then clicked off a few shots before leaving. Meanwhile, I was still waiting, waiting, waiting – wondering if in fact I had missed something. Finally, right at the end of the day, when all seemed beyond redemption, the light began to dance and the scene came alive. I was the only one still there and I believe I caught the big fish. I hope those others enjoyed their sardines!

For more phototips, visit The Journey website **www.panographs.com**

TECHNICAL ASPECTS

Surround yourself with the best support. Having good suppliers is a key to getting great results. If they are the best in their fields then you won't have to worry about that aspect of your photography. Here are some contacts I highly recommend for various services.

For Photographic Printing

CFL Print Studio in Australia is the best digital Ilfochrome (Cibachrome) print lab I have found anywhere. (Phone: 61 2 4365 1488 or Email: info@createdforlife.com)

Airline Travel

There are no better Airline companies than American Airlines and Qantas. I spent hundreds of hours flying with them during the shooting of this project, always enjoyed friendly service and never lost a single piece of baggage.

Financial Services

We all need a bank capable of thinking outside the square. I have been with Bank of America for over 10 years and they have helped me greatly with the various aspects of my American and international banking needs.

The equipment I use

• My main camera is a Linhof 617 III S with three interchangeable lenses – 180mm, 90mm and 72mm. It uses 120 roll film and gives 4 shots to a roll with an image size of 6cm x 17cm. I believe this is the best medium-format panoramic camera on the market.
• I use a Linhof tripod with ball head and quick-release mounts. Nearly all my images are shot from a tripod and this one is quick to set up, which helps with urgent shots.
• I also use Noblex cameras, both Pro 6/150U (120 roll film) and a 135U (35mm roll film). These are my pick of the rotating lens cameras as they have great depth of field and are easily hand held.
• For light readings I use a Sekonic spot meter as well as my trusty Nikon F90X which also allows me to grab some 35mm shots along the way.
• I use Hi-Tec filters – specifically an 81B color correction filter (but not at sunrise or sunset) and occasionally a graduated neutral density filter to hold back the skies. I also sometimes use a graduated, slightly warming filter to help with the color on those really dull days. However, I use natural light wherever possible.
• My film of choice is Fuji – it's the only film able to capture the diversity of color in creation. I mainly shoot Velvia or Provia 100F.

For information on Limited Edition Prints from this book, visit the Ken Duncan Online Gallery: **www.kenduncan.com**

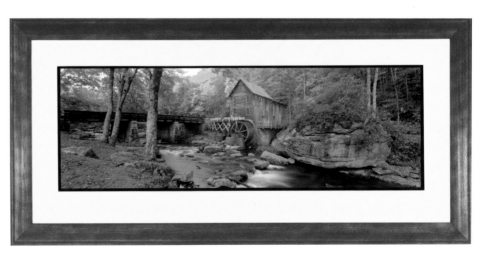